THE STEP-BY-STEP
DARKROOM COURSE

David Kilpatrick

NEWNES BOOKS

Ellie

CONTENTS

Published by Newnes Books
a division of the Hamlyn Publishing Group
Limited 84-88 The Centre, Feltham,
Middlesex, England and distributed for them
by the Hamlyn Publishing Group Limited,
Rushden, Northants, England

Designed and produced for Newnes Books
by Eaglemoss Publications Limited

© 1985 by Eaglemoss Publications Limited

ISBN 0 600 33264 0

Printed in Italy by Tipolitografia
G. Canale & C. S.p.A. - Turin

INTRODUCTION

If you have ever wondered why your photo dealer has shelves with chemical kits, photo printing papers and developing equipment on show you need this book!

Darkroom work today is not the cupboard-under-the-stairs business it used to be. Most of the time you work in daylight, in comfort, with reliable and simple processes giving superb results quickly. Colour is actually simpler than black and white in some ways, and the easiest processes to tackle at home are often exactly the ones which cost most through shops. A large colour print from a colour slide is a costly item; a special Cibachrome print is even more expensive. At home, though, the Cibachrome process is the most reliable and best for beginners . . . so start at the top!

This book takes you, first, step-by-step through typical basic processes. You can see how things are laid out and handled, and see the kind of results you expect. Common faults or problems are ironed out as you go along. Used hand-in-hand with the instructions for the particular kit you choose to try, this course helps fill the vital gaps. It's like having the tricks of the trade explained by an old hand, which is by far the best way to learn.

Later on you will see how creative techniques and ideas are built on the basic steps of each process. The beauty of darkroom work is that you are in control, and the result is always a personal achievement. At first it's enough to match or better the results you get from shops, make bigger prints, or see your slides an hour after shooting them. Eventually you can become an artist with enlarger and chemicals, and 'make' pictures rather than just 'take' them. The surprising thing is how simple it all is.

Improvising a darkroom

Photographers who wish to keep full control over every stage of picture-making will soon find themselves tucked away in some corner at home, engrossed in developing and printing. When space allows, a permanent darkroom is the most satisfactory arrangement but you can still do all kinds of darkroom work in a temporary, improvised set-up. Almost any room can be quickly and easily converted for photographic processing. It must be efficiently blacked out, of course, and there have to be power outlets for the enlarger and safelight, but running water is not essential. Once a film or prints are fixed they can be put in a bucket of water and taken to another room for the important final wash.

Power can be laid on almost anywhere with an appropriate extension cord which can be bought from most electrical or hardware shops. So virtually any room, from garden shed to attic, can become a photographic laboratory. But the most conveniently converted rooms are the bathroom or the kitchen.

Choosing the room

When selecting a room it is helpful to consider these points.
● Can the room be screened easily to shut out light?
● Does the room have a surface long enough to place at least two, and preferably three, trays side by side? The space needed depends on the size of your developing trays. As a guide, 12 x 15in (30 x 37cm) trays need a length of about 4ft (120cm). You must also allow space— not on the same work surface, if possible— for the enlarger.
● Can the room be made, and kept, clean? Dust and dirt mar the results in both developing and printing.
● Can electricity be supplied safely?
● Is there enough ventilation? Very small, poorly ventilated rooms are oppressive for any length of time.

A light-tight room

Windows are usually the chief difficulty and a blackout screen is the best solution. It can be made from hardboard, three-ply wood or stiff card fixed to a secure wooden frame. Glue and tack the material to the frame to prevent light leaking in round the edges and paint the screen black on the window-facing surface. Small clips fixed permanently to the window frame will enable you to secure the screen quickly. Minor light leaks can be stopped with 2in (5cm) wide strips of black adhesive tape, or weather stripping

(draught excluder)—which should be painted black if possible—or strips of black foam rubber.

Alternatively, you may find that you can make a blackout screen out of heavy-duty black PVC sheeting, but it may be difficult to seal the edges effectively. A surprising amount of light seeps around door frames (and even through keyholes), so use 2in (5cm) wide black tape, or draught excluder or a heavy, lightproof curtain.

Other possible sources of light leaks include ventilation points and entry points for pipes. Use a venting hood to make ventilators light-tight, so you don't cut off the ventilation. This is *very* important when working in rooms with gas appliances.

Checking for light-tightness: remain patiently inside for at least 10 minutes until your eyes are used to the dark, to check it really is blacked out. Always check the room each time because light can seep into a seemingly black room. It is also important to have the area behind the enlarger black in case leakages of light from the lamphouse reflect off a white wall on to the paper.

The work area

The workbench itself should be covered with washable material (always wipe up any spilled chemicals immediately). Ideally, the enlarger should sit on a separate work surface which is sturdy enought to prevent shake during printing, away from the chemicals in the processing trays to prevent contamination of the paper and to keep electrical equipment away from water. Always be careful about using electricity near water. Have your enlarger grounded (earthed) if this is what the makers advise and *never* touch any switches or plugs with wet or even damp hands. Cord-pull switches are the safest to use.

When using the bathroom as an improvised darkroom you can wash the prints in the bath and a temporary workbench can be conveniently positioned on the bath itself. To raise the surface to a comfortable working height, build the bench on six 12in (30cm) high legs which can be screwed into three pieces of wood 2 x 2in (50 x 50mm), which sit across the bath to support the bench. It does not need to be the full length of the bath as long as there is enough room to work.

Finally, make sure that the door closes firmly and hang a sign outside on the door handle, to prevent anyone bursting in at the wrong moment.

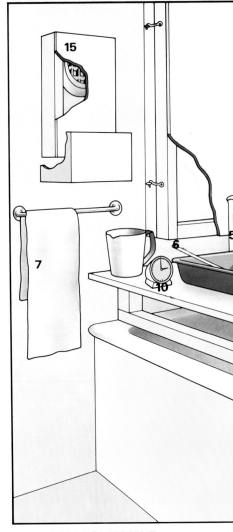

DARKROOM EQUIPMENT
Items marked with an asterisk are useful but not essential.
1 enlarger
2 enlarging easel* (masking frame)
3 printing tongs
4 developing trays
5 graduates
6 thermometer
7 lint-free towel
8 waste-bin
9 safelight
10 timer with large dial
11 blower brush
12 focus finder
13 footswitch for enlarger* or exposure time switch*
14 blackout screen
15 ventilator hood
16 work bench
siphon for washing*, tray warmer*, enlarging meter*, RC and flatbed print drier (glazer)*, print squeegee*

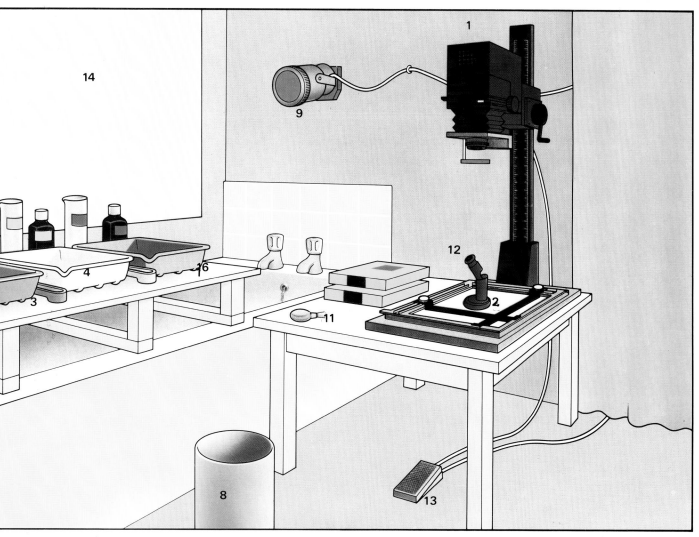

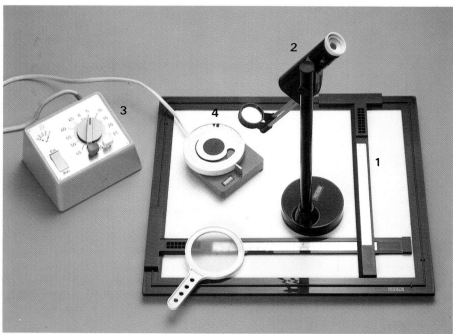

1 An enlarging easel holds the paper flat on the baseboard. It is more economical to buy one that takes a fairly large print—10 x 12in (24 x 30cm). But check that the baseboard is big enough to hold a large enlarging easel, or the easel may not sit evenly on the baseboard.

2 A focus finder is useful to check that the projected image is pin-sharp. Most models let you examine the grain structure of the negative to find the exact focus.

3 An exposure time switch is preset. Once switched on it leaves your hands free for techniques such as burning-in or for processing. They can be simple, requiring setting for each exposure or electronic, offering repeats of the same exposure.

4 An enlarger exposure meter works out the correct exposure and saves making test strips.

Processing black and white film

Starting out

Processing your own film is easy. If you don't believe this statement then either you have never developed your own films before—or you've picked up some very bad habits when learning how to do it!

In either case, this course is for you. It will show you all the practical steps involved in actually processing a film, right from taking it out of the camera. Subjects covered later include printing and colour processing. If you follow all the steps faithfully you will develop the good habits that make good processing a joy to do. Once you start, you'll wonder why you were ever afraid of trying it. Home processing can be quicker, cheaper, safer and *better* than the commercial kind—the advantages are worthwhile.

But there is always some risk when you start something new, no matter how careful you are. Therefore DON'T start your processing experiments with an irreplaceable film, such as one taken on holiday or at a wedding. The best thing is to take a practice film, and practise on that. If you buy a cheap, out-of-date roll of film from a photographic dealer, then it won't really matter if you make a mistake and spoil it.

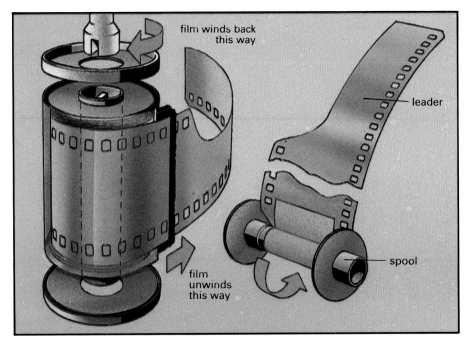

film winds back this way

leader

spool

film unwinds this way

THE 35mm CASSETTE
Seen from the camera top, film is wound clockwise on to the cassette spool and unwinds anti-clockwise. The slots on the spool-top mate with the camera's rewind lever so that you can wind the film back into the cassette.

THE FILM
A 36-exposure cassette contains about 4.5ft (1.5m) of film. One end is taped to the spool, the other has a specially shaped piece of film called a *leader*. In a new roll the leader protrudes from the cassette ready for loading.

4 REMOVE THE FILM
Lift the rewind lever fully to open the camera back (or use the catch if your camera has one). Do this in shade or indoors with the camera back facing you. Remove the cassette, angling the bottom out first. Grip the cassette not the film, or you will unwind it. With the leader out, the film looks like any other roll of film. So you *must* now label it clearly.

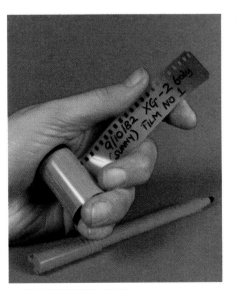

5 IDENTIFY THE FILM
Write on the leader strip so that you can identify the film later on. Do this even if you only number it instead of writing all the data shown here. Then you will at least know which film to process first. Later on you will find it useful to record other details which will be helpful when you come to process it. Here, the date, camera body and weather are also recorded.

6 PREVENT RELOADING
Wrap a rubber band round the used cassette to stop you re-using it accidentally. It also keeps the cassette tidy and stops the leader being pulled out. Adhesive tape can also be used for this, but the rubber band is quick and secure. Other ideas to stop you reloading a used cassette include tearing off ½in (1cm) from the leader end, or creasing it hard.

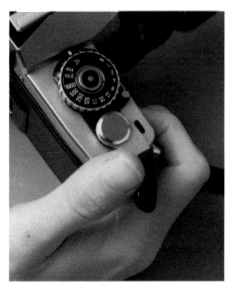

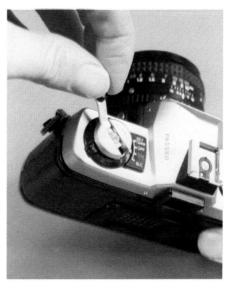

1 THE FILM ENDS
You take a picture and wind on the film but the wind-on lever suddenly stops before it has completed its travel. Do not force this lever, because it means that you have finished the roll of film. Check the frame counter. You can expect 25 or 26 shots from a 24-exposure roll and 37 or 38 shots from a 36-exposure roll, though you may sometimes get fewer.

2 TESTING FOR FILM
If you aren't sure that the film has finished, there's a simple way of checking. Unfold the rewind lever, but do not *lift* it up. Gently turn it one way until it meets resistance, then the other way. If the film is finished, you will only be able to manage half to one turn in each direction. If the film is not finished, it will be able to move several turns.

3 REWIND THE FILM
Hold the camera to your ear and press the rewind release button (or turn the switch on Olympus models). Wind back the film slowly, listen for the *first* click, and then stop. This way you do not wind the leader back inside the cassette. For home processing you want the leader sticking out, so that you don't have to break open the cassette to reach the film.

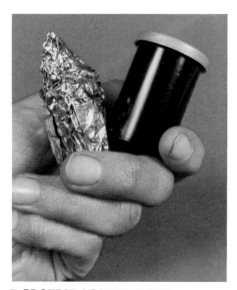

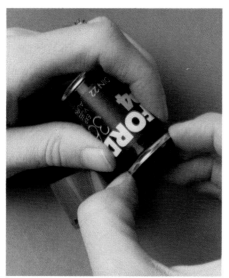

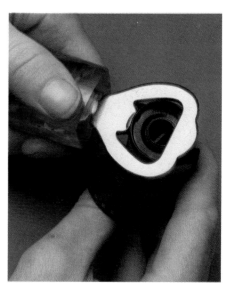

7 PROTECT AGAINST LIGHT
A cassette is not totally lightproof. Leave one out in the sun and many shots would then show bands of light. Protect the cassette by storing it in the maker's film canister. (Label or put a rubber band round this as well, so you can see which film cans contain used rolls.) If you have no cans, use aluminium foil, or store used film in a closed pocket of a camera holdall.

8 WHAT IF THE LEADER IS WOUND BACK INTO THE CASSETTE?
If this happens, you need to break open the film. The red background here means don't do this in the light, only in total darkness. To open Ilford and some other cassettes, grip with left hand and squeeze the cassette together at the end next to the cap. Remove the cap, which is now loose, with the right hand. Don't hold it pointing down or the film may fall out.

Some cassettes are crimp-sealed at the end without the protruding knob. The best way to open them is to use a bottle opener on this end. You cannot reseal this type of cassette, so only open them when you are about to develop the film, or have an old loadable cassette ready to transfer the film into. (With cassettes of some makes the lid can be pushed back on.)

Loading the spiral

For many people, getting a 4.5ft (1.5m) roll of film into a spiral reel 3.5in (9cm) in diameter means trouble. In fact it's easy once you know how but you *must* practise first. Do this by following the steps given here, using an outdated or unwanted film. Close your eyes when you come to the parts that have to be done in total darkness (shown here by a red background).

These reels are specially designed to hold the film spirally inside the developing tank, so that there is no chance of one part of the film touching another part. Processing chemicals can circulate freely around the film to reach every part. This helps it to develop evenly.

To illustrate the developing stage, we have shown a typical easy-to-use universal film developing tank with an adjustable spiral reel. A cross section of the tank is shown on the right. It consists of a black plastic cylinder with a screw-on lid. The lid has a cleverly-designed light-trap so that liquids can enter, but not light.

You can place either one or two reels into the tank. Here, only one is shown. Incidentally, always make sure the reel is dry before you start loading.

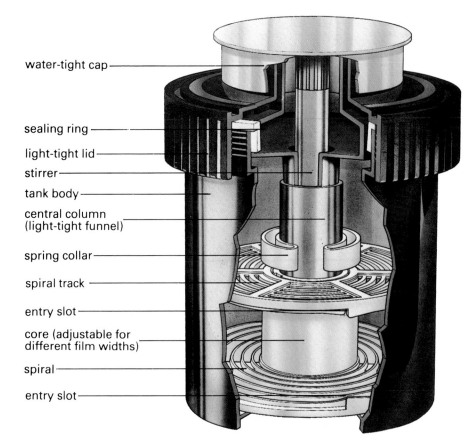

water-tight cap
sealing ring
light-tight lid
stirrer
tank body
central column (light-tight funnel)
spring collar
spiral track
entry slot
core (adjustable for different film widths)
spiral
entry slot

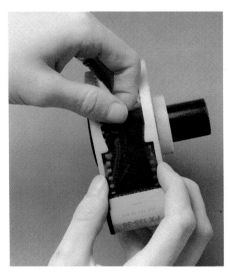

4 INSERT THE FILM

If you are loading from the cassette, you can insert the first inch (2-3cm) of film with the lights still on. Use the grip shown here to pull the film in with your left thumb and forefinger, rather than trying to push it in. Use your right hand to hold the cassette and steady the reel. Note that there is a slight outward curve to the film—this helps it go in smoothly.

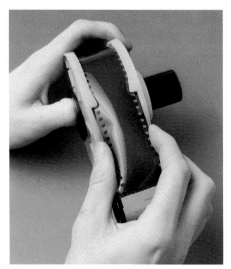

5 TURN OFF THE LIGHTS

Before you load any more film into the reel, turn the lights off (indicated by a red background here). You will now be unwinding film that has pictures on. For this trial run, close your eyes instead. Squeeze the film gently as this will probably let you enter another inch of film into the reel. Enter as much as you can. Then there is less chance of the film falling out.

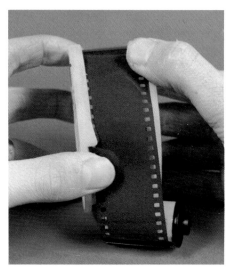

6 LOAD THE FILM

Hold the reel, gripping one half in each hand. Smoothly and firmly turn the right-hand half of the reel forward, as in the picture above. Have your thumbs touching but not pressing the film. Then you will be able to feel the film being loaded. If you can't feel this happening, press down *slightly* on the film with your thumbs to increase the pressure on it.

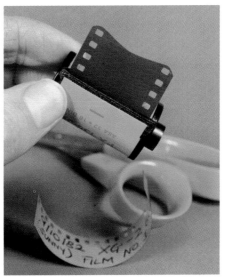

1 SAFE SCISSORING
The film will not go into the reel with the leader still on. It must be cut off with a pair of scissors. Get used to holding the cassette in the way shown above. Then, if you ever need to do this in the dark, you won't accidentally cut your fingers because they are tucked in towards the cassette. Do not tear or crimp the cut end, otherwise it may jam the reel.

2 A STYLED TRIM
Cut the end of the film to a concave shape as shown here. This makes it very easy to load the film into the spiral reel. The rounded corners go past the outward-pointing struts of the reel without being impeded—these struts often catch a square-cut film. The concave cut means that if the film end curves it does not touch other parts of the film during processing.

3 LINE UP THE REEL
This is the film reel. You can see the channels that the film runs along and the lugs marking the entry point. The ball bearing is part of the mechanism that grips the film's sprocket holes and pulls it into the reel. Before loading the film, line up the two entry lugs like this, then hold the reel with these on top and exactly aligned. Now get the trial cassette of film. . .

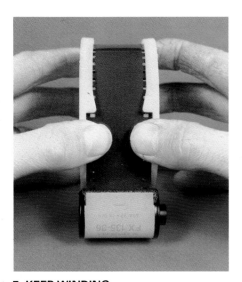

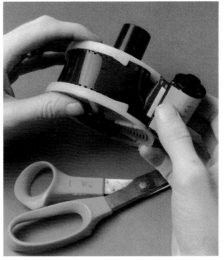

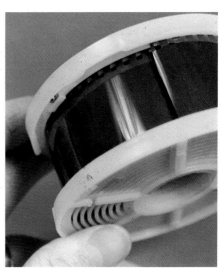

7 KEEP WINDING
When the right-hand half of the reel reaches a stop, you can do one of two things: either turn it back, or turn the left-hand half of the reel forwards, copying the first action.
Whichever method you adopt, you will soon have an easy alternating action. Each forward turn grips film and feeds it in through the opposite half's entry lug.

8 DETACH THE FILM
Do this by cutting the film as close to the cassette lip as possible. But take care not to leave any adhesive tape on the film in the reel. Some films can be easily torn off just by twisting (see above), but make sure you do not pull the film out of the reel. Do not cut or tear the film until you are totally sure you have loaded all of it. Check this by pulling on it.

9 WIND IN THE FILM END
If you leave the film end sticking through the entry of the reel, even by a fraction of an inch, it may start to unravel during the processing. This is because the chemicals lubricate the reel and overcome its grip mechanism. Prevent this by loading the film end right past the ball bearings of both reel halves. The film will now be loose inside the reel.

Loading the tank

Once the film is on the spiral reel, the next stage is to load this into the developing tank. This is a specially designed piece of equipment that is light-tight yet still allows the developing solutions to be poured in and out.

It contains a number of parts, all of which must be assembled correctly for the tank to work. For example, the tank contains a column called the *pillar* which holds the reel. If you put this in the wrong way round, the tank will not close completely and solutions will escape.

The steps here show how to assemble a typical tank, though others may show variations. This tank has more parts than any other type, so if you know how to assemble it then you can handle any other make, too.

Practise the steps on a bench, and keep all the tank parts inside the developing tank while you do this. In particular, do not leave the pillar loose on the bench—it can easily roll on to the floor and get lost. Without it the developing tank is no longer light-tight.

Steps with a red background have to be carried out in the dark. When you're practising it's easier just to close your eyes and have the lights on.

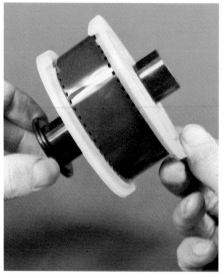

1 FIT THE PILLAR

Push the spiral reel on to the central pillar and slide it down as far as it will go. It does not matter which way round the reel goes; either way the two parts should fit firmly into each other. The pillar helps to keep out the light and, when the whole assembly is inside the developing tank, the pillar lets you stir the reel round inside the solution.

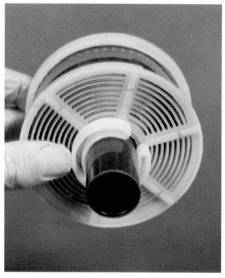

2 FIT THE RETAINING CLIP

Next fit the retaining clip over the pillar and push it down on to the reel so that the reel is held fast. When you come to develop the film you will be turning the tank over repeatedly, to wash the film with the solution, so the clip must hold the reel steady. When you aren't using the clip don't keep it on the pillar, or it may lose its spring.

6 THE CHANGING BAG

The best place to load film into the developing tank is a darkroom. If you don't have a darkroom you can use a changing bag. These bags are double-lined with black material, each layer having a zip so that you can get equipment inside. They also have two arm-holes to let your hands inside, with elastic cuffs to stop light getting in.

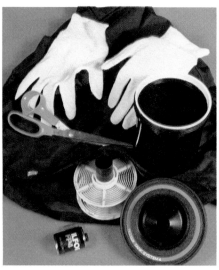

7 WHAT YOU NEED

To use a changing bag, you need the equipment shown here. Don't put anything else inside (for example, the stirring rod or water-tight cap). If the film leader is accessible (as here), trim this and start the film in the spiral reel as shown in last week's course. (Only wind on the first inch or two! Any more and you'll be exposing film with pictures on.)

8 INTO THE BAG

The changing bag has two skins and two zips. All items must be inside *both* bags; only in there is it completely light-tight. It is very easy to place items in the space between the inside and the outside bags if you're not careful. After putting everything in the inner bag, zip it up. Then check the space between the two skins to make sure everything's inside.

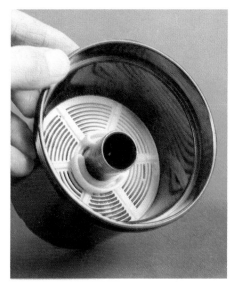

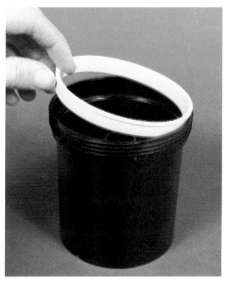

3 PUT THE ASSEMBLY INTO THE TANK

Place the assembled reel, pillar and clip into the tank so that the reel is at the bottom. Stand the tank on a surface and check that the whole assembly can rotate freely inside it by giving the top of the pillar a sharp twist. Take care that you are using the right pillar if you have more than one developing tank. They can easily be mixed up.

4 ADD THE SEALING RING

This is a white, slightly soft, plastic ring that fits into the top of the tank. When you screw on the lid its softness gives a very firm, tight seal and stops the lid from coming unscrewed during processing. It also seals the joint so that chemicals do not leak out. If the sealing ring feels loose, it can be improved by stretching it.

5 SCREW THE LID ON

This needs a bit of care because it's easy to get the threads engaged wrongly. To do it correctly, hold the body and lid as shown here and first mate them up as closely to parallel as you can. Then screw the lid on. Do not do this too tightly, just make sure that the lid is firmly locked down. The lid is light-tight, so you can now turn the light on.

9 SEAL THE BAG

After checking that everything is safely inside the inner bag, do up the outer zip. Once your hands are in the sealed bag, you will have to keep them inside until you've finished, and it gets warm inside! It's best to wear cotton gloves to stop your hands from becoming sticky and marking the film. Once your gloves are on, put your hands through the holes.

10 USING THE BAG

Wear a shirt or sweater when using a changing bag, since this gives a better seal round your arms than if they were bare. Feel all the items in the bag and clear a space before you start. Load the film on to the reel, only pulling out 1in (2.5cm) at a time. Work slowly and carefully. Be careful with the scissors and make sure you don't cut the bag lining.

11 UNLOAD THE BAG

Once the film is inside the tank and the tank lid is securely screwed on, remove your hands, unzip the bag and take everything out. Do not place the tank in direct sunlight, even though it's light-tight. Normal domestic lighting won't harm it, though. The next step is to prepare the chemicals that you will need to process the film.

Making solutions

With your film loaded inside the developing tank, you are now almost ready to begin developing.

For this stage, you don't need much equipment: a measuring jug, a thermometer, some sort of timer, storage bottles and the necessary chemicals. A few extra items will make the job easier, though (see right).

The chemicals you need are a developer, and a fixer, though you should also use a stop-bath and a wetting agent. To show you the steps, we have used Paterson chemicals: Acutol, Acustop, Acufix and Paterson Wetting Agent. But there are others which will do just as well.

The developer, stop-bath and fixer are all bought in concentrated form and need to be diluted before you use them. The stop-bath and the fixer can be used over and over again, so it's worth your while making up a solution of these and storing them. The developer, on the other hand, can only be used once. So this is made up as you need it.

A good place to make up solutions is the kitchen since it has a supply of running water. Take care, though, and make sure that you keep all chemicals well away from food.

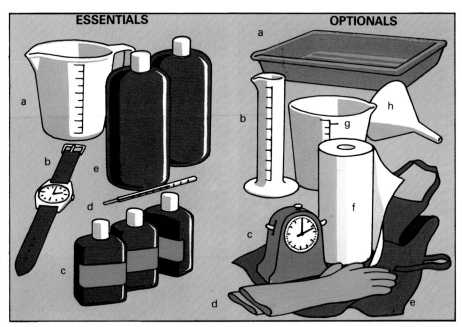

ESSENTIALS **OPTIONALS**

▲ For developing, you will need: a) a measuring jug with capacity between 300ml and 600ml, b) a watch with a second hand for accurate timing, c) the necessary chemicals, d) a thermometer to check the temperature of the solutions, and e) two plastic storage bottles, capacity 300-600ml.

▲ You will find the following useful: a) a developing dish to act as a drip tray, b) a 100ml measuring cylinder, c) an accurate timer, d) rubber gloves, e) an apron, f) a roll of kitchen paper, g) an extra 300-600ml measuring jug, and h) a funnel to help in pouring.

4 MAKE UP THE FIXER
The developer is used just once and then thrown away. The fixer and the stop-bath both keep well, so they can be made up in advance and stored. For the fixer, 600ml is a convenient amount to make. Pour 450ml of water at about 23°C into a measuring jug, and 150ml of fixer into another, smaller jug. Then add the fixer to the water and stir well.

5 BOTTLE THE FIXER
Store the fixer by bottling it with the aid of a funnel, preferably in a special plastic bottle. Then label it. Leave a space on the label so that later on you can mark how many films you've used it for. Stick the label near the top; then it's less likely to fall off when the bottle is in a water-bath. Finally, wash the jugs and funnel in several changes of water.

6 MAKE UP THE STOP-BATH
Now make up the stop-bath. This has to be diluted 1 + 30. So, for 600ml, you need just 20ml of the stop-bath concentrate and 580ml of water at 20°C. Take care when pouring the concentrate into the water—it is very acidic and will burn if it touches your skin. If you have sensitive skin, wear rubber gloves when mixing any chemicals, especially the stop-bath.

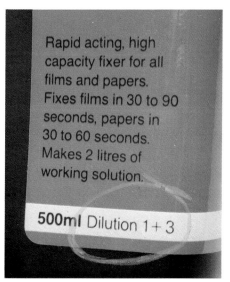

1 THE INSTRUCTION SHEET

The developer, stop-bath and fixer all come with a set of instructions. Read these carefully before you start. They tell you the temperature the chemical should be at when you use it (usually 20°C), and how long you should leave it in the developing tank. This varies with different films. For example, Ilford FP4 in Acutol needs 6 minutes to develop at 20°C.

2 DILUTING THE CHEMICALS

Before you use any of these chemicals, they must be diluted with water. *On no account use them neat.* The amount you need to dilute them by is given in the instruction sheet and on the bottle label. For the fixer the dilution ratio is 1 + 3. This means one part fixer to three parts water. The developer is diluted 1 + 10 and the stop-bath 1 + 30.

3 HOW MUCH DO YOU NEED?

For each chemical, you need enough to cover the whole film. This depends on the film size, and the size and shape of the developing tank. The base of the tank tells you how much you need for different film sizes, per roll of film. For one roll of 35mm film the figure is 290ml. You don't need exactly this amount, though. It's safer to use a little more.

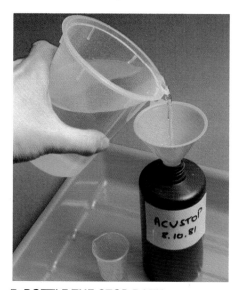

7 BOTTLE THE STOP-BATH

Bottle the diluted stop-bath in the same way you did the fixer, using a similar 600ml plastic bottle. Then label it, sticking the label at the top of the bottle. The stop-bath turns purple when it's used up. So, unlike the fixer, there's no need to mark how many films it's been used for. Again, thoroughly wash the funnel and the measuring jugs afterwards.

8 CONTROLLING THE TEMPERATURE

You now have both the fixer and the stop-bath ready—all that remains is to mix the developer. This will be done just before it's needed. To keep the other two chemicals at the right temperature (20°C), or to raise them up to it, put them in a basin of warm water. This is called a *water-bath*. Stir the solutions with a thermometer until they reach the right temperature.

9 ALLOW FOR ROOM TEMPERATURE

If you're doing this in a cold room, bring the solutions up to a degree or two warmer than 20°C. Your water-bath will now have cooled down, so add a little hot water or replace the bath with some fresh warm water. This will keep the bottles at the right temperature while you make up the developer and develop the film. To check on the temperature use a thermometer—don't guess!

1 PREPARE THE DEVELOPER
You already have the stop-bath and the fixer standing in the water-bath, and your film is loaded into the tank. Now take 300ml of water at 21°C, and 30ml of Acutol. Mix them thoroughly. The solution will be clear and look either colourless or slightly yellow. The extra 1°C over the recommended 20°C is to allow for the temperature falling during processing.

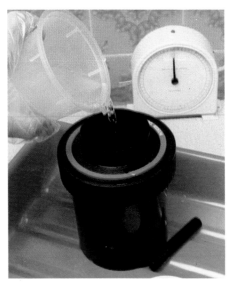

2 START DEVELOPING
Pour the developer straight into the tank, making sure that you don't splash any. Don't pour too quickly or air will be trapped inside the tank and it will overflow. Prevent this by holding the tank at a slight tilt to help air escape. Place the tank in a developing tray if you have one. This will insulate the tank from the cold work surface beneath it.

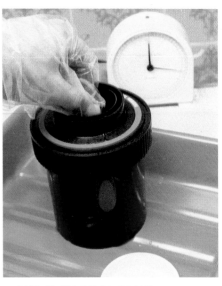

3 DISLODGE AIR BUBBLES
As soon as all the developer is in the tank, start timing. Then slot the agitating rod into the tank top and use it to twist the reel quickly back and forth. This dislodges any air bubbles trapped at the top edge of the film. Keep twisting the rod for about 20 seconds. You can also give the tank a sharp tap on the worktop to help dislodge bubbles.

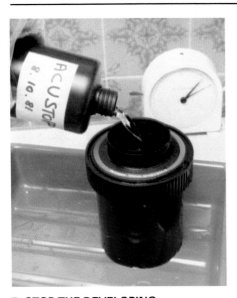

7 STOP THE DEVELOPING
At six minutes (or as close to it as you can get) start pouring in the stop-bath which you have ready. You need at least 290ml, and it's safer to use slightly more. Then agitate the solution by twisting the rod for a half to one minute. Afterwards, pour it back into its bottle, using the funnel. You can keep re-using the stop-bath until it turns purple.

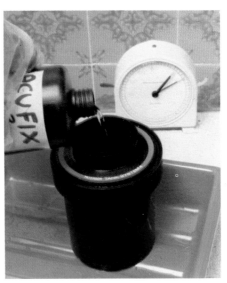

8 POUR IN THE FIXER
Now pour in the fixer. Once again, you do not need exactly 290ml, as long as you use at least this much. Agitate the solution with the rod for ten seconds, then for another ten seconds at the end of each minute. With fresh fixer, the film will be fixed after 30 seconds, but it safer to fix for three minutes. There is no need to fix for longer than five minutes.

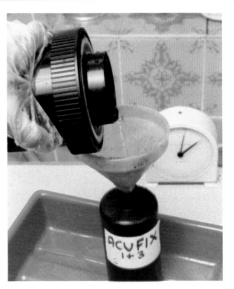

9 RE-BOTTLE THE FIXER
Return the fixer to the bottle and mark 1 on the label. This indicates that you have used it to fix one 36-exposure roll. (For a 20-exposure roll you would mark ½.) Later on, these marks will enable you to work out when the fixer has been used up—unlike the stop-bath the fixer does not suddenly change colour. Store away both the stop-bath and the fixer.

4 PUT THE TANK CAP ON
Put the white plastic sealing lid on to the tank now. Don't press it down quickly, but place it on as shown so that the air can escape. Then push it firmly down *all the way*—only the last few millimetres of its travel provides the water-tight seal. Without it, the developer will leak out later on. Finally, press the centre of the cap slightly to exclude air.

5 INVERT THE TANK
As soon as the timer shows one minute, grip the tank securely and turn it upside down. Wait until the noise of the developer draining over the film stops, and immediately turn it the right way up. Then invert it once more and back again. This will ensure that fresh solution replaces used-up developer around the film. Repeat this inversion process each minute.

6 POUR OUT THE DEVELOPER
Ilford FP4 needs six minutes to develop in Acutol 1 + 10 at 20°C. So, instead of inverting the tank again at the six minute mark, remove the cap and pour the developer down the sink. Start pouring ten seconds before the six minutes is up, because the film continues to develop while you pour. If you have no sink nearby, pour it back into the measuring jug.

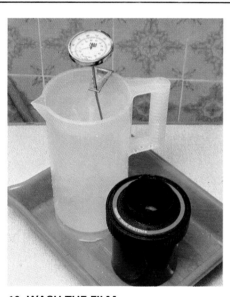

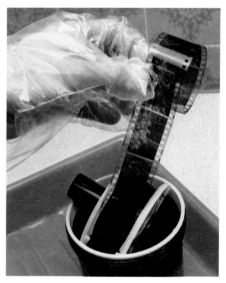

10 WASH THE FILM
All residues of chemicals must be washed from the film before you can dry it, otherwise the negatives will fade. A good way of doing this is to use several changes of clean water at the developing temperature of 20°C. Make up the water to the right temperature in a jug and give the film ten one-minute rinses, all the time agitating with the rod.

11 USING RUNNING WATER
If your hot and cold taps together give you running water at 20°C, you can use that for washing. It should take 20 minutes. To use colder running water, first reduce the temperature of your washes by 2°C until you reach the temperature of your running water, then use this to complete the wash. For water at 10°C washing takes one hour. Washing is quicker with the tank lid removed.

12 EXAMINE THE FILM
Once the fixing is complete you can open the tank to examine the film; you do not need to wait until the end of the wash. Handle the film by its edges and pull out only a short amount. Normal film should look completely clear with images in neutral black. If it is milky after 5 minutes return it to fresh fixer, avoiding a temperature jump.

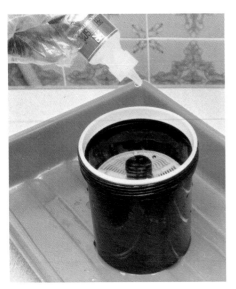
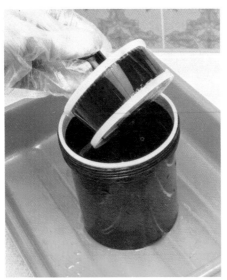
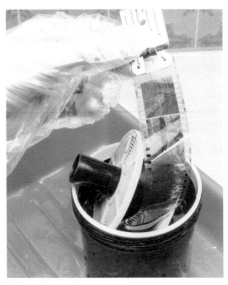

1 ADD A WETTING AGENT
After washing the film, give it a final rinse in a wetting agent. Fill the tank with water, preferably distilled or ionized by a water softener. Add either five drops of a photographic wetting agent or a single drop of washing-up liquid. Leave for one minute, occasionally stirring the solution with a twist rod to make sure the wetting agent reaches all the film.

2 REMOVE THE REEL
Lift the reel out of the tank so that the surplus water can drain off. Using a wetting agent helps the water to drain off evenly.

3 ATTACH THE FILM
Rest the reel on the side of the tank as shown and pull out about an inch of film. Attach a clip to the end of the film, making sure that it doesn't touch any of the images. Use a proper film clip for this; these have sharp teeth which grip firmly. You can also use a plastic clothes peg but it may slip off unless you double over the end of the film.

7 SPEEDY DRYING
The film must be hung up to dry in a dust-free atmosphere. One way to ensure clean, fast drying is to use a special cabinet like the one shown above. This can be closed while the film is dried by a built-in fan. An alternative is to use a hair dryer at a low setting—blow-dry the shiny side from at least 6in (15cm) away. Avoid raising dust—it will stick to the film.

8 CHECK FOR DRYNESS
The bottom of the film will be the last part to dry, so check this for any spots of water. You can touch the film where there are no images, but make sure your hands are dry first. Then check for damp areas by viewing the film with light reflecting off it, as shown above. Any damp parts will look darker than the rest, and drying marks from spots of water will also show up.

9 COUNT THE NEGATIVES
Before you take down the film, count the number of frames. A 36-exposure roll might easily give you 37 or 38 pictures. The easiest way to store your negatives is as strips of five or six. So decide now how you will cut up your film. There might be some blanks or bad shots that you can reject to make a neat set of strips which are suitable for filing.

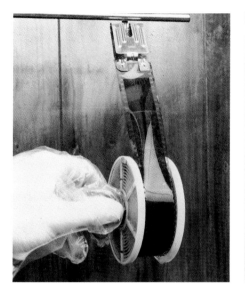

4 HANG UP TO DRY
You need a support such as a line or a rod to hang the film from. It should be at least 6ft (2m) above the floor, for 36-exposure films, and at least 3in (8cm) away from any walls. Attach the clip to your hanging point, then slowly and carefully unwind the film by turning the reel. Do not pull downwards on the film or you may tear it out of the clip.

5 ATTACH A WEIGHT
Catch the film as it leaves the reel, otherwise it may roll up and damage the emulsion, which is still wet and soft. Then attach another clip to the end of the film to keep it taut. If the clip is light, add some lead or Plasticine to weight it to stop the film curling as it dries. Place a tray or bucket under the film to catch any drips.

6 WIPE THE FILM
The film still has surplus water on it. You can remove this by wiping the non-emulsion (shiny) side with soft kitchen paper. Do not touch the dull emulsion side! Alternatively, use squeegee tongs to wipe both sides at once. Check the blades for grit first, then don't squeeze too hard, and don't pull on the film, or you may scratch it.

10 CUT UP THE NEGATIVES
Working on a smooth, dust-free surface, cut the film into strips of the right length. Hold the film against the light when you do this. It's a good idea to store the strips in polythene sheets in a negative file. The Unicolor file shown here takes strips of five frames, but most others take six. (Before filing the strips you might want to make a contact sheet.)

11 FILE THE STRIPS
You can now insert the strips of film into the filing sheet pockets. Only handle the negatives by their edges—never touch the image area. Slide the strips carefully into the sheets, and do this over a clean worktop. Then if you drop one, it will not fall on the floor and become dirty.

12 INDEX THE FILM
As soon as you have filed the film, write on the filing sheet all the details you may want to know later on: date, subject, film type, and a filing number if you think you may eventually have a large number of files. It is also a good idea to record development data, including the times and the temperatures used, so you can learn from your results.

19

Making contact prints

How to make a test strip

Having processed a roll of black and white film, you probably won't want prints of all the pictures. Some may be wrongly exposed or not show the subject well. But it's difficult to judge this from looking at the small 24x36mm negatives.

A quick, cheap way of converting your pictures to positive form without having to print them one at a time is to make a *contact sheet.* This is where you print all your pictures on one sheet of paper so that they come out the same size as the negatives. The images are small, but clear enough to see which are worth enlarging. But in order to make a contact sheet, first you have to make a *test strip.* This is to find out how long an exposure you need for the contact sheet. (Paper development is standardized, so the exposure must be accurate.) Some of the steps shown here need to be done under a *safelight:* a special lamp giving out a weak, often red or yellow, light, that has little effect on photographic paper. Undeveloped paper is always handled under this light, *never* under ordinary lighting. Steps needing a safelight have a safelight symbol in the corner.

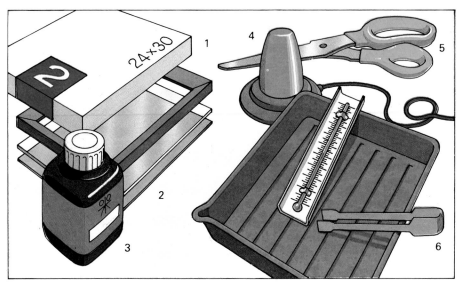

WHAT YOU NEED

1 Paper To demonstrate the steps, we used 10x12in (24x30cm) Ilfospeed, Grade 2 glossy paper. This size is easy to work with, and matches our negative file. You can use 10x8, as 6 strips of six 35mm negatives will just fit on.

2 A sheet of glass This is to hold the negatives flat against the paper, so it should be the same size. Or you can buy a proof printer or contact frame.

3 Print developer We shall be using Paterson Acuprint.

4 A safelight such as the 15watt Paterson model, so you don't have to work in the dark.

5 A pair of scissors or *safe* guillotine.

6 A developing tray—slightly larger than the paper—a **thermometer** and a pair of **tongs**.

Many other brands are available apart from the ones we used.

4 OPEN THE PAPER
Turn the white light OFF and the safelight ON. Unseal the glued flap of the Ilfospeed packet. Inside, you will find a black polythene packet. Pull it out and at the other end you will find the opening. Inside are ten sheets. Remove one, using cotton gloves if your hands are sticky. Fold the polythene packet and return it to the other packet, opened end first.

5 EXAMINE THE PAPER
Look at the paper under the safelight to see which is the emulsion side. You will see that one side is glossy and the other is matt. The glossy side is the emulsion side, which is sensitive to light. (This is the opposite of the case with film where the sensitive side is dull.) Avoid creasing the paper, and avoid getting fingerprints on the glossy side.

6 CUT INTO STRIPS
You will be using this sheet to make test strips. Cut the paper into nine strips, each about an inch (3cm) wide. You now have one test strip for each sheet of paper in the packet. Put eight of the strips back with the paper, and keep one out.

1 BLACK OUT YOUR DARKROOM
Your darkroom, kitchen or bathroom needs to be blacked out to stop light from entering. For windows, use a sheet of heavy card cut to shape and held in place with black canvas tape. For doors, either tape the edges or hang some black canvas. The first time, stay in the room with the lights out for at least five minutes, to see if your blacking out is efficient.

2 HANG UP THE SAFELIGHT
Fix the safelight about 3ft above your work area. It can be hung from an ordinary hook. Don't use a stronger bulb than the manufacturer recommends. And remember, a red safelight is for black and white paper developing. It is *not* safe for films or colour papers.
For the work area, use any clean, flat surface such as a table or a laminated board laid over a sink or bath.

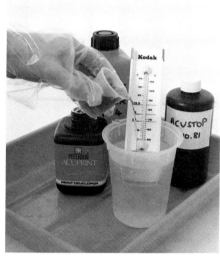

3 MIX THE CHEMICALS
Warm your existing bottle of Acustop solution (used earlier when processing the film) to between 16°C and 22°C by standing it in a water-bath. Make up a fresh bottle of fixer (such as Acufix) at 1+3 dilution. Label this 'Print fixer'— keep it separate from your film fixer and use it only for paper. Finally, take 500ml of water and add 55ml of Paterson Acuprint developer.

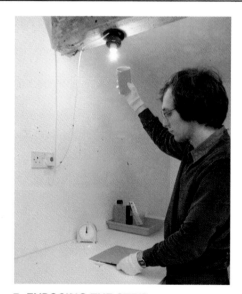

7 EXPOSING THE STRIP
Place the strip *glossy side up* on the bench below the safelight. Put a piece of thick card over it so that just an inch (3cm) shows. Then expose it to the light. You can remove the safelight cover to expose the strip to white light for one second (as shown above). An alternative is to switch on the room light for one second. Either gives a one-second exposure.

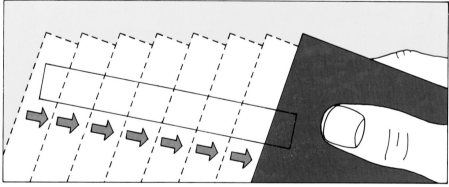

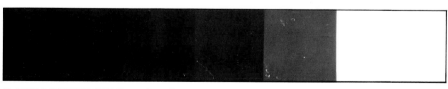

8 EXPOSE THE STRIP IN STAGES
Now we want to make another six exposures of one second each moving the card along to uncover another inch of the strip—and expose this for one second—each time. The easiest way to do this is to switch the light on and quickly move the card along each second. You can either count the seconds, or use a watch or clock. The digital ones are good for this. Do not expose all of the strip, however. Leave at least an inch unexposed. When you have developed this strip, you will have a grey scale extending in steps from black to pure white (the *unexposed* part being white) as shown above.
The next step in making a contact sheet is to process the test strip and find the exposure required.

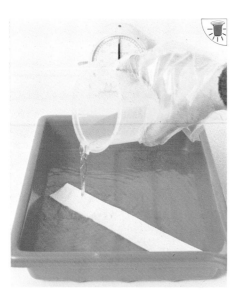

1 POUR IN THE DEVELOPER
This is a quick way to process a test strip and contact sheet using only one tray and a small amount of chemicals. Place the exposed test strip in the developing tray glossy side up. Then pour in the diluted Acuprint developer you have already made up and warmed to 20-22°C. (See Issue 106.) The symbol in the corner above means do this under safelighting.

2 ROCK THE DISH
Rock the tray every five seconds to agitate the solution while developing. This is to make sure the paper is always in contact with fresh developer. After one minute, check the temperature of the developer to make sure it is still about 20°C. You can stop developing after 90 seconds. If in doubt, develop for slightly too long rather than too short a time.

3 POUR OUT THE DEVELOPER
When the time is up, pour the developer back into its measuring jug—it will be used later to develop the contact. Stand the jug in a tray of hot water so it maintains the right temperature. The test strip should show a range of tones from pure white (the unexposed part) to full black. If not, make another test, giving more exposure if it's too light and *vice versa*.

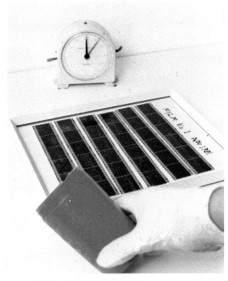

7 ARRANGE THE NEGATIVES
Place the negatives face down (that is, dull side up) on the glass as shown. We used a 10x12in (24x30cm) picture frame for this—this size is easy to handle and not too expensive. Wear cotton gloves, and handle negatives only by their edges. If you wish, you can write data on the front of the glass with a felt-tip pen (don't write on the negative side).

8 ADD THE PAPER
With the safelight on, take a full sheet of 10x12 (24x30cm) paper out of the packet. Place it shiny-side down on top of the negatives. Be careful not to disturb the strips as you do it. Then put the hardboard or thick card over the paper. Hold it down firmly and quickly turn over the whole sandwich to reveal the negatives ready for exposure (see step 6 above).

9 MAKE THE EXPOSURE
Place the frame on your worktop so it is the same distance from the safelight as the test strip was. Expose the frame in exactly the same way as you did before—either by removing the safelight cover or switching on a light. Time the exposure. The time is the one worked out from the test strip (see step 5 above)—the shortest time that produces a full black on the paper.

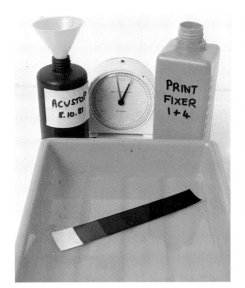

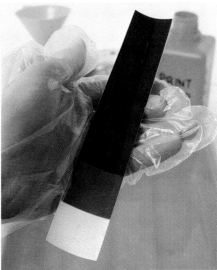

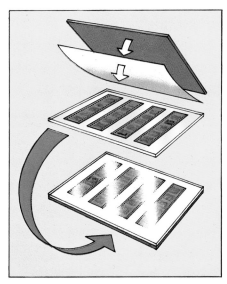

4 STOP AND FIX
Pour in the stop bath solution (which is also at 20-22°C) and rock the tray continuously for 30 seconds. Pour the stop solution back into its bottle. Pour in the fixer solution (also at 20-22°C) and again rock the tray for 30 seconds. You can now turn the light on. Fix for another 30 seconds (more if you want the strip to be permanent and return the fixer to its bottle).

5 ASSESS THE STRIP
Rinse the strip in water and examine it under white light (daylight is best). Start at the pure white step, and count the number of steps to the first step that is *completely* black. Multiply the number of steps by the exposure time for each step to find the exposure for the contact sheet. Here the sixth and seventh sections are fully black, so the time is 6 x 1 second or 6 seconds.

6 MAKING THE CONTACT
To make the contact sheet, the strips of negatives must be held in contact with a sheet of printing paper. To hold them flat and together it is best to sandwich them between a sheet of glass and a piece of thick board. A simple way to make this sandwich is to build it upside down, then turn it over to make the exposure to white light, as shown in the diagram above.

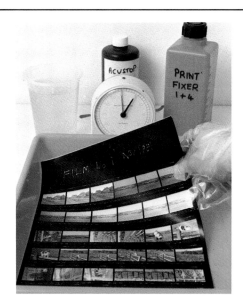

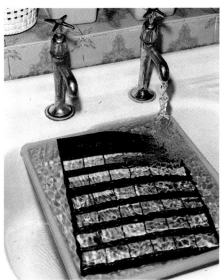

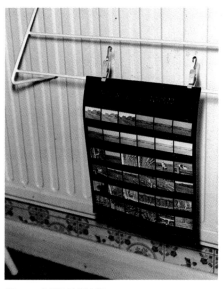

10 PROCESS THE SHEET
With the safelight still on, process the contact sheet using the same times, temperatures and agitation as you used for the test strip, except for fixing. As you want the contact to be permanent it must be fixed for five minutes (check the instructions for the fixer you are using). Pour away the developer you have used. Pour the fixer back into its storage bottle.

11 WASH THE CONTACT. . .
After fixing, wash the sheet in warm running water (20°C) for at least five minutes (check the instructions for the paper you are using). If you don't have running water at this temperature, wash the sheet in ten changes of water. Wash the sheet for 30 seconds in each change of water, rocking the tray all the time. Do not use hot water as it can damage the print surface.

12 . . .AND DRY IT
Hold the print up by the corner to drain off water, then blot both sides with kitchen paper for faster drying. Hang the print somewhere warm, where the air can circulate freely around it. If you hang it near a radiator it will dry quickly, but too much heat will make the print curl. Dry it gently! The contact sheet is now ready for filing with your negatives.

Black and white printing

The enlarger

To make your first properly enlarged black and white prints, you must have an enlarger. This is simply a device that projects and focuses an image of a negative on to a sheet of photographic paper.

It consists of a head containing a lamp to project the image, a lens to focus it, and some means of holding a strip of negatives. This head sits on a column, at the bottom of which is a baseboard with a holder for sheets of paper. By moving the enlarger head up or down, the size of the projected image is increased or decreased to give different sizes of prints, or different blow-ups.

The figures given in this series for enlarging and exposing are based on the enlarger having a 50mm lens (the most common focal length for enlarging a 35mm picture) and a 150 watt bulb. Colour enlargers may have weaker bulbs, so if you have one of these you will need to increase the exposure times.

Apart from an enlarger, you will need two pairs of tongs to handle the paper, a set of four processing dishes, size 10x12in (24x30cm), and a sufficiently large surface to work on. You will already have the rest of the equipment.

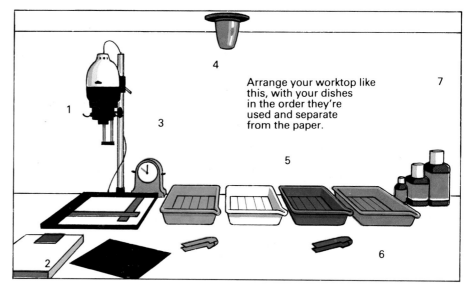

Arrange your worktop like this, with your dishes in the order they're used and separate from the paper.

WHAT YOU NEED
The essentials for enlarging are:
1) an enlarger with a baseboard and a paper easel on it to hold the paper flat;
2) the paper itself, and some opaque material for masking when exposing a test strip;
3) a timer or an accurate watch with a second hand;
4) a safelight.

To process the print you need:
5) three or four dishes, all 10x12in (24x30cm)—one each for developing, stopping, fixing and washing (if your darkroom doesn't have running water). Arrange the dishes in the order they are used, from left to right if you are right-handed;
6) two pairs of tongs to handle the paper;
7) the necessary chemicals.

4 FIND THE NEGATIVES
Open your file sheet and find the set of negatives you want to enlarge. Have the appropriate contact sheet filed opposite the negative sheet so you can find the negative you want by examining the contact sheet. This way, you don't have to take out a whole sheet of negatives to find the one you want. Make sure the strips are in the right order, though!

5 EXAMINE THE CONTACTS
The images on the contact sheet are too small for you to be able to judge clearly their sharpness and composition. Therefore, examine the contacts individually with a magnifier to pick out the best. For this, use a stand magnifier if possible. It gives a good-quality image and, if you stand it on the sheet, the image is automatically in focus.

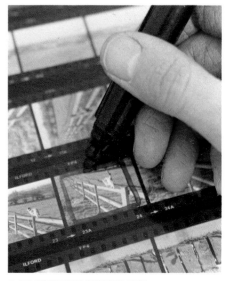

6 MARK THE CONTACTS
Mark the contacts of the negatives you want to enlarge with a Chinagraph, wax crayon or spirit-based pen. Use either black, blue or green so that it shows up under the orange-red safelight. When making a note of the negatives' numbers, be careful about the A's. Sometimes 23 and 23A come on the same negative, but in our example, 23A and 24 come together. This is negative 24 *not* 23A.

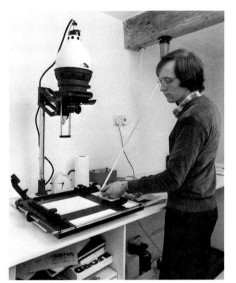

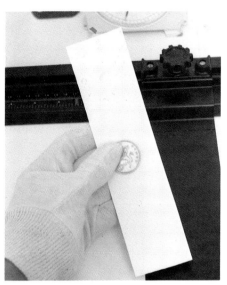

1 SET UP THE ENLARGER
Set up your enlarger on the worktop so that its baseboard is at least 3ft (1m) from the safelight. If possible, shield the baseboard from direct safelighting. Keep the paper somewhere convenient, but in any case well away from all the chemicals and processing trays. If you are cramped for space, keep paper on a shelf *above* the bench away from any risk of chemicals spilling onto it.

2 TEST YOUR SAFELIGHTING
Check your safelighting before you start—you won't be able to make prints with pure whites if it is not safe. To do this, place a coin on a spare strip of paper, preferably a soft grade. Leave this on the baseboard for at least three minutes—five minutes is a better test. Then process the strip as normal, except it does not need a thorough wash.

3 IS IT GOOD ENOUGH?
Examine the processed strip. No image on it means the lighting is safe; a grey image means that it's not. To trace a fault, repeat the test with the safelight off (ie. total darkness). If a grey image still appears, improve your blacking out. If not check that your safelight is not too near and that it has the correct wattage bulb in it.

7 CLEAN THE NEGATIVE
Pick a negative you want to print and remove the strip containing it, touching only the edges. Use gloves if possible, or handle it with a soft lens cloth. If it needs it, you can polish the shiny side of the film (the back) to remove scum marks by rubbing very gently with a soft cloth. Finally, dust both sides gently with a blower brush.

8 INTO THE CARRIER
Remove the negative carrier from the enlarger. Open it and insert the strip, shiny side up, with the top of the picture closest to you when the carrier is in the enlarger. Some enlargers have just a slit or a hinged head with no carrier, but the orientation of the film remains the same. Dust the carrier beforehand and avoid scratching the film as you load it.

9 LOAD THE ENLARGER
Put the carrier in the enlarger. Once it is in, *never* try to pull a strip of negatives through the carrier—you risk making tramline scratches on the film. Some enlargers allow the tension to be slackened so that a negative strip can be moved on from frame to frame. However, it is good practice *always* to remove the carrier to do this.

1 SET PAPER SIZE
Set the easel to take an 8x10in (20x24cm) piece of paper. This is a popular enlargement size, and most enlargers will blow up a 35mm negative this big. This size paper can be cut from your 10x12in (24x30cm) sheets, leaving you with strips for testing. Set the easel to be slightly smaller than the paper so it will hold it flat.

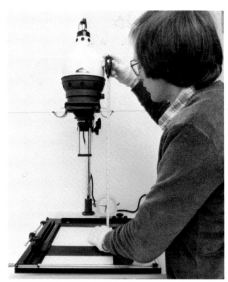

2 SET ENLARGER HEIGHT
Set the enlarger so that the negative carrier is 21in (53cm) above the baseboard. Enlargers and lenses do vary, however, and you may find an inch or so less gives the right size enlargement. Lock the enlarger head (if lockable) and turn on the enlarger lamp. Do not leave it on for more than a minute at a time or it may overheat.

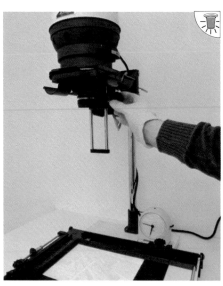

3 VIEW AND FOCUS
Switch on the lamp and you will see an image projected on to the baseboard. Open up the lens to its widest aperture, turn off the room light and switch on the safelight (indicated here by the safelight symbol). The image will probably be blurred. Focus it using the lens's focusing control—usually either by turning a knob or the lens.

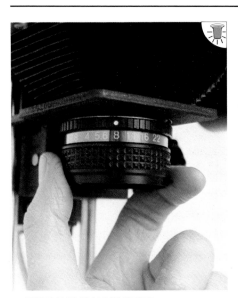

7 STOP DOWN THE LENS
Change the lens aperture from wide open (for focusing) to a smaller setting for the exposure. Set the aperture to f8, or f5·6 for small colour-type enlargers or ones with 75 watt bulbs. The smaller aperture improves sharpness and makes the exposures reasonably long, making them easier to time. Now turn off the enlarger light.

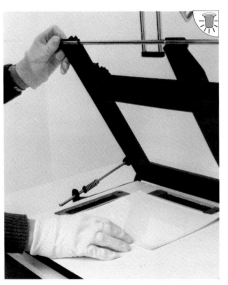

8 EXPOSE THE TEST STRIP
Place your test strip, shiny side up, over a typical averagely-exposed part of the picture. Do not choose sky or shadow areas but go for areas such as skin, grass or building detail. (We are using a full sheet here so that you can see the later steps more clearly.) The test strip is used to find out the correct exposure time.

9 EXPOSE THE WHOLE STRIP
Switch on the enlarger lamp and expose the test strip for two seconds if your aperture is f8. If your enlarger has a 75 watt bulb, give the strip a two second exposure at f5·6. For a small colour enlarger, give four seconds at f5·6, and double all the later exposure times as well. Use a watch with a second hand that's easy to see or a proper timer for this.

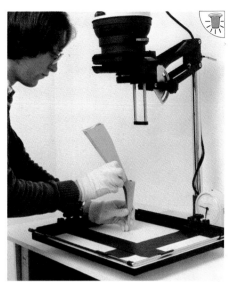

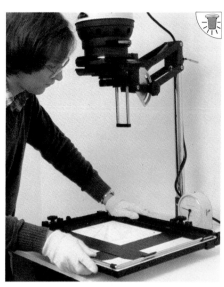

4 THE FOCUSED IMAGE

Keep moving the focusing control beyond the point of best focus and back until you are sure you have it exactly focused. For the best quality prints, you want to be precise in your focusing. As a guide, you should be able to see the grain of the negative clearly when the image is sharp. Also, any dust and fluff should stand out sharply.

5 USE A FOCUS FINDER

Use this device if you find it difficult to see exactly when the image is in focus. It's not always easy if your eyesight is poor or your enlarger has a low-power bulb. A fine focus finder magnifies part of the image and projects it up so that you can view it comfortably. Some types have high magnifications but you need good eyesight for them.

6 COMPOSE THE PICTURE

Move the masking frame until the picture area contains a suitable part of the negative. Do not try to compose the picture by moving the negative inside its carrier. Have the image slightly overlapping the frame of the easel. Check that the horizon and any uprights are parallel to the edge of the picture—unless you want a particular 'special effect'.

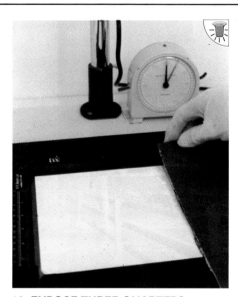

10 EXPOSE THREE-QUARTERS

Cover about a quarter of the test strip with card or heavy paper. Make sure the material you use is light-proof. You can use the inside of your photo packet if you wish, but check first that it's sealed properly. Give the uncovered part of the strip a further two seconds exposure. This exposed part will now have had a total of four seconds exposure.

11 EXPOSE HALF

Uncover the paper halfway and give an extra *four* seconds exposure. Note that you double the length of the exposure each time. This way you get a greater range of densities on the strip, which lets you judge better what the correct exposure time should be for the print.

12 EXPOSE A QUARTER

Covering three-quarters of the strip, give an eight-second exposure. You now have steps of two, four, eight and 16 seconds. One of these should be roughly correct, though you may need to pick a time midway between two steps. If you wish, you can have more than four steps, but an exposure time longer than 16 seconds is rare.

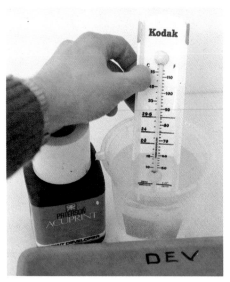

1 MAKE UP DEVELOPER

Make up fresh print developer at 22°C. You will need at least 500ml (450ml water plus 50ml concentrate) to cover the paper. This amount will process about 30 8x10in (20x24cm) prints. Then pour the solution into a clean developing tray marked 'DEV'. If you have already exposed the test strip, do this under safelighting. If not, use ordinary white light.

2 POUR OUT THE STOP AND FIX

Have your stop-bath and fixer in a bowl of warm water to warm them to about 20°C. (The temperature is not that critical but should be over 12°C in any case.) Then pour the stop into a dish marked 'STOP' and the fix into one marked 'FIX'. If the dishes are coloured and marked like this, then you won't mix them up. Line them up from left to right (if you are right-handed).

3 START DEVELOPING

With the safelight on, quickly slide the exposed test print under the developer surface, emulsion side up, making sure that it is covered as rapidly and evenly as possible. If necessary, rock the dish slightly to make the developer wash over the print as you insert it. Do not touch the developer with your fingers; either use gloves or let go of the print.

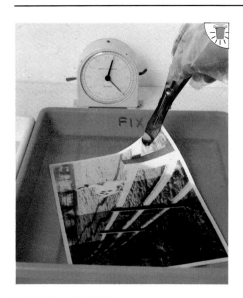

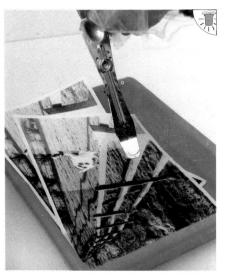

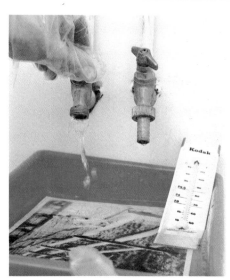

7 INTO THE FIXER

Put the print into the fixer, once again agitating to make sure that the entire surface is flooded with solution. This becomes very important later on, when you may want to process several prints in a row and two or three could be in the fixer at the same time. Press the print down with the flat of the tongs. Turn the print face down and leave to fix for up to five minutes.

8 STORE IN WATER

Remove the fixed print and store it in a dish of plain water at 15-20°C. Agitate the print when you put it in, then leave it to soak. If you wanted you could wash the print straight away (step 9), but storing allows you to keep several prints then wash and dry them together. Also, you will need to store prints if your darkroom doesn't have running water.

9 WASH THE PRINT

Wash the prints in running water for at least two minutes. The water need not flow strongly, but make sure that it flows over all the emulsion surface. Check the temperature; if it is below 16°C continue washing for ten minutes, and if at 10°C for half an hour. If you are washing more than one print, keep rearranging their order in the dish to stop them from sticking together.

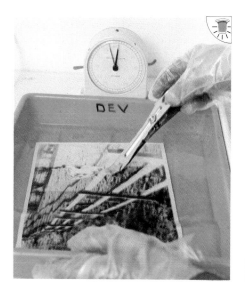

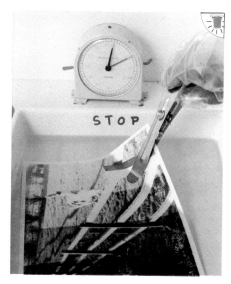

4 AGITATE FOR TWO MINUTES
Start the timer. Let the print soak for ten seconds, then gently rock the dish by lifting the near end slightly once every few seconds, setting up a gentle washing of the solution over the print. Do this at least twice a minute, and preferably every 15 seconds, for two minutes. If the print tends to float, carefully press it down with a pair of tongs—but do not scratch the print.

5 DRAIN THE PRINT
Lift the print out of the developer without splashing. Use print tongs for this and grip the print firmly because it will be slippery. Let it drain for ten seconds. At this stage, the print should be fully developed and look like the example here. Metal, plastic or bamboo tongs are all suitable, but take great care with the emulsion—it is easily damaged.

6 INTO THE STOP-BATH
Slide the print carefully into the stop-bath, making sure that all the print is covered. Agitate by rocking the dish, then rinse the tongs in plain water and put them back in the developing dish. With a second pair of tongs, lift the print out of the stop-bath and drain it as before. These tongs will only be used for the stop and the fixer.

10 SPONGE OFF SURPLUS WATER
After the wash, speed the drying by dabbing surplus water off the emulsion with a wad of clean dry kitchen paper. Do this straight after the print has been taken from the wash, not when it has partially dried. A sharp tap or shake also dislodges water droplets, but avoid splashing nearby areas if you do this. You can also wipe the print with special rubber-jawed tongs.

11 HANG UP TO DRY
Finally, hang the print up somewhere where you don't mind water droplets falling—place a dish underneath if necessary. Make sure the peg or clip that you use only touches the white border of the print. The print should be dry in about two to five minutes with heat drying, or in 30 minutes if left to dry naturally in a warm, dry room.

PROCESSING TABLE FOR RC OR PE (PLASTIC COATED) PAPERS

1	Expose the paper		
2	Develop Agitate every 15sec	2min	22°C
3	Drain	10sec	
4	Stop-bath	15sec	20°C
5	Drain	10sec	
6	Fix Agitate for 30sec Turn sheet over	5min	20°C
7	Drain Store in water		15-20°C
8	Wash in running water	2min 10min 30min	20°C 15°C 10°C
9	Drain and sponge off water		
10	Dry		

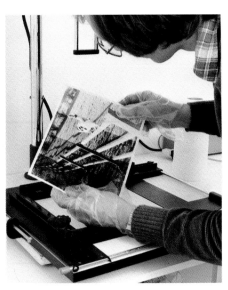

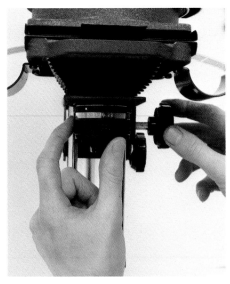

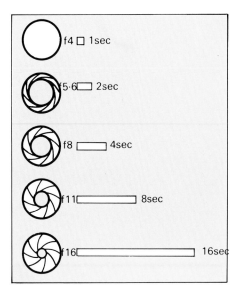

f4 ☐ 1sec

f5·6 ☐ 2sec

f8 ☐ 4sec

f11 ☐ 8sec

f16 ☐ 16sec

1 EXAMINE THE TEST STRIP

Wait for your test strip to dry, then assess its quality and exposure. It should have a full range of tones from clear white to pure black. Hold the print under your enlarger's light and see which step had the best exposure. Pick one which just shows detail in the whites and shadows and has good middle tones. Here, the two middle strips were both slightly 'off'.

2 ADJUST THE EXPOSURE

Work out the correct exposure time. Here, it is between the four- and the eight-second steps, so six seconds is correct. Check that the print was sharp and if necessary refocus at full aperture. For the correct exposure, you needn't alter the time, instead you can adjust the aperture. Six seconds at f8 is near enough equal to four seconds at midway between f8 and f5·6.

3 APERTURE AND EXPOSURE TIME

If you want to change the aperture, for example, stop down to increase sharpness, there's a simple relationship between aperture and exposure time. Increase or decrease the aperture by one stop and you must halve or double the exposure time, respectively, to get a correct exposure. For ½-stops, increase or decrease the exposure by half.

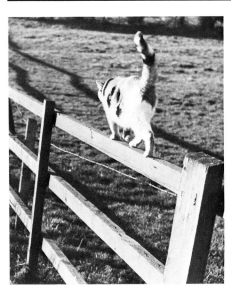

THE CORRECT RESULT

This picture was shot on Ilford FP4 in low sunshine using 1/250 at f8. The print was made on Grade 2 Ilfospeed and has been made slightly light to keep the sunny feel of the shot. Except for the brightest fur on the cat, this picture has good detail everywhere, including shaded areas. The following pictures show some typical mistakes.

UNDER-EXPOSURE

This was given only half the required exposure during printing—three seconds. Notice the lack of true blacks. Even if the print was developed for twice the normal two minutes it would not look right. Under-development gives a similar result but the whites are greyer and the picture looks 'flat' rather than 'bright' like the one here.

OVER-EXPOSURE

Over-exposure during printing gives a very dark result with no detail in the shadows. This picture had twice the recommended exposure. Again, you cannot correct this mistake by under-developing. A similar effect can happen if you over-develop, but only if you leave the print in the solution for more than normal times. The print will frequently be stained as well.

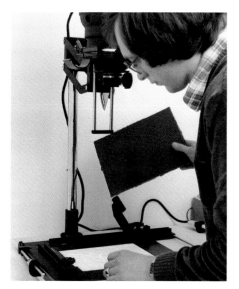

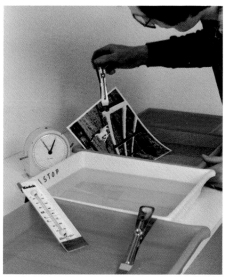

4 EXPOSE THE PRINT

Insert a full sheet of 8x10in (20x24cm) paper into the easel, close it and make the exposure that you have decided upon. We chose six seconds at f8. Use a blank card under the lens to expose the paper. This is the best way because it avoids vibrating the enlarger. You can also make the exposure with a switch in the enlarger circuit.

5 PROCESS THE PRINT

Process the print following the procedure you used to develop, stop and fix the test strip. Check first that the temperature of the developer is above 20°C. The final print will look darker under safelighting than the dry test strip did under white light. But resist the temptation to lighten the print by shortening the developing time. It will look normal in white light.

6 WASH AND DRY

Wash the print under running water and dry it as you did the test print. Then check it to see if it's as good as you hoped. If not you can always adjust the exposure slightly and make another print, but it's not usually necessary. The picture above is typical of the quality you should get using the materials, methods and processing described here.

OUT OF FOCUS

This is an exaggerated example; if you get this, your enlarger's focusing mechanism probably slipped. On a well-focused print you should be able to see the granular structure of a coarse-grained negative clearly enlarged on the paper. If not, your focusing was poor or your lens not a good one. You should also be able to see any dust and scratch marks from the negative.

STAINING

Purple-yellow and other kinds of stain on the print can occur if you forget to use a stop-bath, or if it's exhausted. Similarly, using exhausted fixer causes prints to darken or turn yellow when they are exposed to light. This also happens when part of a print is not immersed in the fixer. Promptly refix in fresh solution. This will remove slight stains, but not serious ones.

UNEVEN DEVELOPMENT

This happens if the print floats to the surface of the developer when you first put it in and you forget to rock the dish or push the print down with the tongs. If you see this happening, immerse the print fully and extend the developing time to three or four minutes to even out the development. Do not develop for longer than this or the whole print may become too dark.

Processing colour slides

Doing it yourself

No longer do you have to wait days or even weeks to get your colour slides back from the processing lab. You can process them yourself at home in less than an hour, and it's easier than you think. You don't even need a darkroom providing you have a changing bag.

Not only is home-processing quicker—it can be cheaper. The results should be at least as good as those of medium-cost developing services. Because your film will be hand-processed instead of being fed through a machine, you avoid the scratches and marks too often left by processing labs.

You can also change the film speed rating to uprate most slide films or correct for exposure errors, but first you should learn how to handle normal development.

There are several different processing systems; we shall be showing you how the Kodak E-6 method works.

The easiest way to buy the chemicals you need is to get them in kit form. There are several makes on the market, and we shall be using the Unicolor kit. Apart from the chemicals, you will probably already have all the necessary equipment if you do your own black and white processing at home.

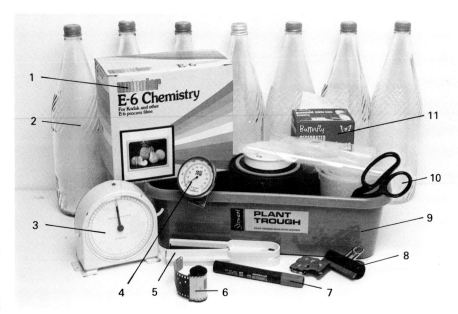

WHAT YOU NEED

1 Unicolor kit to make one US quart
2 Seven 1 litre bottles thoroughly cleaned out—preferably ones with plastic caps, *not* metal ones as used here
3 Minute-seconds timer
4 Accurate thermometer
5 Squeegee tongs
6 Roll of exposed film processable in E-6 chemicals
7 marker pen
8 Film clips
9 Water-bath (both the chemicals and the tank need to be kept at a temperature close to 38°C)
10 Pair of scissors
11 Labels

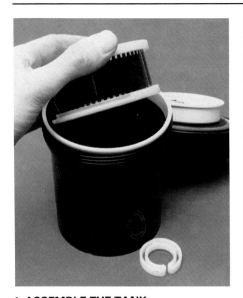

4 ASSEMBLE THE TANK
Push the spiral on to its central pillar and slide down the retaining clip to hold the spiral firmly in place. Make sure it is secure because you will be agitating this film many more times than with black and white development. Place the whole unit inside the tank. Fit the plastic sealing ring to the top of the tank, then screw down the lid.

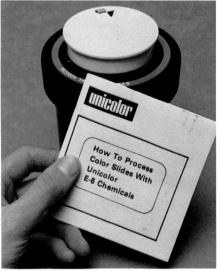

5 READ THE INSTRUCTIONS
Switch on the lights and put the loaded developing tank to one side. Find the Unicolor instruction leaflet and carefully read it from start to finish—it is very thorough and very clear. On no account open or mix any of the solution bottles until you have read the instructions and checked the kit to make sure that all the items are there.

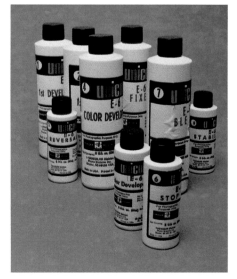

6 CHECK THE SOLUTIONS
Carefully take all the bottles out of the kit and check that none leaks. All the bottles will have a coded date stamped on them (see instructions). Check that it hasn't lapsed—Unicolor will replace out-of-date bottles free of charge, provided they haven't been opened. Count the bottles: there should be five large ones and four small ones.

1 MAKE SURE IT'S E-6
Check that the film cassette has E-6 written on it like this roll of Ekta-chrome – nearly all slide films are Process E-6. *Do not try to process these films by this method: Tacma, Kodachrome or Orwo. Films you can process in E-6 chemicals* include Ekta-chrome, Fujichrome, Ilfochrome 100, Agfachrome 200, 3M Color Slide and any brand clearly marked 'E-6'.

2 CHECK THE KIT
Check to make sure that you have the 1 quart kit. Unicolor also market a 1 pint size. This has different mixing instructions, though it works the same way. These quantities are US measures, not Imperial. All quantities are also given in metric in the instructions, so stick with these to avoid confusion. Only metric quantities will be used here.

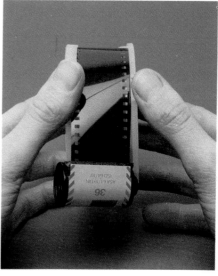

3 LOAD THE SPIRAL
First load your roll of film into the spiral of a developing tank (for details of how to do this, see Issue 101, pp2802-3). Load the film in a changing bag or in total darkness. Use scissors to cut off the film at the end because it may be hard to tear. Avoid handling the film: the dull emulsion side is very sensitive, so touch only the shiny side.

7 GET SOME WARM WATER
Wash your solution bottles, if you have not already done so, even if they are new. Have some bottle labels at hand so that you can label each solution as you make it up. Use a waterproof marking pen for this. With a 2 litre jug make up some water at 43°C. All the processing solutions will be mixed with water at this temperature.

8 MEASURE OUT THE WATER
Pour 480ml of this warm water into a measuring jug. This is sufficient to dilute all of the first developer. If you prefer, you can make up half of the concentrates and store the solutions in half-size bottles. This is the method recommended in the instruction booklet. Diluting all of the chemicals in one go is more accurate, however.

9 POUR IN THE WATER
Pour the measured amount of water into one of the bottles. Use a funnel and take care not to spill any. Label the bottle as shown in picture 8 and make eight strokes on it. By crossing these off, you will be able to count the number of films processed. The quart kit will process eight rolls and you have to increase the processing times after you have done half of them.

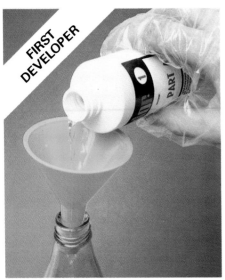

1 ADD FIRST DEVELOPER PART A

Find the Unicolor bottle marked with a '1' in a white circle. This contains First Developer Part A. Do not mistake it for bottle 4 which contains *Colour* Developer Part A. Add the contents of bottle 1 to your glass bottle containing 480ml of water at 43°C (see Issue 112). Use a little of this solution to rinse out the Unicolor bottle (to get the dregs). Pour this back into the glass bottle.

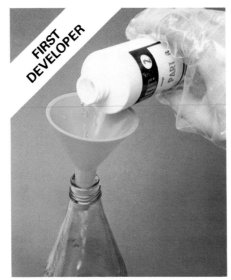

2 ADD PART B

Take bottle 2. This contains Part B of the First Developer. It is in a large bottle, unlike Colour Developer Part B which is in a small bottle. Add the contents to the same bottle that you poured Part A into. Again, rinse out the Unicolor bottle with a small amount of the solution. Now tightly cap the solution bottle and rinse the funnel thoroughly in clean water.

3 MAKE UP REVERSAL BATH

Pour 900ml of water at 43°C into one of your glass solution bottles. To this add the contents of bottle 3, marked Reversal Bath. Rinse out the Unicolor bottle with the diluted solution, in the same way as before. Then screw on the top of the bottle tightly, label and date it clearly. Again, rinse the funnel thoroughly in running water.

7 DILUTE THE BLEACH

Add the contents of bottle 7, the bleach, to 720ml of water at 43°C. Pour the bleach very carefully because it is corrosive and will stain if splashed. Wear protective gloves when you mix Unicolor chemicals. They could cause irritation if they come into contact with your skin. If this does happen wash the chemical off quickly with plenty of water.

8 MIX THE FIXER

Add the fixer, in bottle 8, to 720ml of water at 43°C. Mix the solution thoroughly—if it is simply poured in it forms a layer separate from the water. Some E-6 slide process kits have the bleach and the fixer combined as one solution, but in the Unicolor kit they are kept separate. This means the processing takes longer, but it can be more reliable.

9 MIX THE STABILIZER

Take 900ml of water at 43°C and make up the stabilizer solution from bottle 9. This contains formaldehyde and is poisonous. Also its vapour can damage films and photographic paper, so cap the solution bottle firmly and rinse the concentrate bottle well. All the Unicolor concentrate bottles should be rinsed and recapped. Keep them for reference until you've used the kit.

4 ADD COLOUR DEVELOPER PART A
Take another solution bottle (labelled and dated) and add to it 660ml of water at 43°C. Take bottle 4—marked Colour Developer Part A. Pour it into the solution bottle. Like the first developer, the colour developer comes in two parts. Again, rinse the Unicolor bottle with some solution, then tip it into the glass bottle. Don't bother washing the funnel.

5 ADD COLOUR DEVELOPER PART B
Find bottle 5, Colour Developer Part B—it's a small bottle. Pour its contents into the same solution bottle that you poured Part A. You will notice that a reaction takes place immediately and a dark grey-brown cloud forms. This is normal. Mix the solution thoroughly and its colour changes to purple-brown. Rinse the bottle and wash the funnel.

6 MIX THE STOP-BATH
Pour the contents of bottle 6, the stop-bath, into a solution bottle containing 900ml of water at 43°C. Again, label this bottle and date it. Dilute the chemicals in the order shown here. It's the same order as used in processing, so contamination between neighbouring chemicals is not too serious. If you change the order, contamination could mean failure.

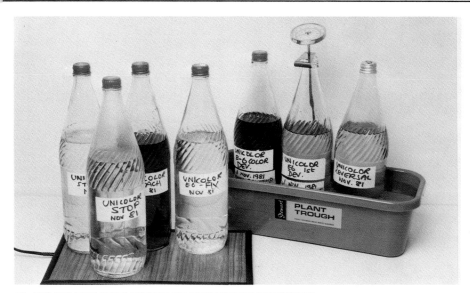

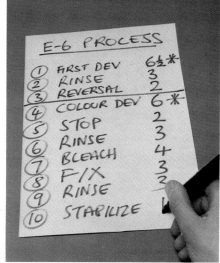

10 WARM THE SOLUTIONS READY FOR PROCESSING
You have seven solution bottles, all sealed and clearly labelled and dated. Before you begin processing, warm them up to their working temperature of 38°C. One way to do this is to place them on an electric heating pad of the type used for home winemaking. You could leave it on to keep the solutions ready for use, but remember that high temperatures shorten storage life.

Alternatively, place the solutions in a bowl of warm water. Any bowl will do so long as it's large enough to hold the bottles. This method is better for raising the temperature quickly to the required level just before processing. If you use a water-bath make sure you write the labels on the solution bottles with a spirit marker.

11 MAKE A CHART
Pin a large chart like this on a wall near your processing area. It shows the order in which you use the chemicals and the times for each step. The two steps marked with an asterisk are the only ones where precise temperature control is needed—38°C plus or minus ¼°C. The rest have to fall within 33-39°C. The line after step 3 means the tank can be opened then.

35

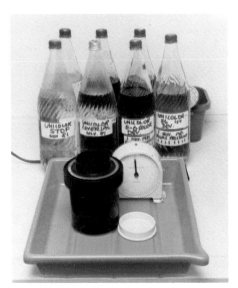

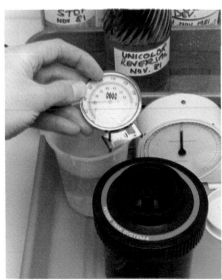

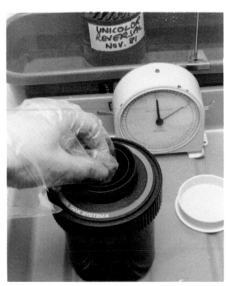

1 WARM THE SOLUTIONS
Before you start processing put as many of the solution bottles as possible into a bowl of warm water to bring them up to a temperature of 38°C. Alternatively, warm them with a heating pad (see Issue 113). Stand your tank in a developing dish, then if you spill any chemicals you won't stain your clothing or the worktop.

2 CHECK THE TEMPERATURE
Pour 300ml of first developer into a clean measuring jug—do not confuse it with the colour developer! Check that its temperature is close to 38°C, the tolerance is only ¼°C either way. In a cold room its initial temperature should be 39°C. Use a special colour developing thermometer to do the measuring, since ordinary spirit thermometers are not accurate enough.

3 START DEVELOPING
Pour the developer into the tank evenly but quickly. Set the timer going straight away. Tap the tank sharply on your worktop to dislodge any air bubbles that may be on the film surface. Do not agitate by inverting the tank at this stage, however. If you do it will cause more air bubbles to form. Twist the rod to agitate the solution for 15 seconds.

7 MARK OFF THE FILM
On the first developer bottle label, cross off one of the marks to show that you have just developed a film. It is very important that you do this each time a film is developed, so do it immediately after you've started washing the film. Use a spirit marker pen for this; then the ink will not be washed off by water or chemicals. Meanwhile warm up your reversal bath.

8 MEASURE OUT THE REVERSAL
Check that the reversal bath is at about 38°C and pour out 300ml of it into a measuring jug. The temperature for this stage is not as critical as it was for the first development. It needs to be between 33-39°C. The timing, however, has to be exact. The reversal bath must be in the tank for two minutes, excluding the time taken to pour it in and out.

9 POUR IN THE REVERSAL
Pour the reversal bath into the tank, as before, start the timer and give the tank a sharp tap on your worktop to dislodge air bubbles. Then agitate the tank with the rod, but when the timer shows 10 seconds leave the tank to stand for the remaining one minute and 50 seconds. Meanwhile have your colour developer warming in the water-bath; this will be the next stage.

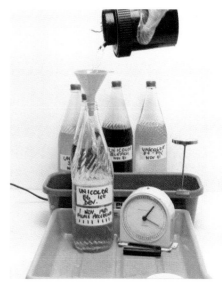

4 INVERT THE TANK
When 30 seconds is up, agitate the solution by inverting the tank. Continue doing this once every 15 seconds, inverting the tank just once each time. Wear gloves when doing this to protect yourself against the developer solution. The first development takes 6½ minutes, including the time taken to drain the film at the end.

5 PREPARE WARM WATER
While the film is developing fill a large jug with warm water. It needs to be between 33-39°C. You will be using it for the water rinse after the first development. Don't forget to keep inverting the tank every 15 seconds while you are preparing the water. When the film has been developing for 6¼ minutes start pouring out the developer.

6 POUR BACK THE DEVELOPER
Pour the developer back into its original bottle, using a clean funnel. Do not discard it! The first developer will process up to eight rolls of film, so you must keep all of the solution. Immediately after pouring out the developer rinse the tank with your warm water and keep changing the water six times during the next 2-3 minutes; the exact time is not important.

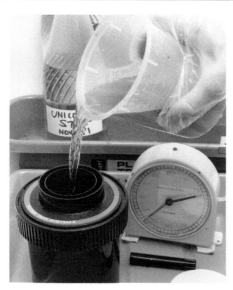

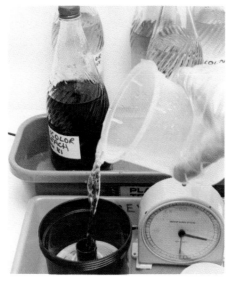

10 POUR IN THE COLOUR DEVELOPER
When exactly two minutes is up pour the reversal bath back into its bottle and pour the colour developer into the tank—check first that its temperature is between 37.2-38.3°C. Do not rinse the film between these two stages. Leave the colour developer in the tank for at least 6 minutes—the time need not be accurate. You can now open the tank.

11 ADD THE STOP-BATH
Pour the colour developer back into its bottle. Then add the stop-bath to the tank, after making sure that it's between 33-39°C. Agitate the tank continuously for the first 15 seconds and then for two seconds in every 15. Meanwhile get some water ready at 38°C for rinsing. Pour the stop-bath back into its bottle after one or two minutes; the time is not critical.

12 RINSE WITH WATER
Fill the tank with your warm water and agitate using the same timings as you used for the stop-bath. Keep agitating for two or three minutes. Insufficient rinsing causes magenta stains on the film, so use two or three changes of water if you're not sure. Have your bleach and fixer warming up to the correct temperature while you're rinsing.

1 ADD THE BLEACH
Check that the temperature of your bleach solution is between 33-39°C, then pour it into your developing tank. Agitate it by twisting the rod for the first 15 seconds and repeat for 2 seconds in every 15. Keep this up for 3-4 minutes. The timing is not critical—if in doubt keep the bleach in the tank for slightly longer. Return the bleach to its bottle.

2 ADD THE FIXER
Next, pour in the fixer (after first checking that it's between 33-39°C) and give it the same pattern of agitation that you did the bleach. Pour the fixer back into its bottle after 2-3 minutes, though again the time can be extended slightly if you wish. During this stage prepare 2 litres of water at 33-39°C, or adjust your water supply to this temperature.

3 RINSE THE FILM
Fill the tank with your warm water, agitate well, then pour it away and replace with fresh water. Continue doing this so that the film gets six washes with warm water in 2-3 minutes. Alternatively, if you have a supply of running water, wash your film with this, using a rubber tube to direct the water into the tank. Again, wash the film for 2-3 minutes.

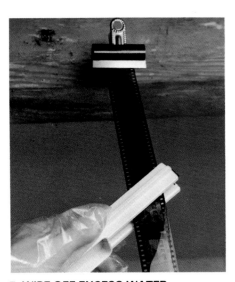

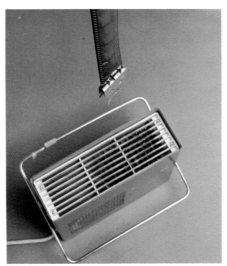

7 WIPE OFF EXCESS WATER
Make sure the film is firmly gripped at the top—hold it if necessary. Wipe off excess water, either with a pair of squeegee tongs or with the inside of two fingers pre-wetted to avoid scratching the film with dry skin. Use one continuous downward wipe only. *Never* be tempted to wipe part of the film again, even if drops are left behind.

8 DRY THE FILM
If your room is reasonably dust-free put a 1kw fan heater under the film, aimed upwards to blow it dry. Have the fire slightly to one side to avoid drips falling on it. The film will dry in 5-10 minutes. If the room is too dusty just leave it hanging to dry. It will take about 40 minutes. Do not enter the room during drying—this only stirs up dust and fluff.

9 IS THE FILM DRY?
When the time is up examine the film to check that it's dry. Handle the film with clean dry hands and test the edges and blank frames to make sure they are really dry. When the film is partially dried it should lose its dark milky appearance and look quite normal. While the film is drying prepare a clean work surface ready to transfer the film onto.

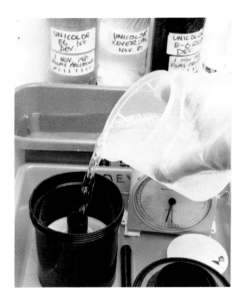

4 ADD THE STABILIZER
After the rinse pour in the stabilizer and agitate for 10-15 seconds. Then leave it in the tank for a further 20 seconds to one minute (the timing is not critical) and return it to its bottle. To ensure best results have the stabilizer warming up the processing temperature of 33-39°C beforehand. (If you prefer you *can* carry out this stage at room temperature.)

5 REMOVE THE FILM
Carefully unwind the film from its processing reel, handling it only by the edges or the end. If there is any risk of dropping the film, support the reel in the tank, as shown here, while you do this. Be particularly careful with the inside surface. This is the emulsion side and is still very fragile. The outside surface is much more resistant to damage.

6 HANG IT UP
Firmly clip the end of the film and hang it from a hook at least 6½ft (2m) above the floor. Attach a weighted clip to the bottom of the film to stop it curling up while drying. At this stage the film does not look clear or bright; it looks murky and slightly milky. This is normal and does not mean that you have processed the film wrongly.

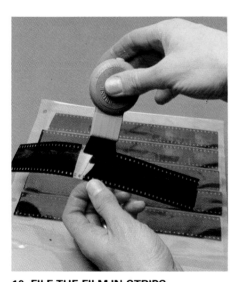

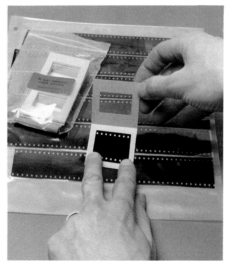

10 FILE THE FILM IN STRIPS
Lay the film lightly coiled on your work surface and cut it up into strips of six exposures—it's more manageable that way. You can now either mount the slides straight away or file the strips in a negative sheet to protect them. Before filing, if necessary dust the strips with a blower brush so that no particles of dust or grit scratch them.

11 MOUNT THE SLIDES
Cut out from the strips the individual frames you want to mount. Hold each frame carefully between two fingers so that you touch the edges only and position it over one of the windows of the mount. Then firmly seal or clip down the other half of the mount. Card mounts are cheaper than plastic ones, but the latter can be re-used if you want to replace one slide with another.

12 MARK THE MOUNT
Record details about the slide on the mount—before you forget! You can include the date and place, camera, lens, exposure details and your name. Record also any details about the subject. With plastic mounts use a marker pen or self-adhesive labels for permanence. If you're going to project the slide mark a coloured dot in the bottom left-hand corner as you view it.

Colour printing from slides

The Cibachrome method of printing

One of the great advantages of shooting slides rather than prints is that it's much easier on your pocket because you don't have to print every frame. Against this, however, prints are much more convenient to view than slides.

To get the best of both worlds, many people shoot with slide film then have the few really good pictures on that roll (there's only ever a few!) printed individually. This can work out cheaper than shooting all your pictures on negative film, but it's still a relatively expensive process.

The cheapest and most rewarding way is to print them yourself directly from the slides using one of the many kits now available for this purpose. We shall be showing you how to use one of these kits—Ilford's Cibachrome-A—starting from the moment you open the pack and taking you right through to the finished print.

Before you start, dig out five or six slides you want to print. Choose well-exposed, brightly lit, colourful slides rather than dark and contrasty ones. You will find these much easier to print well with the Cibachrome process.

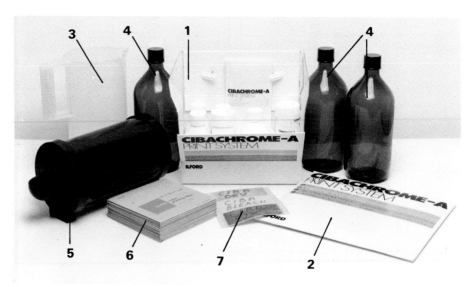

WHAT YOU NEED
Much of the equipment you need you will already have if you do your own black and white processing. Special items for Cibachrome printing are:
1 a 1 litre Cibachrome-A processing kit;
2 a packet of 10x8in Cibachrome-A type paper, either glossy or pearl;
3 a large measuring jug for mixing the chemicals;

4 three 1 litre bottles for storing the diluted solutions;
5 a print processing drum. Many different companies have these; for example, Ilford, Paterson, and Durst;
6 a set of colour printing filters. Your enlarger will probably have a drawer for taking 3in square filters. The ones shown here are the larger Kodak filters;
7 labels, one for each bottle.

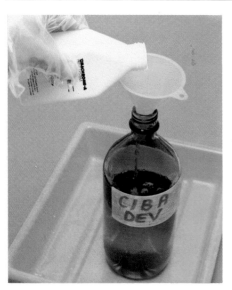

4 ADD DEVELOPER PART A
Add the developer part A to the storage bottle, using a funnel to prevent splashing. Wear rubber or plastic gloves when doing this and at all stages of using Cibachrome chemicals. Rinse out the Cibachrome bottle with a small amount of solution and return this to the storage bottle. Now rinse the funnel and drip tray in water to prevent contamination later on.

5 ADD DEVELOPER PART B
Pour developer part B in the storage bottle, again using the funnel and drip tray. Rinse out the Cibachrome bottle in the same way as before to make sure you catch all of the concentrate. Then rinse out the funnel and drip tray, and cap the storage bottle securely. The part B solution is yellow and so therefore is the final developer solution.

6 MIX THE DEVELOPER
Mix the developer solution by inverting the bottle a few times. It is most important that the developer is thoroughly mixed, particularly if you intend to use it straight away. Then put the developer bottle to one side and discard both the empty Cibachrome bottles. Rinse the drip tray and the funnel again and wipe down your work surface.

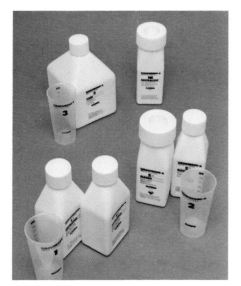

1 OPEN THE KIT

Check the contents of your kit. It should contain six bottles of chemicals, three small measuring cups and an instruction leaflet. The chemicals consist of Developer parts A and B, Bleach parts A and B, a large bottle of Fixer and a bottle of Neutralizer. The cups are labelled, 1, 2 and 3, and are used only with Developer, Bleach and Fixer, respectively.

2 GET READY TO MIX

First read the instructions carefully. Then take a clean, 1 litre brown glass or plastic bottle. Label it DEV—we are using a coloured label here to make identification easier later on. You will also need a thermometer to check the temperatures of the liquids when you mix them, a funnel and a drip tray to work in because the chemicals can stain work surfaces.

3 PREPARE THE WATER

Pour out 600ml of water into a measuring jug and check that its temperature is about 28oC. This need not be exact—the working temperature is 20-28oC—but allow for your chemicals and the bottle being cold and so reducing the temperature of your final solution. Pour this water into your solution bottle.

7 PREPARE WATER FOR BLEACH

Take 850ml of water at 40-45oC. It needs to be this hot otherwise the bleach powder will not dissolve. Have the water in a large measuring jug. That way it's much easier to dissolve the bleach than if the water were in a bottle. Label a second storage bottle for the bleach bath, using a different colour label to help you identify it later on.

8 DISSOLVE THE BLEACH PART A

Add the bleach part A slowly to the water, stirring constantly. Take great care not to allow lumps to fall in and cause splashing. Keep stirring the solution until all the bleach has dissolved (a fine residue after 5-6 minutes is quite acceptable). Here we have used the central pillar of a developing tank as a stirrer, but any long plastic implement will do.

9 ADD BLEACH PART B

Add the bleach part B (it's an orange liquid) and stir the solution. Then pour the bleach into its bottle as quickly as possible, avoiding splashes. It has a sharp smell, so you must do this in a well-ventilated area (as you should whenever you mix chemicals). Cap the bottle and now rinse thoroughly all measures, stirring rod, the funnel and the drip tray.

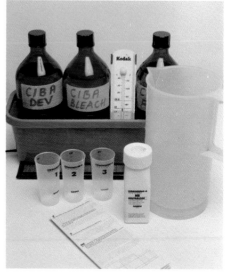

1 PREPARE WATER FOR THE FIXER
Last week, we prepared diluted solutions of the developer and the bleach from the Cibachrome-A kit. One more chemical remains to be diluted; the fixer. First, prepare 400ml of clean water and check that its temperature is about 30°C. The exact temperature is not critical. If your fixer concentrate is very cold have your water at a higher temperature, say, 40°C.

2 MIX THE FIXER
Take a 1 litre bottle and label it FIX, using a brightly coloured label so that the bottle can be easily identified later on. Place the bottle in a drip tray and pour your water into it. Then add the concentrated fixer. Cap the bottle securely, then rinse out all the measuring jugs, funnels and trays you have used for the mixing. Also wipe down your work surfaces.

3 WARM THE SOLUTIONS
Put your three solution bottles into a bowl of warm water to keep them at a temperature of 24°C. Alternatively, place them on a heating pad such as the type used in home winemaking. (Both the water bath and the pad are shown here.) Then put all this to one side, along with your three measuring cups, the bottle of neutralizer powder, a 2 litre measuring jug and the instructions.

7 SET UP YOUR ENLARGER
Get your enlarger set up and ready for printing. For Cibachrome printing, you don't need a special colour enlarger. You will get perfectly good results with an ordinary black and white enlarger, such as the one shown here. It is old-fashioned but there are still many models like it. Your enlarger doesn't even need to have a filter drawer.

8 DROP IN THE FILTERS
If your enlarger has no filter drawer, simply open the lamphouse top and drop them in on top of the condenser glasses. (Cut a disc of card, to fit the round condenser top, with a square opening for the filter. This stops white light at the filter edges diluting colour from the filter.) For test purposes filters can also be used *under* the lens, but this can lower the sharpness of the print.

9 IN THE DRAWER
Your enlarger may have a special tray lying between the lamp and the film carrier called the *filter drawer*. If so, slide it out and drop your filters in. If necessary trim the filter to make it fit. Filters come in various different sizes, and filters drawers may vary from 75mm square to 125mm square. this one takes 95x125mm, whereas the filters are 125mm square.

4 CHECK FOR PAPER FILTRATION

Look at your packet of Cibachrome-A paper. On it you will find figures showing what strengths of filter are usually needed to produce the correct colour print from a particular type of film and that particular batch of paper. This is to compensate for the slightly different colour qualities between different batches of paper and between different makes of film.

5 WHAT THE NUMBERS MEAN

Since we are using Ektachrome film the numbers we need are:

Y	40
M	00
C	05

This means we need a yellow filter with a strength of 40CP (colour printing) units and a cyan (blue-green) filter with a strength of 5 units. Find these filters from your set.

6 TAKE OUT THE FILTERS

Open the filter packet and inside you will find a sheet of coloured plastic or gelatin. Very carefully remove it, handling it only by its edges. Notice that the filter value is printed on the edge. You may need to cut your filters later on so they can be fitted more easily into your enlarger. If so, never cut off this value. Without it, it's very hard to judge a filter's strength.

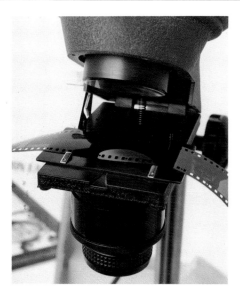

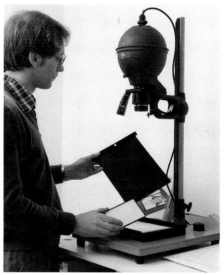

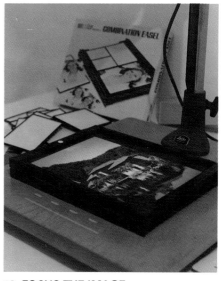

10 INSERT THE SLIDE

Find the strip of film that contains the frame you want to print. It is better to make prints from unmounted strips rather than mounted frames, because many enlargers don't have the facility to handle mounts. Dust the strip carefully then insert it into the film carrier, glossy side up and with the bottom of the scene away from you for landscape formats.

11 POSITION THE EASEL

Place your paper easel beneath your enlarger, but do not load it with paper yet. The easel will hold the paper in place and keep it flat. Here we are using a Unicolor Combination Easel. This easel has divides for masking off parts of the paper, and it has a darkslide cover so that lights can be switched on while you have a sheet stored inside. Remove this darkslide and keep it nearby.

12 FOCUS THE IMAGE

Switch on the enlarger light and move the lamphouse up or down until you have an image size of 10x8in. Move the easel until this image fits the frame, then open up the enlarger lens to full aperture and focus the image. If you are not sure whether the image is exactly focused, use a special magnifier. Check the image for dust or hairs on the negative —they show up clearly when in focus.

1 MAKE AN EXPOSURE TEST

To save expensive colour paper, make a simple exposure test on black and white paper, using Ilfospeed Grade 1. Close the enlarger lens down to f8 and expose strips for totals of 4, 8, 12 and 16 seconds. Develop the print. Note the strip which shows the lightest tone in the slide as pure black (here the 16-second strip). Half this exposure will be correct (8 seconds).

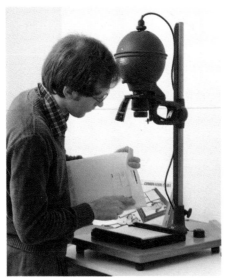

2 OPEN THE PAPER

Carefully open the Cibachrome packet at the end with the label showing the filter values. Use a knife or scissor blade to slide under the glued flap, then you'll avoid damaging the packet. You can open the packet in daylight because the paper is contained in a sealed inner packet made of foil. This is completely light-proof and moisture-proof.

3 OPEN THE INNER PACKET

Steps 3 to 7 should be done in the dark. Locate the empty end of the foil packet (it's folded back over the pack), unfold it and cut across the part beyond the fold. Take care not to cut the paper. Inside is a pack of ten sheets of paper, protected by two sheets of cardboard, one on either side. They are much thicker than the paper and cannot be confused with it.

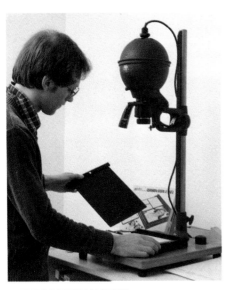

7 EXPOSE THE PAPER

Switch on the enlarger and expose the paper for the required length of time. In our case, this is 8 seconds at f8. Since the paper is almost black the visual image will be very dim. Don't panic—this is normal. After exposing, store the print in the easel by covering it with the darkslide or place it in a light-proof packet.

8 PREPARE THE PROCESS BENCH

Now get your processing area ready and check your chemicals. You have an hour or so to do this. If the print is not processed within that time its quality can suffer. You need a reasonable amount of space for the processing steps. This work bench is 24in deep, which is enough to have the chemicals warming at the back and the processing drum rolling back and forth at the front. If possible, work in a well-ventilated room with a sink. If your darkroom has no sink, obtain a large water-proof household bin like the one shown here. Use this for pouring spent chemicals into during the processing stages. It can then be emptied down a drain when you've finished. Make sure it has a well-fitting lid to contain the fumes. Keep it under your bench.

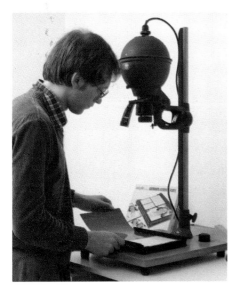

4 LOAD THE EASEL
Remove a sheet of paper and insert it into the paper easel, emulsion side up. Glossy Cibachrome paper has a very reflective emulsion side and it's easy to tell which side is which. Pearl paper is matt on both sides, so run a *dry* finger gently on the side which you think is the back. If it is, there will be a whispering sound, which you soon learn to recognize.

5 DIVIDE THE EASEL
You don't have to produce full 10x8 prints. If your easel has dividers use these to make smaller prints and so save on paper. The Unicolor Combination Easel shown here has small rectangles to block off areas of paper. By using them in combination you can produce two 7x5in prints, four 5x3½in prints or eight 3½x2½in prints. It also gives you an easy way of making tests.

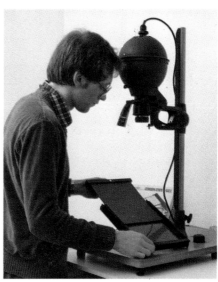

6 USING THE DARKSLIDE
If you want to switch the light on after you've loaded the paper, use a darkslide to keep the light off it, otherwise it will be ruined. A darkslide is a light-tight cover that slips into a groove in the top of the easel and protects the paper. Make sure the easel stays in position on the baseboard when you do this, and don't forget to remove the darkslide before exposing the paper.

9 LOAD THE DRUM
With the lights out again, get your exposed sheet of paper and curl it up emulsion side inwards as shown. It should form a cylinder length 8in, not 10in, otherwise it will not fit into the drum. Insert it into the drum, then fit the drum lid. Lock it firmly with a twisting motion. The drum is now light-tight, but do not expose it to bright daylight.

10 MEASURE OUT THE NEUTRALIZER
Before you pour out *any* Cibachrome chemicals, take the bottle of neutralizer powder supplied with the kit and measure out enough to fill the top of the cap. Use water-proof gloves for this. This dose of neutralizer is enough to prevent any unpleasant fumes from one 90ml measure of all three processing chemicals—the quantity used to process one print.

11 PUT IT IN A JUG OR BIN
If your darkroom has a sink, put the neutralizer powder into a jug (plastic, glass or stainless steel) of at least 2 litres. When you've finished, pour its contents down the sink.
Alternatively, put the neutralizer into a bin. This will hold enough for a number of prints. (Note: The new Cibachrome A2 kit will need no neutralizer.)

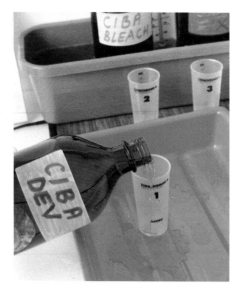

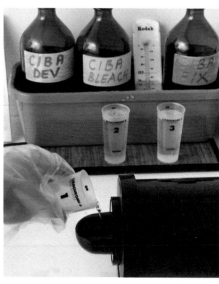

1 CHECK SOLUTION TEMPERATURES
Before you begin processing, check the solution temperatures which should be at 20°C, 24°C or 28°C. (The water bath may be warmer.) The instructions give three different times for these three temperatures; the tolerance is 1.5°C either side. If the temperatures don't fall within these limits, adjust your water bath by adding hot or cold water as necessary.

2 MEASURE THE DEVELOPER
Take the small plastic measure labelled '1' and pour into it 90ml of your developer solution, using a drip tray below to protect your work surfaces. The measures are marked with a bold numeral at 90ml. Since you have 1000ml (1 litre) of the solutions and the paper comes in packs of ten, you have enough solution for all ten sheets, with 100ml left over for possible wastage.

3 START PROCESSING
In the same way, pour out the bleach into measure 2 and the fix into measure 3. Put all three in a water bath or on a heating pad. With your timer ready to start, carefully pour the developer (measure 1) into the drum aperture. The development times are 2½ minutes if the solution is at 20°C, 2 minutes if it's at 24°C and 1½ minutes if it's at 28°C.

7 DISCARD THE BLEACH
Pour the bleach into the same jug that contains used developer. There should not be any noticeable reaction. Give this mixture a brief stir now—this will help the neutralization later on. Drain the drum as thoroughly as you can. Take time over this if you wish, for there is no urgency to get the fixer into the drum straight away. Zero the clock between each step.

8 POUR IN THE FIXER
Pour in the fixer in the same way as before. Its pungent odour will probably be fairly strong, so use an extractor fan or leave your door open, and do not breathe in deeply next to the drum. The fumes are not really harmful, but could cause a sore throat if you are making a lot of prints. Fix for 3½ minutes at 20°C, 3 minutes at 24°C or 2½ minutes at 28°C.

9 DISCARD THE FIXER
Discard the fixer into the jug when the time is up. It will foam rapidly and there will be a pungent odour for a short while. When the foam has died down pour the contents of the jug down the drain. Again the fixing time is a minimum and can be exceeded by half a minute with no adverse effects. It is important never to give *less* than the stated times.

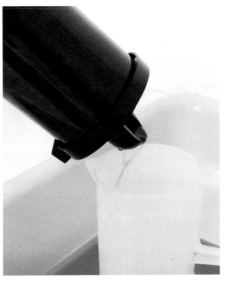

4 ROLL THE DRUM
On a clear area of the bench, set the drum rolling backwards and forwards in rapid succession. This brings the developer out from the reservoir to flood the paper. Start the timer immediately. Keep up the rolling action while the paper is developing. If you use the Unicolor drum, as here, it can only roll one full circumference each way.

5 DISCARD THE DEVELOPER
As soon as the correct time is up, pour the developer as rapidly as possible into your waiting jug or bin. Do not pour it down the sink. There is about 15 seconds leeway either side on the development time; it is better to give too much than too little. Whatever you do, stick to the same procedure for all subsequent prints; then your results will be consistent.

6 POUR IN THE BLEACH
Now pour the bleach (measure 2) into the drum in the same way as before. The bleach may fume a little when it mixes with the residual developer, but this is normal. Again, roll the drum, making sure the agitation is thorough. The processing time is 4 minutes at 20°C, 3 minutes at 24°C and $2\frac{1}{4}$ minutes at 28°C. If in doubt give a little longer – no harm will result.

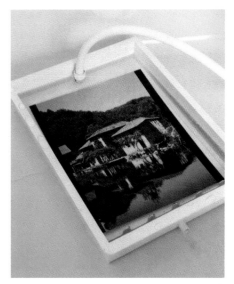

10 WASH THE PRINT
With the print inside the drum, wash it immediately with several changes of water or with a steady flow of water swilled around. Use water at 20-28°C for this. Wash for about 30 seconds, then remove the print. If your tap water is very cold gradually reduce the water temperature in steps of 4°C. This avoids damaging the print emulsion. Now open the drum.

11 REMOVE THE PRINT
Look inside the drum and you will soon see whether your first Cibachrome print is successful. The dry image should have black borders and a bright clear picture in the centre. (The wet print may have blacks that look rather reddish.) Handle it with great care and remove it from the drum by its edges only. The surface is extremely fragile while it is wet.

12 GIVE A FINAL WASH
With the print out of the drum, it can be washed properly for five minutes to remove any traces of chemicals and make the print permanent. Because the emulsion is easily damaged, the ideal washing system is a single tray like this Paterson 10x8 print washer. It keeps a regular flow of water over the surface of the print, so the print cannot float out of the tray and get scratched.

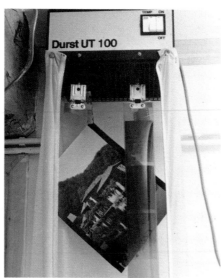

1 WASH THE DRUM
While the Cibachrome print is washing, rinse out the drum and lid very thoroughly with plenty of running water. Make sure you rinse well into the corners of the drum and the light trap of the lid. If you don't subsequent prints may be stained. Then dry the drum and lid. Wipe them carefully with a fluff-free cloth and leave in warm air to finish drying.

2 DRY THE PRINT
After washing the print for five minutes gently wipe away any surface water. Take care not to scratch the print—the emulsion is fragile. It is easy to wipe water from the back of the print. Then dry it using a film dryer or a fan blower such as a hair dryer. Warm air needs to circulate all round the print if all of it is to dry properly and quickly. Drying racks work, but only if you are willing to wait.

3 FAULTS—CONTAMINATION
Examine the print to see that all is well. If something has gone wrong, check these possible faults.
Failure to wash the drum thoroughly when you've finished one print can cause the next print to be badly stained, because fixer or even bleach will be contaminating undeveloped paper. Contamination may also cause weak greyish prints with patchy contrast.

FAULTS—WRONG SAFELIGHT
This bright red print is a result of using, by mistake, the red safelight intended for black and white printing. It was turned on for about ten seconds when the paper was being handled. Never use the safelight during colour printing. Similarly, a poor blackout can give the print a greyish cast. Cibachrome prints should have strong black edges. If they don't check your blackout.

FAULTS—FILTRATION ERRORS
Using the wrong filter at the exposure stage (either wrong colour or wrong strength) will give a colour cast to the print. On a Cibachrome print, it takes a fairly strong filter error to produce an obvious colour shift. In these examples, the left-hand print received 40 units more yellow than it should have, and the right-hand side received 40 units too much magenta.

FAULTS—DAMAGED EMULSION
Scratching the surface of the emulsion can tear off some of the dye layers and destroy the image. Here the magenta and yellow layers have peeled off to leave just the blue layer. Prevent this by taking great care when you handle the print, and when you use clips or tongs. Scratching is much more likely to occur with glossy than pearl paper, the latter being tougher.

FAULTS—DEVELOPMENT ERRORS

Too little development, or developing at too low a temperature, will produce a dark print that lacks sparkle, see above left. Too much development, or too high a temperature, will produce a very contrasty, harsh print, as on the right. (However, this may benefit a flat dark transparency.) Make sure you time the development very accurately—it is the critical stage.

FAULTS—OVER-EXPOSURE

This is the result of exposing the paper to too much light. Here the lens was not stopped down from full aperture after focusing. The correct exposure was eight seconds at f8, but instead the paper received eight seconds at full aperture f2·8. This is eight times the correct exposure. Considering this, there is still a surprising amount of detail in the print.

FAULTS—UNDER-EXPOSURE

Too little exposure produces a worse result than over-exposing. The print above received eight seconds at f16, a quarter of the correct exposure, and is very dark as a result. With the Cibachrome process, and a normal density slide you can usually give from half to double the correct exposure and still have an acceptable print. If in doubt, err on the side of over-exposure.

4 THE ORIGINAL SLIDE

To compare results, here is the original transparency, a 35mm Ektachrome 64 shot. It was given slightly less exposure than the camera's meter indicated to produce saturated colours. These always print better than weak colours on Cibachrome. The image contains strong blues and greens, but no vivid reds, only the subtle colours of the roof tiles.

THE EKTAFLEX PROCESS

This new process includes all the necessary chemicals – the only solution needed is the activator. Temperatures are not vital and times do not have to be exact so print making is easy. Exposure and colour filtering follow the usual colour printing pattern except that the slide is reversed in the enlarger, so the emulsion faces the lamp, because the image is viewed from the other side of the print. The two reversals cancel out. The system uses separate film and paper. The film is exposed in darkness, and then is soaked in activator in a special machine. Film and paper go together through rollers and emerge as a sandwich. After peeling apart, there is the finished print. The film is then discarded.

Developing colour negatives

Home processing

Modern chemicals make it quite easy to process colour negative films at home, but you should only consider this if you are doing it for enjoyment. First, you do not save money, as the cost per roll is roughly the same as having it done by a lab. Second, high temperatures are needed, and small processing variations do have an effect. Third, there is a slight compromise in quality when using dual purpose negative/print processing kits—though this is too subtle for most people to notice.

You must follow all the instructions here very closely. Keep temperatures within a quarter of a degree, and all times within 10 seconds, except where the text indicates otherwise. Bear in mind that variations in processing will increase the amount of work you have to do to make a good print from the final negative. In general, then, we do not recommend home processing colour negatives, unless you have reasons for not wishing to send a film to a lab, or need them in a hurry. However, it is something you should know how to do, so to illustrate the steps we have chosen Photocolor II kit, which can also be used for making prints on Kodak 74RC paper.

1 WHAT YOU NEED

Check through your Photocolor II kit. It should contain two large bottles for the two main solutions, a third small bottle (not shown here) which you will need later on for print developing, an extra screw cap and an instruction booklet. You will also need a timer, a developing tank, a thermometer, a water bath, kitchen paper, measures and two storage bottles of about 500ml.

2 CHECK YOUR FILM

Make sure your film can be processed in Photocolor II developer. The cassette should be marked 'Process C-41'. Suitable films include Kodacolor II and 400, Vericolor, Sakura, Fuji, Boots, Barfen, 3M and Tudor. Photocolor II will not process slide films or any Agfa films apart from Agfa CNS400. The instruction booklet has a full list of suitable films.

5 MEASURE THE DEVELOPER

Take one of your storage bottles, wash it out and label it 'DEV'. The 500ml bottles used here hold more than enough solution—you need around 300ml to develop a roll of film. We will prepare 450ml of developer solution rather than 500ml; it's easier because you can use 150ml of concentrate and 300ml of water. First measure out the concentrate into a clean rinsed jug.

6 CAP THE CONCENTRATE

Do not seal the concentrate bottle with the original cap. It will no longer be air-tight and the concentrate will oxidize and become useless. Instead use the spare cap supplied with your kit. First squeeze the bottle to force out the air, then screw on the new cap. Keep squeezing the bottle as you tighten the cap to expel as much air as possible.

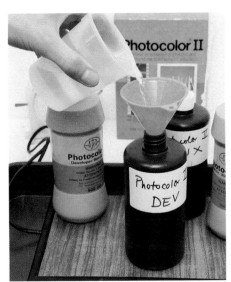

7 MIX THE DEVELOPER

Pour the developer concentrate into the storage bottle using a clean funnel. *Do not use the funnel with any other solution.* Measure out 300ml of water, making sure it's at the correct temperature, and pour it into the storage bottle using the same funnel. Finally, squeeze the bottle to exclude air, cap it and place it on a heating mat or in a water bath at 40-42°C.

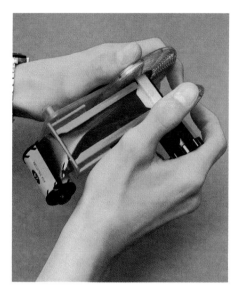

3 LOAD THE FILM
In complete darkness load your film into your developing tank's spiral and assemble the tank. Now switch on the lights. Here we are showing the GePe tank, though any make will do. The GePe tank's spiral has a plastic film guide clipped to the reel column. This takes the film leader and feeds it into the spiral from the centre outwards, so you don't need to handle the film.

4 CHECK THE DEV TEMPERATURE
Measure the temperature of the developer concentrate. This has to be diluted for processing, and needs to be at 40°C. An easy way of achieving this is to add water at the right temperature. In this case the developer was at 22°C and the dilution is two parts water to one of concentrate. By diluting with water at 49°C, the working solution will be at the required 40°C.

SOLUTIONS AND TEMPERATURES
Because Photocolor II solutions need to be quite hot for processing it is easier to bring them up to the right temperature when diluting them rather than warming them later. All you need to know is the dilution ratio and the difference in temperature between the concentrate and the required solution temperature. Multiply this temperature difference by the number of parts of concentrate used. Now divide this by the parts of water used and you will have the temperature difference you need between the water and the solution.
EXAMPLE:
Temperature of concentrate $= 16°C$
Solution temperature $= 40°C$
Dilution ratio $= 1 + 3$
Temperature difference between them is $40°C - 16°C = 24°C$
Multiply this by parts of concentrate (1) and divide by parts of water (3): $24 \times \frac{1}{3} = 8°C$
So temperature difference between the water and the solution needs to be 8°C. Therefore the water has to be at 48°C.

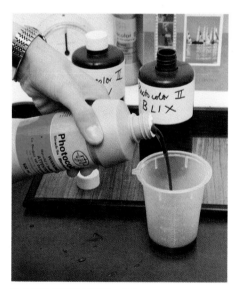

8 MEASURE OUT THE BLIX
Wash out your second storage bottle and label it 'BLIX' (an abbreviation for bleach fix). The blix concentrate is dark orange-brown and has to be diluted 1+1 with water. Measure the temperature of the blix so you will know what temperature water you will need to make the solution 40°C. Here, the blix is at 18°C. Pour out 250ml of it into a measuring jug.

9 DILUTE WITH WATER
Prepare 250ml of water at the required temperature. Here it needs to be at 58°C (18°C *above* the solution temperature of 40°C, because the blix is 18°C *below* and the dilution is 1+1). Do all your mixing and pouring in a large shallow drip tray—a seed tray is ideal. It's less messy that way, and your are not as likely to stain your work surface with the chemicals.

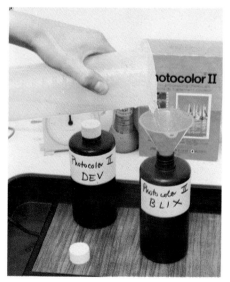

10 BOTTLE THE BLIX
Pour the blix concentrate into your storage bottle, using a funnel. Then add the water. Place the bottle on a heating mat or a water bath to keep it at its working temperature of 40°C. If the blix does not fill the bottle don't squeeze to force out the air; it won't harm the solution. In fact, you can regenerate used blix to some extent by shaking it in its bottle to mix it with air.

1 GET READY FOR PROCESSING
You are now almost ready to begin processing your film. First, have your developer and blix bottles standing in a water bath or on a heating mat to keep them at 40°C. Place a thermometer in the developer so you can keep a close eye on its temperature. It's a good idea to give the film a pre-wash with water before developing it, so measure out 300–400ml of water at 42°C.

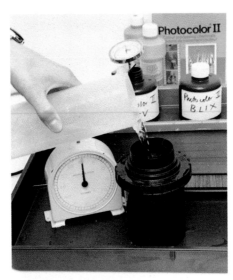

2 PRE-WASH THE FILM
Pour the pre-wash into the developing tank. Start the timer, then gently agitate the film to remove any air bubbles and ensure even coverage. Begin pouring out the water after 75 seconds so that the tank is empty at the 90 second mark. Do not discard this water—you can use it again later on. Pour it into a container and keep it warm in the water bath.

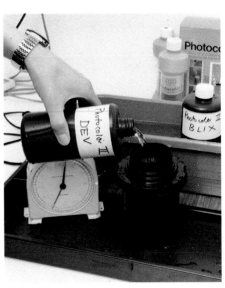

3 ADD THE DEVELOPER
Check the developer is at 40°C then pour it in so that all the developer is in the tank after 105 seconds. Make sure you pour in at least as much solution as is needed to cover the film. If in doubt, measure out your developer first. As soon as the developer is in, give the tank a quick shake. Firmly re-cap the developer bottle.

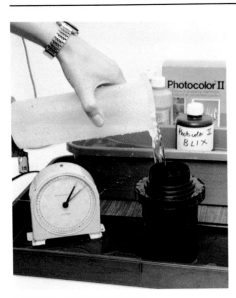

7 RINSE OR STOP BATH
Pour in the rinse as soon as possible. Agitate the film with the twist rod for 30 seconds, then discard the water. Don't keep it this time because it's now contaminated with developer. If you prefer you can use a commercial stop bath, or a solution of 2% acetic acid, instead of water. Then you can be sure of stopping development. However, water is usually adequate.

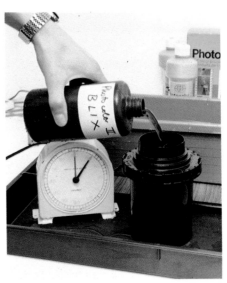

8 ADD THE BLIX
Check the temperature of the blix—it should be 40°C. Pour it into the tank after you've discarded the stop bath. Take care when doing this because blix can stain clothing. The minimum time for the blix to be in the tank is 4 minutes, but it is safe for you to exceed this slightly. Once the blix has done its job it ceases to have any effect and it won't harm the film.

9 AGITATE THE TANK
Agitate regularly, either by inverting the tank for 5 seconds in every 15 seconds, or by using a twist rod, or by shaking the tank. Keep this up for at least 4 minutes. If you are processing a 400 ASA film, such as Kodacolor 400, allow six minutes for the blix, to be on the safe side. Have the blix bottle and a clean funnel ready to return the solution.

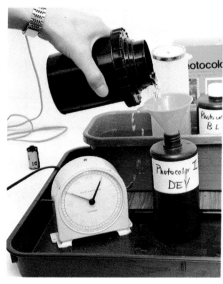

4 DISLODGE AIR BUBBLES
During the first 15 seconds, tap the tank on the bench top to dislodge any air bubbles. There shouldn't be any, but the development time is very short and any unevenness will show up badly. For the next 15 seconds, agitate the tank continuously by shaking it, using the twist rod and tapping it on your bench. All this is very important if you want the best results.

5 INVERT THE TANK
At the end of 30 seconds invert the tank and hold it upside-down for 5 seconds. Continue inverting the tank in this way every 15 seconds. If you don't do this, the film may be under-developed. The development started when the clock showed 1 minute 45 seconds and it lasts for 3 minutes 15 seconds. So it should stop when the clock shows exactly five minutes.

6 POUR OUT THE DEVELOPER
Start pouring out the developer 15 seconds before the end, so that all of it leaves the tank just as 5 minutes is up. *Do not discard* the developer—pour it back into the solution bottle. Have a rinse of water at 40°C ready to pour into the tank immediately afterwards. Use the pre-wash, so you won't have to warm up fresh water during the critical development period.

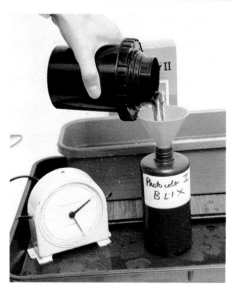

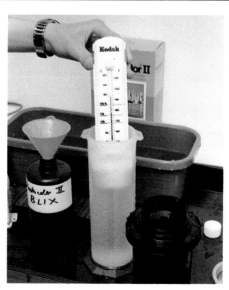

10 BOTTLE THE BLIX
Return the blix to its bottle, using a different funnel from the one you used for the developer. Seal the bottle firmly. There is no need to hurry with the next step (the second rinse) but do not leave the film uncovered by solution in the tank for longer than a minute.
The processing is now completed, and all that remains is to wash the film thoroughly and dry it.

11 PREPARE THE WATER
Make up about 500ml of water at 35–40°C. This will be used to rinse the film. Because the film was processed at a high temperature (40°C) it must be washed at a high temperature to avoid damaging the delicate emulsion. This means using a number of changes of water, starting with a rinse near the film's temperature, then gradually reducing it to nearer room temperature.

12 WASHING
Pour into the developing tank about 150–200ml of the water you have ready. Shake the tank so that the water washes round the whole film, then discard it. Repeat this twice more with the rest of your water. Make up another 500ml of water at 2°C lower than your first rinse. Again, wash the film three times. Continue to lower the temperature of your washes until you reach about 30°C.

1 THE FINAL RINSE
By stages, reduce the temperature of your rinses to about 30°C. Once you are down to this temperature give the film a final rinse. Use filtered water for this final rinse. Ordinary tap water is likely to leave marks on the film as it dries. If you don't have a proper filter Paterson and other firms manufacture special filter funnels, and Unicolor make a wall-mounted one.

2 ADD A WETTING AGENT
A further way to avoid drying marks is to add a wetting agent to the final rinse. Add no more than three or four drops of wetting agent, such as Paterson Anti-Static, to 300ml of water. Alternatively, dilute a teaspoon of good-quality unmedicated shampoo or a simple washing-up liquid to a pint of water and add three or four drops of this to 300ml of water.

3 LET THE FILM SOAK
Leave the film soaking in the tank with the water and the wetting agent for two or three minutes. The rinsing water will look slightly foamy, but no more so than you can see here. Do not rinse the film again in any other water after using the wetting agent or its effect will be lost. Before you pour this water away, soak your squeegee tongs in it, in readiness for wiping the film.

FAULTS: UNDER-EXPOSURE
This negative is very thin through being under-exposed. It would be impossible to make a good print from this negative because there is no detail in the shadows.

This result is clearly not caused by under-developing the film because the frame numbers are correctly exposed. Also, the only bright part of the picture—the lamp—would not be so dense on the negative if under-development were the cause.

FAULTS: OVER-EXPOSURE
Too much exposure when taking the picture gives a negative looking like this. None of the picture area is clear, even in the shadow areas such as the bottom left of the picture. There is hardly any distinction between the different colours in this negative, but despite that a reasonable colour print could be made from it. Again, the frame numbers are the correct density, so over-development could not be responsible.

FAULTS: UNDER-DEVELOPMENT
This affects the whole film and not just the picture area. The frame numbers are weaker than normal, though still visible. The density of the image is very low, though there is still some shadow detail. There are no strong highlights, even in the sky. It would not be possible to make an acceptable print from this negative.

Under-development is caused by developing the film for too short a time or at too low a temperature.

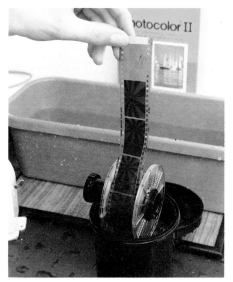

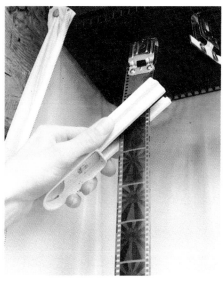

4 REMOVE THE FILM

Support the film on the tank as shown here and unwind it a little, taking care not to scratch it. Examine the film. It should look like this—an orange background with images in muted colour. The frame numbers should be clearly visible. The film will look slightly milky when wet, but do not worry about this. It will disappear on drying.

5 HANG UP TO DRY

Hang up the leading end of the film at least 6ft (2m) above the floor and unroll the film from the spiral. Use your squeegee tongs (previously soaked in the rinse) to wipe the film with a single downward stroke. Leave the film to dry naturally where dust is unable to settle on it. If you have a proper drying cupboard such as this Durst UT 100 hang the film up in this.

6 EXAMINE THE FILM

Check the film to see whether it has been correctly processed. Examine the base orange—it may be pale or dark, depending on the make of film, but it should have an even density all over. The frame numbers and the manufacturer's name on the rebates should be clearly developed and not look weak. Shadows should hold some detail and not be a clear orange. The highlights should be dense, but you should still be able to see through them.

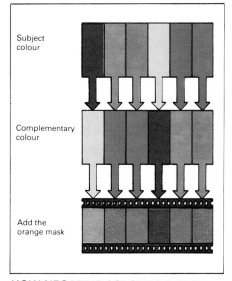

FAULTS: OVER-DEVELOPMENT

The negatives are extremely dense and very contrasty. The frame numbers are darker than they should be and the band running through the sprockets is almost black instead of the normal medium brown. Highlights are almost opaque. A print taken from a negative such as this would look harsh with bleach-white skin.

Over-development is caused either by developing for too long or at too high a temperature.

FAULTS: FOGGING

This is caused by stray light striking an undeveloped film. In this case, the film was exposed close to a red safelight, which has caused a green colour cast to appear over both the image area and the rebates. (After printing, the picture would have a red cast, the complementary colour to green.) Always work with colour films in complete darkness. Don't use a safelight, it's meant only for black-and-white work.

HOW NEGATIVE COLOURS WORK

Next week we start colour printing. To understand this you must understand the colours in a negative. Each colour is *complementary* to the original colour. Subtract one of these colours from white light and you are left with the other. Red and green are complementary. The negative also contains an orange mask, so the colours you see are a combination of this and the complementary colours.

Colour printing from negatives

Starting out

Having learned how to process your own colour negative films in this course, you are now ready to print them. The Photocolor II chemicals you used for processing the film will also process the paper, providing you make the prints on paper such as Kodak Ektacolor 78RC.

As far as the processing itself is concerned, printing from a colour negative is as easy as printing from a slide. But it's harder to judge the colour balance and adjust it to get the best results.

There are several reasons for this. First, the negative has reversed colours combined with an orange mask, instead of the natural colours of a slide, so it's more difficult to judge the correct colours. Second, colour paper for negative printing is much more sensitive to changes in the colour balance than reversal paper, and it varies more from batch to batch. Third, different makes of colour negative film may need widely differing filters to reach the same final colour print.

This means you must run a colour analysis test first to get the best results. It also helps to stick to one type of film, chemicals and paper throughout. That way, your results should be as consistent as possible.

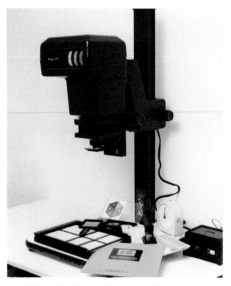

1 THE COLOUR ENLARGER
An advantage, when printing from colour negatives, is an enlarger with a proper colour head. The model shown here, the Vivitar 356, has three coloured dials to alter the light towards yellow, magenta or cyan. We are also using a Unicolor Combination Easel, a Unicube colour assessor system and a packet of 10x8 (24x20cm) Ektacolor 78 RC glossy paper.

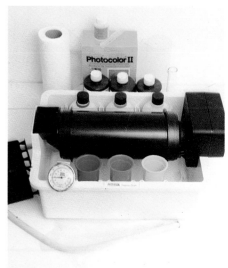

2 THE PROCESSOR
For the processing we shall be using a Paterson ThermoDrum kit. It's easier to use than the hand-rolled drum method we showed for making prints from slides. The kit contains a water bath, the drum with motor, and three different coloured bottles and measures. You will also need your Photocolor II kit, thermometer, more measures and a roll of kitchen paper.

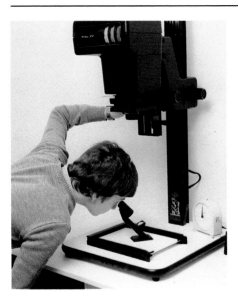

6 FOCUS AND COMPOSE
Switch off all lights and compose and focus the image. (You can have your black and white safelight on for convenience.) Blow it up to 10x7in (24x17cm). Use a focus finder to get the focusing exact; colour negatives are much harder to focus with the naked eye than black and white negatives. Do not dial in any filtration at this stage because it makes the image dimmer.

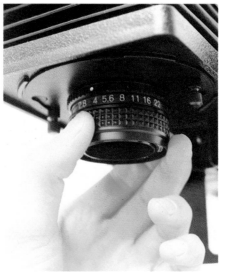

7 STOP DOWN THE APERTURE
For the Unicube test, close down the lens aperture to one stop below its maximum opening (here from f2·8 to f4). The exposure times given here depend on the lens being at f4: If you find it's at a different aperture when you stop down, adjust the exposure times to compensate. Don't use the lens at full aperture just to be at f4: if you do, the test results may be wrong.

8 SET THE FILTRATION
Set the colour dials in the enlarger to a trial filtration of 60 yellow, 60 magenta and 0 cyan. On every packet of paper there are filter figures, but ignore them at this stage. They indicate deviations in colour between different batches of paper. When you start a new packet you can compare its figures with the old ones and adjust the filtration values accordingly.

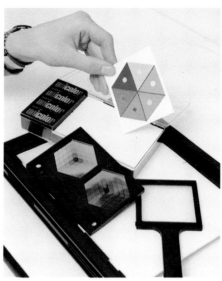

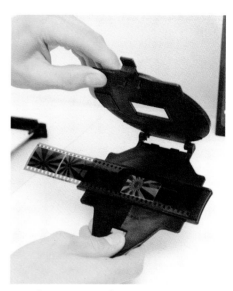

3 CHOOSE YOUR NEGATIVE
From the film you've just processed pick out a negative you want to print. Choose one that has strong colours—they are easier for a beginner to print well. We've selected a close-up shot of a dartboard. An advantage of choosing a negative like this is that you can easily compare the colours in your print to the actual colours of the subject.

4 THE UNICUBE ANALYZER
Before you print the negative you must make a test print, to determine the exposure and to find out the filtration values to dial in. For this you need the Unicube (or similar device). This consists of a square diffuser that you hold under the enlarger lens, two coloured hexagons through which you expose the test print, and a grey hexagon for matching up the test print.

5 INSERT THE NEGATIVE
First dust away any specks from the negative, then insert it into your enlarger's negative carrier. (On some models, including the Vivitar 356, you can insert the negative first and then dust it after it's closed.) Place the negative exactly in the frame so that only the picture itself is showing. Then close the carrier and insert it into the enlarger.

9 INSERT THE PAPER
Switch out all lights, including the safelight and the enlarger light. Open your packet of paper and remove one of the sheets. Put the rest of the packet away, and insert this sheet into the easel. If you want to economize, you can use halves or quarters of sheets for testing, though Unicolor recommend you use a whole sheet. We are using a full sheet to show the results clearly.

10 SET UP THE EASEL
Using the dividers supplied with the Unicolor easel, mask off an L-shape to leave a 5x3½in area for the Unicube. If you don't have dividers with your easel cut out a thick piece of L-shaped card to the right size and use that. Then place the two coloured hexagons in the remaining part of the easel. Have the diffuser ready to hand when you come to expose the paper.

11 EXPOSE THE PAPER
Hold the diffuser under the enlarger lens and expose the paper for 20 seconds at f4. Now place a divider over the part of the paper covered by the Unicube (or place a piece of card on top), and uncover the rest of the paper. Take the diffuser away from under the lens and give the paper another exposure, this time for 10 seconds at f5·6.

1 LOAD THE DRUM
After making the exposure, curl the print along its longer edge, emulsion side facing in, and load it into the processing drum. Make sure first that the drum is clean and dry, then seal the ends of the drum to make it light-tight. If you are using the Unicolor easel, then you can use the darkslide to protect the print until you are ready to process it.

2 MIX THE DEVELOPER
First, dilute one part of the Photocolor II developer with two parts of water. Use warm water to bring the solution temperature up to about 35°C. Make up about 500ml of solution in a storage bottle. Note: you may prefer to make up all solutions before you expose a print. Then wash your hands thoroughly before handling the paper, to avoid producing stains.

3 MEASURE OUT THE ADDITIVE
Find the small measure and the small plastic bottle containing developer additive that come with the kit. Measure out 15ml of additive and pour it into your 500ml of developer solution. (Note that the measure is only marked up to 13ml, so you must do this in two stages, such as 10ml and 5ml.) Seal the storage bottle and shake it to mix the solution thoroughly.

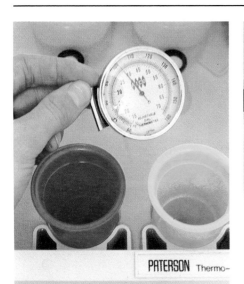

7 CHECK THE TEMPERATURE
Before you begin, measure the temperature of the water bath. Ours is at 39°C. The temperature doesn't have to be perfectly accurate because the Photocolor II kit gives a range of processing times for different temperatures. The water bath and the solutions do need to be at the same temperature, however, so either warm the bath up or wait for it to cool.

8 MEASURE THE SOLUTIONS
Pour out enough of each solution to fill its corresponding cup up to a mark shown on the inside. This will be 60ml in each case. Make sure you fill the cups up to this mark, otherwise there won't be enough solution to cover the print. But don't fill the cups completely, either. Full cups are meant to be used only with the larger 12x15in processor and drum.

9 POSITION THE DRUM
Put the drum holder in place at the left hand end of the ThermoDrum unit. Insert the pointed end of the drum into the holder, then drop the other end on to the two motorized rollers. These drive the drum during the processing. Check the water level to make sure that the drum won't float off the rollers. If necessary, remove some water from the bath.

4 MIX THE STOP-BATH
Dilute 5ml of Paterson Acustop in 500ml of water for the stop-bath. This is half the recommended strength, but the stop will be used once only and then thrown away. Make up the stop-bath at 30–35°C; its temperature is not as critical as with the developer. Also it's not necessary to use a stop-bath—you could use water instead—but it may improve your prints.

5 MIX THE BLIX
Dilute the blix (bleach-fix), one part to two parts of water. Make up about 500ml at 35°C. The blix solution used for prints has half the strength of the solution used for films. This is because prints are much quicker to bleach and fix than films. Finally, bottle the blix. Note that the Paterson bottles we are using here have a colour code around the neck for easy identification.

6 FILL THE WATER BATH
Place the storage bottles in the Paterson ThermoDrum kit in the order shown here: red, yellow and blue for developer, stop and blix respectively. Place the coloured measures opposite them in the same order. Then fill up the bath as far as the mouldings, with water at 40°C. This is slightly higher than the recommended processing temperature to allow for cooling.

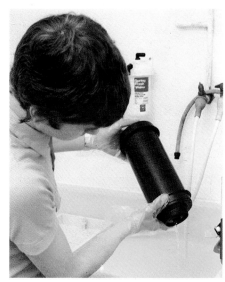

10 MEASURE OUT SOME WATER
Measure out about 250ml of water at 37°C. This will be used as a pre-wash to warm up the drum and paper so they don't cool down the incoming developer. The Photocolor II kit recommends a pre-wash in water at 40°C, but this is meant for drums rolled along a bench, since these start off cold and need to be warmed up. If you are using a ThermoDrum, 37°C is warm enough.

11 ADD THE WATER
Pour the water in at the left-hand end of the drum, into the funnel formed by the drum holder. You can pour it in quickly without fear of it overflowing. After pouring, quickly turn on the motor, using the switch at the right-hand end of the drum. Let the drum rotate for 40 seconds. If it fails to start straight away, give it a gentle turn to get it going.

12 DRAIN AWAY THE WATER
Lift the drum out of the bath in the same way that you put it in—the right-hand side first. Empty the water out into the sink via the right-hand side. Use the same procedure later during the processing when you come to empty the tank.
If in doubt about loading and unloading, look at the diagrams shown on the ThermoDrum.

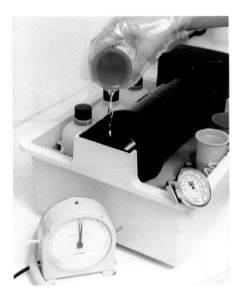

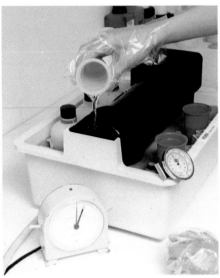

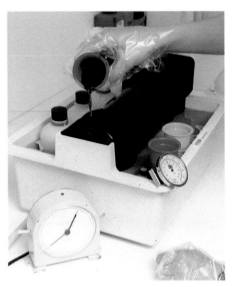

1 DEVELOP THE PRINT
Check that the developer is within ¼°C of 34°C. Then draining the water bath out of the tank, immediately pour in the developer and restart the motor. The developer remains in the tank for 3 minutes, including the time taken to pour it in and out. Here the developer is going into the drum exactly as the clock reaches one minute.

2 ADD THE STOP-BATH
Drain the developer so that the stop-bath can be poured in exactly on the 4-minute mark. Give the stop-bath 20 seconds; if necessary you can extend this time to 1 minute, but no longer. Its temperature needs to be between 30–34°C. Keep checking the temperature of the water bath. Top it up with warm water if it falls much below 37°C.

3 ADD THE BLIX
Drain the stop and pour in the blix. Give the blix at least a minute. You can extend this time up to 2 minutes if you wish without harming the print, but you must never give less than a minute. The temperature is not critical, but try to keep it within 1°C of 34°C. When the time is up, drain away the blix carefully—it could stain your clothing if you spill any.

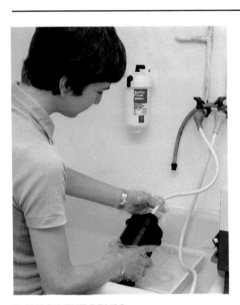

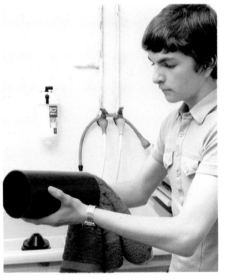

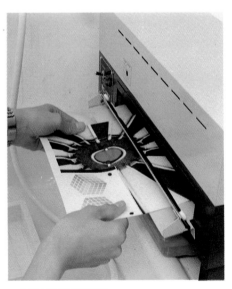

7 WASH THE DRUM
While the print is rinsing, wash out the drum with plenty of running water. Don't try to save time by washing the drum and the print together while one is inside the other. Remove the ends of the drum and rinse these separately. Never rinse the drum while it is assembled as you won't be able to wash away the chemicals lodged in the joins between the parts.

8 DRY THE PARTS
Dry all the parts of the drum thoroughly with a towel or kitchen paper. Take extra care with the inside surface of the cylinder, where the next print will come into contact with the drum. Never try to process a print with a damp drum. If you want to continue processing immediately, it's safer to buy a spare drum and use that while the first one is drying completely.

9 DRY THE PRINT
Take the print out of the rinse and dry it. There are several ways of doing this. You can simply peg it on a line and either leave it to dry naturally or place a heater underneath to speed things up. Or you can place the print in a drying cabinet. Here we are using a roller feed dryer. This takes prints up to 14in (35cm) wide and dries them in 30 seconds.

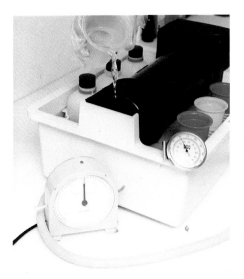

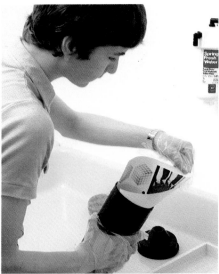

4 RINSE WITH WATER

Follow the blix with a water rinse. Use about 250ml of water at a temperature of at least 30°C. Repeat this with two or three changes of water, reducing the temperature of the rinse each time until it reaches tap water temperature. With some process kits, you can follow the rinse with a stabilizer solution to increase permanence but this is not suggested with the Photocolor II kit.

5 REMOVE THE PRINT

Open up the drum and remove the print very carefully to avoid damaging the soft, wet emulsion. The print sticks strongly to the side of the drum, so you will probably need to prise a finger underneath to loosen it. Pull the print out spirally like this—it's much easier than trying to pull it out straight. The print should have a slightly misty, cold appearance.

6 WASH IT

Put the print in a developing dish or a print washer tray and give it a final wash for 3 minutes at tap water temperature. You can't yet make an accurate judgement of the colour—that will have to wait until it's dry—but you can get a rough idea. Here, the test print looks very close to being correct for colour and the exposure looks quite accurate, too.

12 ADJUSTING THE COLOUR

In our test print the accuracy of the filtration was surprisingly good. But the adjustment could have been much greater, say 40M + 50Y. In that case, the grey patch would have appeared on the hexagon at the bottom of the previous picture. This is the wide-range hexagon and covers up to 80CC units. The one at the top of the picture is the close-range hexagon that goes up to 20CC units in intervals of 5CC.

If the grey patch appears in the wide-range hexagon, make another test with the corrected filtration dialled in. The narrow-range hexagon will then indicate a final adjustment. Unicolor suggest aiming for an accuracy of within 5CC units.

If the picture contains an uneven balance of colours, then getting the Unicube right to within 5CC may be a waste of time, as all the colours could be quite wrong. You then need to use your own judgement.

Don't forget to check that the main exposure is correct. Exposure adjustments are slight if you are changing the filtration by 20 + 20 or less. For larger filtration adjustments, the instruction manual has a table of exposure changes.

10 EXAMINE THE PRINT

Check the print for sharpness, even processing, clean white and strong blacks (you can check the blacks by the two spots on the Unicube test). Next, take the Unicube grey matching card and check it against the small areas in the hexagons. One of the two hexagons should have a neutral grey patch somewhere. Find the corresponding patch in the manual.

11 WORK OUT THE CORRECTION

The values given in the manual are the corrections to be made to the enlarger's filter settings. The test print shown here has its neutral grey patch circled in red. From the manual this patch is found to correspond to 10Y + 10M. You can either dial in these values, or you can dial in 10 less cyan, which is equivalent. Here, cyan is already at zero, so this isn't possible.

1 THE FINAL PRINT
Dial in the filter adjustments given by the Unicube test. In our case we added on 10Y + 10M to make 70Y + 70M. Then make the print, adjusting the exposure time if necessary according to the test print. The print shown here was given 2 seconds less exposure time than the test print, making 8 seconds at f5·6. The result has neutral blacks and whites, and bright colours.

2 USING THE LIGHT LEVER
For the next negative set the dials to zero before focusing. (Some enlargers have a white light lever to remove the filter values from the light without disturbing the dialled-in values.) When you start a new pack of paper check the filter values on it. Our new packet showed −10M, compared to the first packet's 5Y −15M (see Issue 124). Dial this difference of 5Y −5M into the enlarger.

FAULTS: NO FILTRATION
This is caused by accidentally forgetting to dial in the filtration values, or by leaving the white light lever switched down during the exposure. The print has the same colour cast as the filters that were omitted (in this case magenta plus yellow), and is also too dark. With most films and papers 'no filtration' is quite distinctive from any other fault.

FAULTS: FILTER ERROR −M
Here is another example of a simple filtration error. This time, 25M too little has resulted in a magenta cast of similar strength to the yellow cast in the previous print. The filtration settings were 65Y + 50M. Note that it is hard to detect colour casts in the red and green parts of the print, but it's easy to see them in the blacks and whites.

FAULTS: FILTER ERROR +Y +M
This print has a similar strength of colour cast, but it does not correspond to the filters being used. It is in fact a cyan cast caused by using too much of both yellow and magenta. It can also be caused by using too little cyan, but this is unlikely as cyan is very rarely needed. It is nearly always the result of over-filtration. The settings were 90Y + 100M.

FAULTS: NO DEV ADDITIVE
This print may look alright at first glance, but it has muddy colours, a greenish cast and poor contrast. It also needed longer exposure than the other prints (10 seconds). It is caused by forgetting to put the print developer additive into the developer solution. The additive *must* be used, 3 parts per 100, to ensure full colour contrast and balance.

FAULTS: OVER-EXPOSURE
This is the result of forgetting to close down the lens. In this case the aperture was at f2·8 instead of f5·6. This is a common mistake that you can only avoid by sticking to a strict routine of double-checking everything you do. Over-exposed prints show very little real colour, but the overall tone is neutral, showing that the filtration value was correct.

FAULTS: UNDER-EXPOSURE
With this print, the lens was set to f11 instead of f5·6. This can easily happen if you forget to open the lens to full aperture for focusing, then set the aperture to its working value by 'clicking' it rather than examining it in room light. The brown stain on the print is caused by poor drum washing leading to the developer being contaminated by blix.

FAULTS: FILTER ERROR −Y
This print has too much yellow caused by the filter value of the yellow being too low. Only 40Y was dialled in instead of the recommended 65Y. So the print has a cast of 25Y. There are also marks on this print from not using enough developer (just above centre, left) and touching the print with blixy fingers before processing (lower left).

FAULTS: OVER-DEVELOPMENT
This is the result of accidentally leaving the print in the developer for twice the recommended time. The print has a magenta-brown cast and is much too dark in the shadows, even though the correct exposure and filtration values were used. Compared to an over-exposed print the result is much more contrasty. Over-development increases density and warms up colours.

FAULTS: UNDER-DEVELOPMENT
Under-development is a more common mistake than over-development. This print had half the correct development time, causing it to lack contrast, be too light and have a strong blue cast, especially in the deep blacks. Both under- and over-development can be caused by the temperature being wrong. In the former case too low and in the latter too high.

DELIBERATE OVER-DEVELOPMENT
The colour print process has a surprising degree of latitude. This is an example of deliberately boosting the colour and contrast by over-developing for twice the normal time, with the exposure time cut by half. For some flatly lit or dully coloured subjects, treating the print individually like this can sometimes improve the image.

Improve your black and white prints

1 ARE YOUR PRINTS SPOTTY?
No matter how hard you clean your negatives, your prints are still likely to have small white marks on them caused by dust, scratches and water deposits. On black and white prints they are most noticeable on grey and black areas, especially in featureless parts of the print such as the sky. All these marks can be easily and quickly spotted out with retouching medium.

2 SPOTTED INK
Buy some spotting or retouching ink from your local photographic dealer. It comes in tubes of water-based pigment. You will need black, though white and grey are also useful. Squeeze out a very small blob of black onto a palette or a piece of paper. A good surface to use is the back of a gummed label. The gum gives the ink a glossy finish to match the glossy print surface.

3 DILUTE THE INK
You will need a fine 0 or 00 brush made of either sable or squirrel hair. Wet the brush and take a minute amount of the black ink, as small as you can pick up. Work this into a uniform patch of grey ink. Take some more ink and add this to the diluted ink. Keep on doing this until the grey patch has about the same tone as the area of the print you want to spot.

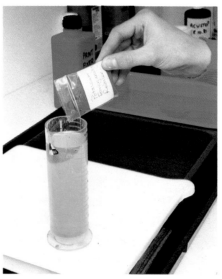

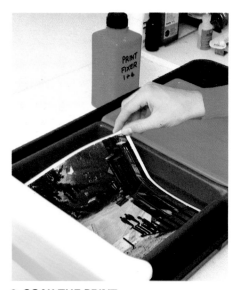

7 LIGHTENING A PRINT
After processing, this print was seen to be too dark when it was examined in good light. It had been exposed to bring out detail in the cobbled street, but the dark buildings on the right are also important. Rather than make a new print it is possible to rescue a print like this, which has normal range and contrast but is a shade too dark. The technique is called *reduction*.

8 MIX THE REDUCER
You will need a chemical called potassium ferricyanide. You can buy it either under a proprietary label or as the chemical itself. Measure out 500ml of water at 20°C and add to it about half a teaspoon of the crystals. Stir the solution to dissolve the crystals completely. Note that potassium ferricyanide is a little corrosive and slightly poisonous, so take care.

9 SOAK THE PRINT
Arrange three dishes—reducer, water and fixer. First, soak the print in the water bath for one minute so the emulsion is evenly wetted. This will make the action of the reducer more even over the surface of the print. You can use the reducer and the fixer for more than one print, but not the water bath. It must be replaced each time you reduce a print.

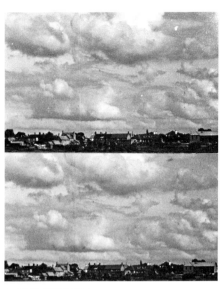

4 STIPPLE OUT THE SPOT

Hold the brush as shown, with only the very tip touching the print. Dab the diluted ink onto the white areas to build up a stipple of very small grey dots. Keep going until you've covered the whole area. Never use brush strokes, even when filling in lines. Reload the brush as often as it dries. Remove any excess ink on the print by dabbing it with a bit of damp cloth.

5 EXAMINE THE PRINT

When you've finished, examine the print in good light, preferably daylight. If there is not enough gum in the ink, then the difference in reflectance between the spotted areas (matt) and the rest of the print (gloss) can mean that the spotted areas still show up, especially if received obliquely. If they do, use spray to make the whole print surface a uniform matt or gloss, according to taste.

6 THE RESULT

The top print is the unspotted original. It was taken with an orange filter to darken the sky and bring out the strong shapes of the clouds. This has produced large areas of even grey which show up spots very badly. The print is also badly scratched on the left-hand side. The bottom print shows the same area after spotting. The whole operation took only five minutes.

10 INTO THE REDUCER

Immerse the print rapidly and evenly in the reducer. Rock the dish to ensure that all parts of the print are covered. The print will begin to lighten, and you must be ready to remove it as soon as the picture *approaches* the correct tone. Don't wait until the correct tone actually appears. The reducer will continue working after you remove the print and the result will be too light.

11 RINSE AND EXAMINE

Quickly immerse the print in the water bath and agitate. The water does not stop the action of the reducer straight away, but it does slow it down. Examine the print. If it is definitely still too dark, put it back into the reducer bath. Otherwise put it into the fixer immediately. If in doubt, you can always repeat the reduction process.

12 FIX, RINSE AND DRY

Give the print one minute in the fixer diluted 1 + 4 at 20°C. Then wash the print thoroughly for ten minutes and dry it in the usual way. The dried print should not show any sign of yellow staining. In our print, the street cobbles have been reduced to just off white, and there is now much more detail and brightness in the buildings on the right.

Understanding tones and grades

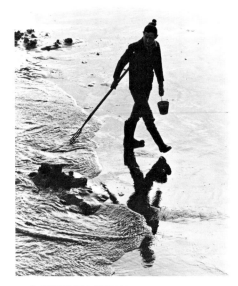

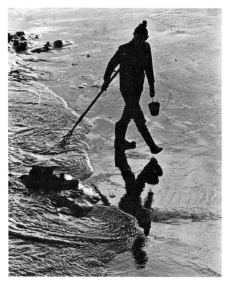

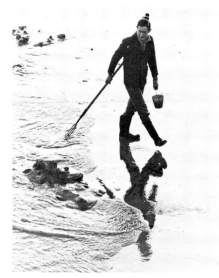

1 A NORMAL PRINT
This print represents a typical average subject, with a range of tones from black to white and fairly bright contrast. It contains a balance of detail in both the figure and the background, and it's how most people would print this picture. However, it's not the only 'correct' result possible from the negative; it's only one of several possibilities.

2 DELIBERATE OVER-EXPOSURE
Making a deliberately dark, heavy print works when there are hidden highlights in the subject, as on the water here. The technique is called over-printing. This print had twice as much exposure as the last one, and the result is very different. But the exposure is still 'correct'—we have now given prominence to the textures in the sand and sea, rather than to the figure.

3 DELIBERATE UNDER-EXPOSURE
Someone else might prefer this result. The subject himself probably would because, unlike the other two prints, it shows his face clearly. The negative was given half the exposure of the first print. The result is totally white sand and little sea detail, but all the tones in the face, clothing and bucket are revealed. Again, the exposure is not wrong, just different.

7 GRADES AND CONTRAST
In black and white (but not colour) printing you can buy paper having different degrees of contrast. The degree of contrast is called the grade, with the number of grades varying with different makes. Ilfospeed paper has four grades, from grade 1 (which gives a very soft toned result) up to grade 4 (which gives a crisp, contrasty print with strong blacks and whites).

8 SOFT PAPER
This is the result of printing a negative on grade 1 paper. Notice that the print contains no true blacks; you will only get strong blacks on grade 1 if the negative is very contrasty. A normal negative will produce only grey tones. Grade 1 is useful for portraits, backlit scenes and over-developed negatives. Prints made on grade 1 paper may lack impact.

9 NORMAL PAPER
This was printed on average contrast, grade 2 paper. The print does have a full range of tones, but most of them are very close together and there's no real separation. You might think this would be the correct paper to print on, having average contrast, but in fact the print still looks soft. The negative needs to be printed on harder paper to bring out the detail.

4 ACCIDENTAL UNDER-EXPOSURE
This print cannot be called correctly exposed: it is far too light, and the important textural detail in the old stonework has been lost. The best way to deal with this is to make another print, increasing the exposure time! However, you can attempt to 'save' it by giving it extra development, using concentrated print developer and a sponge (not a paper towel).

5 BOOSTING DEVELOPMENT
First soak the sponge in hot water and squeeze it out. This is to warm it up. Pour some concentrated print developer onto the sponge and wipe it over the parts of the print you want to darken. Work with the print in the developer bath and keep immersing it to make sure you get an even result. Never allow the print to stay in the air for more than a few seconds at a time.

6 THE RESULT
Here you can compare the treated print with an untreated one. You can now see the detail in the stonework and the opportunity has been taken to darken the sky. If you want to boost the whole print rather than just parts of it, simply add some more concentrate to the developer dish and stir it in. But don't forget to replace the developer with normal solution afterwards!

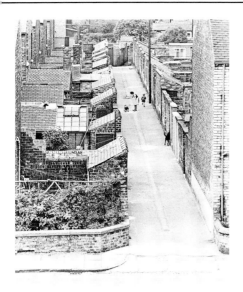

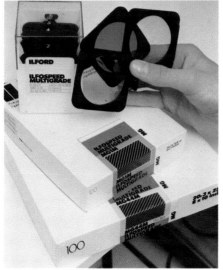

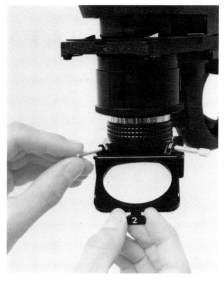

10 HARD PAPER
The print above was made on grade 4 paper, and the result is much better. All the fine detail now seems much sharper and parts of the picture are picked out in a very strong black. With some negatives the result might just have been a harsh print, but with this one, the picture is given much more impact. That is why a full range of papers is essential.

11 ONE PAPER, SEVERAL GRADES
Instead of buying lots of different grade paper, you need buy only one. It's called Ilford Multigrade and it will give you a wide range of grades. To determine the grade, you use the same paper but put special coloured filters over the enlarger lens (or place them in the filter drawer, if your enlarger has one). The filters come with the Multigrade kit.

12 USING THE FILTERS
There are seven filters. The nearly clear filter gives you grade 2, the yellow filters give you grades 0 and 1, and magenta filters grades 3, 4 and 5. The filter drawer fits any enlarger lens and it will allow you to slot in the Multigrade filters. The kit comes with a set of instructions on using the different filters and how they affect the exposure.

Selective printing controls

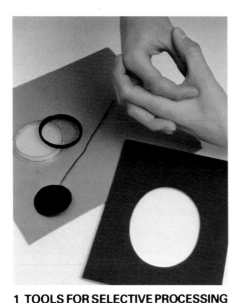

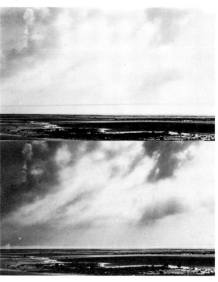

1 TOOLS FOR SELECTIVE PROCESSING
One of the simplest ways of controlling your prints is to manipulate the light from the enlarger. You can mask off some of it to lighten or darken parts of the print. To do this you use a piece of card, your own hands or a special dodging tool on a wire. You can also produce unusual-shaped borders, or soften the picture by holding a diffusion filter underneath the lens.

2 SIMPLE DODGING AND BURNING
When you stop light reaching part of a picture, it is called 'dodging' or 'shading'. The part still receiving light is being 'burned in'. The method is simple when the picture has light and dark parts with a straight division. About halfway through the exposure, hold some card over the dark part to block it off. Keep it moving slightly to avoid a hard edge between the two exposures.

3 THE RESULT
The top print is a straightforward exposure, giving correct tones on the beach, but a very interesting and dramatic sky has been completely lost through under-exposure. For the bottom print a further exposure was given with the card held on the dividing line between beach and sky to cover the beach. Now both parts of the picture are correctly exposed.

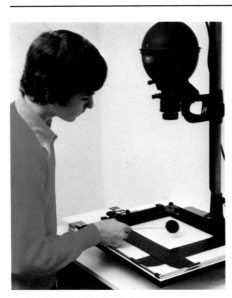

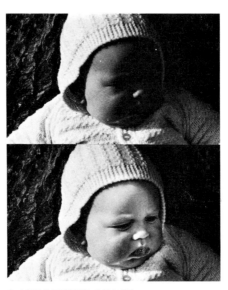

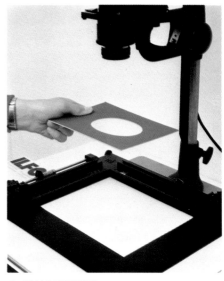

7 THE DODGING TOOL
A disadvantage of using card or your hands is that you can't shade the centre of a print without at the same time shading part of the outside as well. To get round this, cut out a cardboard disc and secure it to some wire. If you carefully keep this moving over the print the wire won't affect the exposure, but the disc will dodge out the centre of the print.

8 LIGHTENING A FACE
A good use for your dodging tool is to bring out detail in a face. The baby above was photographed in bright sunlight and printed for correct detail in the clothing. Just how much difference can be made is shown in the print below. Here, the face was dodged out to give it just a third of the main exposure. This technique works well with backlit portraits.

9 OVAL PRINTS
You don't need to confine yourself to rectangular prints every time. You can make an oval print, for example, just by masking off part of the paper with an oval cut-out. Keep the mask still and you have a sharp-edged oval; move it about slightly and the image fades away towards the border, an effect known as a vignette. This technique works very well with portraits.

4 MORE SELECTIVE BURNING IN
To dodge and burn more complex shapes, you can use your hands to project a spot of light of the right shape and size. Again, keep moving your hands about so that they never remain in one place long enough to make a sharp patch. You will need to experiment for a few prints to find out how much exposure time to give and how best to move your hands.

5 THE RESULT
In the top picture the sky has again been lost through under-exposure, but this time you can't just place a straight piece of card along the horizon to burn in the sky. If you did the top part of the bus would be over-exposed. Instead, selective hand control was used to burn in the sky, which was given four times the exposure of the rest of the picture.

6 COMBINED CONTROL
A straight exposure of a shadow falling across a stone wall produced a print where the shadow area was too dark and the sunlit area too light. For the lower version, a card was cut to the right shape and placed almost in contact with the paper. The shadow area was then given half the original exposure and the sunlit area three times as much.

10 CREATING A VIGNETTE
For this picture an oval mask was held just above the print surface throughout the exposure time and continually moved about to create a soft oval outline. The print itself was kept as light as possible for a high-key effect and to lose any background detail. This is a particularly effective way of removing a messy distracting background.

11 SOFT FOCUS EFFECTS
If you forgot to use a soft focus filter when you took a picture you can produce a similar (but not identical) effect at the printing stage. Simply hold an ordinary soft focus filter beneath your enlarger lens. Cokin and similar system filters work well here. Do not, however, place the filter above the lens or in the enlarger's filter drawer!

12 THE RESULT
Here is the same negative as in step 10, but printed darker and through a soft focus filter. The softening is particularly noticeable on the hair. Soft focus also hides graininess that may show on larger prints and it can hide small scratches on the negative. However, it it harder to 'spot out' a soft focus print than a sharp one without it showing.

How to tone prints

What is toning?

The correct term for black and white photography is 'monochrome' because the final result can be a scale of tones in any one colour, not just grey. On normal photographic paper, the tones appear in shades of grey from black to white, but the paper can be treated chemically to give shades of a whole range of colours. This process is known as toning.

The most familiar toning process is sepia toning, in which shades of grey are replaced by shades of brown to make the print resemble an old photograph. The effect works particularly well with portraits. Another popular colour is blue; it is ideal for seascapes, snow scenes, night-time shots and moonlit effects. These and other colours such as yellow, red, green and mauve, are available in kits from your photographic dealers.

Toning is usually carried out on a completed black and white print—one that has been developed, fixed and washed. It's simplest to tone the print straight after processing, then there is no need to dry it first. But you can also tone an existing print if it is not too old, has been stored carefully and has no scratches or finger prints on it—otherwise the toning will not be even.

1 SEPIA TONING: THE KIT
For sepia toning you can use a kit. The one shown here is made by a French company, Colorvir, though other kits are available. Most kits contain two solutions. One is the bleach bath and is slightly corrosive; the other is the toner solution. Both solutions are in concentrated form and must be diluted before use. You will also need a dish to hold the print and running water.

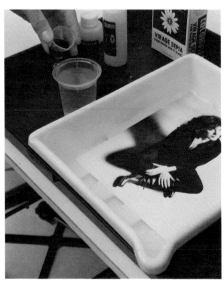

2 MAKE UP THE BLEACH
A 10x8 print needs about 500ml of liquid to cover it, and the bleach concentrate must be diluted 4:100. So measure out 500ml of water at 20°C and add to it 20ml of bleach concentrate. Mix the solution thoroughly to ensure that it will act evenly over the print surface. If your print is dry, have it soaking in water while you do this.

6 BLUE TONING: THE KIT
Blue toners often work as a single solution, where you can immerse the print and watch it change colour. This is the Berg Blue Toner kit from the USA, though others are also available. This kit has two concentrates that have to be mixed together to form the working solution. Unlike sepia toning solutions, this one can be stored for six months.

7 MIX THE KIT
Again, you will need about 500ml of solution to cover a 10x8in print. Add 100ml of concentrate part A to 250ml of water. Then add 100ml of part B and top up with water to 500ml. (The kit's instructions suggest you make up all of the concentrate at once to form a litre of solution, but you need not do this. The solution only lasts 6 months, whereas the concentrate lasts indefinitely.)

8 ADD THE TONER
If the print is dry immerse it in water beforehand to make sure that the action of the toner is even—the toner can work extremely quickly. Pour the toner over the print, keeping the stream of toner moving so it's not landing on the same spot for too long, otherwise that spot may tone first. Rock the dish to keep the solution agitated, and be ready to remove the print.

3 BLEACH THE PRINT
Drain the print if it was soaking and place it in the dish. Pour the yellow bleach solution onto the print and rock the dish to keep the bleach moving over the surface of the print. Continue until all the tones, even the darkest blacks, have a brown tinge. This will take at least two to three minutes. Don't discard the bleach solution; save it for a second print.

4 TONE THE PRINT
Rinse the print and prepare the toner solution, again using 500ml of water at 20°C and 20ml of concentrate. Pour this onto the print. It will immediately change colour from sandy brown to chocolate, and will then darken fully in about a minute. Store the toner and rinse the print. Both solutions will last for about 30 minutes and will tone several prints.

5 THE RESULT
You should end up with a print having rich dark browns and whites that are slightly warmer than the original print, but still fairly clean. The exact colour of the print depends on the kit you used, the type of paper, the developer that the original print was processed in and the time of that development. (Don't try to tone a 'snatched' print; give full development to prints for toning.)

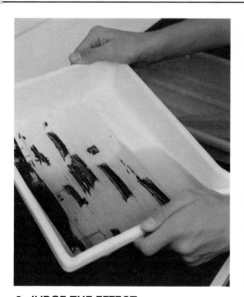

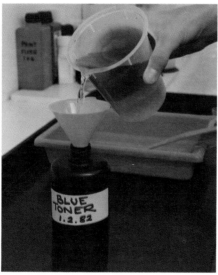

9 JUDGE THE EFFECT
The yellow solution tends to obscure just how blue the print is becoming. This print looks dark blue, but once the solution is washed off it will be much brighter. Don't leave the print in the toner for too long or the highlights will start to turn blue. You can always return the print for more toning later, so remove it just before you think the effect is strong enough.

10 STORE THE SOLUTION
Do not discard the solution. Pour it into a labelled, dated brown bottle. Berg recommend using a glass bottle because the solution tends to deposit out onto the sides of plastic bottles. However, a plastic bottle is quite adequate if you plan to use the solution over a period of weeks rather than months. Seal the bottle well and keep it away from children.

11 THE RESULT
Wash the print in running water for ten minutes. Your final print should look like this. The whites have remained fairly clear, though the toner has extended slightly into the highlights from the shadows to give a soft-focus effect. This can only be avoided by giving the print the absolute minimum toning time, but it's inevitable if you want a strong blue.

Creative sandwiches

What is a 'sandwich'?

If you are used to printing colour slides or black and white negatives you'll find it just as easy to print a combination of two images instead of just one. This combination is known as a 'sandwich'. You simply place one image on top of another and print them as if they were a single image.

The easiest form of sandwich printing (at least, if you're used to Cibachrome printing) is with two colour slides joined together. Just by holding the two slides together up to the light you can see immediately what the result will look like. Printing a black and white sandwich is slightly more difficult because you're dealing with negatives. You can't see the final result just by looking at the two images together. And the combined print is not the same as the two individual prints of the images combined together because the tones are reversed on a negative. So you have to be rather more careful in your choice of images to sandwich.

There is, however, a way of combining two individual negatives into one. It's by exposing each one separately onto the same sheet of paper. We look at this technique here as well.

1 COLOUR: SELECT YOUR SLIDES
Go through your slides and find some suitable images to combine. Very simple subjects such as skies, sunsets and seascapes make the best combinations. Complex subjects do not work well; neither do dark subjects—remember that a dark area on one slide will be dark on the combined image. Try to select two slides from the same type of film. Here, both are on Kodachrome.

2 THE FIRST IMAGE
This is an ideal 'foreground' image: a strong, simple silhouette against an almost plain background. There is little colour, hardly any shadow, and the sky is completely blank. This picture could be dropped over almost any other image—patterns, skies or even a portrait—without creating problems. And because it is a very light slide, it does not add much density.

6 BLACK AND WHITE
This print was selected because it has a plain white sky and a large black area. Thus it is an ideal negative to combine with another, either by sandwiching, where the detail will appear in the cloak, or by double exposure, where the detail will appear in the sky. The film doesn't need to be of the same type here, so long as the negative densities are similar.

7 THE SECONDARY NEGATIVE
This will be the secondary negative, chosen because it does not have a strong subject. Instead, it shows an abstract pattern of surf and is almost evenly grey all over. It does not stand on its own as a picture but will work well combined with another. You may not have a suitable secondary image that's abstract enough. If not you can easily shoot one specially.

8 COMBINE THE NEGATIVES
Place the two strips of negatives next to each other, again emulsion side to emulsion side for sharpness. Get their relative positions roughly right, then put them into your negative carrier. Place the carrier in the enlarger and switch it on so you can see the combined image. Now get the images in exactly the right place by moving the strips slightly.

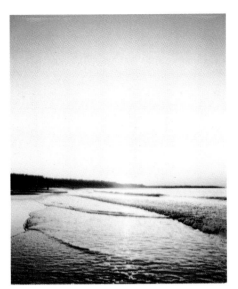

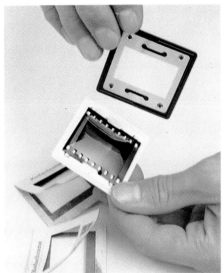

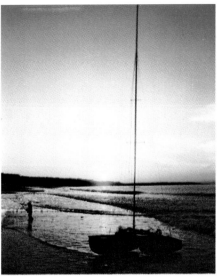

3 THE SECOND IMAGE
This is the background image. It is darker and more colourful than the first one, and will provide almost all the detail in the picture, except where the silhouette of the boat comes through. Make sure your second slide combines well with the first one. Here, the scenes are similar, both are vertical, and they both have the horizon at roughly the same level.

4 COMBINE THE SLIDES
Take the slides out of their present mounts and clean them thoroughly. Clean a glass slide mount in readiness for the slides. (Use glass rather than card to stop them moving once mounted.) Place the slides emulsion side to emulsion side for maximum sharpness. If necessary, stagger the slides to make sure that their horizons match. Now mount them.

5 THE RESULT
Now print the combined slide using your Cibachrome kit (for details, see issues 116–120). This print needed about twice the exposure of a normal Cibachrome print, but no filtration change was required from normal. The horizons are lined up perfectly, and you cannot 'see through' any of the bold silhouetted subjects. This can happen with weaker-coloured subjects.

9 THE RESULT
With a negative sandwich details appearing as dark areas on one negative can only print if they coincide with clear or thin areas on the other negative. This means that in our example the sea won't print over the sky because this is black on the negative. It will only print over the cloak and the woman's face and arms because these are pale on the negative.

10 DOUBLE EXPOSURE
An alternative way of combining two black and white prints is by double exposure. Use a paper easel like this so you can position the paper accurately. Expose the first negative. Then remove the paper while you replace it with the second negative. Return the paper to the easel, making sure you position it accurately and that it's the right way round. Now expose again.

11 THE RESULT
Double exposure has produced a more effective result in this case because the surf has printed over the plain sky but less so over the girl. The picture now conveys much better the image of a girl looking out to sea. Each picture was given half the exposure normally needed to produce a correct density print. This works despite the images being of different subjects.

Making extra large prints

What you need

If a photograph looks good when it's at the enprint size the chances are it'll look a lot better when it's blown up large. And with the quality of modern films you don't need to worry too much about the problem of grain. Medium-speed 35mm films, both black and white and colour, can be enlarged to as much as 20x24in (50x60cm) and still give fairly acceptable quality. Enlargements to smaller sizes such as 12x16in (30x40cm) should now be routine.

Not all enlargers are suitable for making extra-large prints. You have to be able to move the enlarger's head or column to project an image of the right size; the lamp must be powerful enough for you to see the image clearly and the enlarger must have a good-quality lens.

The main practical difficulty is not with the exposing but with the processing. For black and white work you will need two dishes large enough to take the large-size paper. If your darkroom is small, then you can use only one processing dish.

For extra-large colour prints the method is much the same as for small print, except that you will need a large drum—the processing dishes are too inconvenient.

1 EXTENDING YOUR ENLARGER
The first step is to project a large enough image. One way is to extend the enlarger column so you can move the head further away from the baseboard. If the column is 1¼in thick then you can buy an extension like the one shown above. It also moves the negative further out so you can use wider paper. Other enlargers may have special extensions available.

2 PROJECTING ON TO THE FLOOR
Another way is to turn the head or column round and move the enlarger to the edge of the bench so it projects on to the floor. Make sure you place a heavy weight on the baseboard, otherwise the enlarger will topple over. Check that the floor and the bench-top are parallel; if they aren't you won't be able to focus all of the image at once.

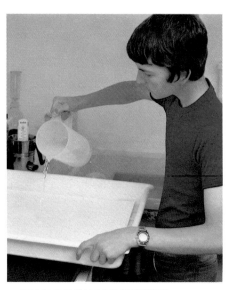

6 SINGLE-DISH PROCESSING
For larger prints such as 20x24in it's often convenient to use just one dish for the processing, especially if your darkroom is small. Place the print in the dish, emulsion side facing up, and pour developer over it. Keep moving your hand as you pour to cover the whole surface and prevent a 'hot-spot' from forming. *(Remember to keep a safety light on during processing.)*

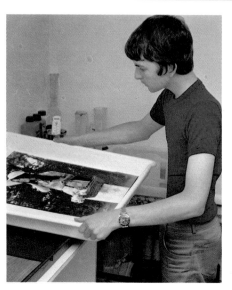

7 DEVELOPING AND FIXING
Use a slow-working developer with dilution adjusted so that development will take about two minutes or longer. Then you need use only a small amount (1000ml). Rock this over the image until all of it is evenly developed. Return the developer to its container, rinse the print with 1000ml of water, then add 1000ml of fixer diluted 1 + 3. Rock this over the print for 2–3 minutes.

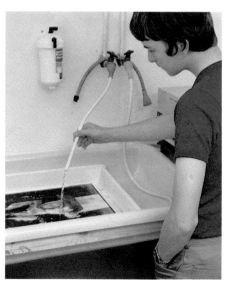

8 WASHING
Big prints need careful washing, especially if they are to be used for an exhibition. Use a short hose to direct water over the print. Wash each quarter individually for five minutes. With a plastic-coated (RC) paper, do this emulsion side upwards—it's the emulsion that absorbs the chemicals, not the base. Keep the print covered while washing and use a fast flow of water.

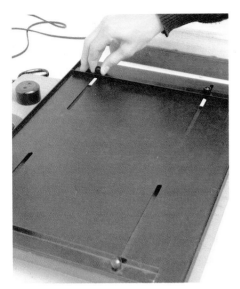

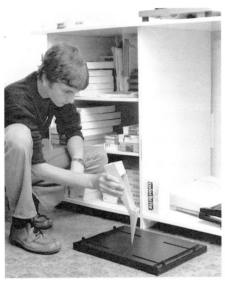

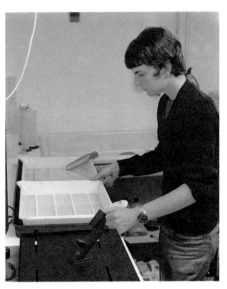

3 LARGE PRINT EASELS
For large paper sizes you don't need to buy an expensive masking easel. Instead, use a large piece of card on which to place the paper (as in picture 1), or buy a simple large paper easel, as shown here. This easel is black to minimize reflections and increase contrast. It produces borderless prints size 12x16in or less, and is far cheaper than a masking easel.

4 FOCUSING AT FLOOR LEVEL
You can use a special large focus finder, such as the Unicolor one shown here. This allows you to see the focused image and adjust the focusing control on the enlarger at the same time. Ordinary focus finders are less suitable because you have to get down to see the image. Put a piece of white paper on the easel to make focusing easier.

5 TWO-DISH PROCESSING
To process small black and white prints you generally use three dishes— developer, stop-bath and fixer. With prints up to 16x20in you need use only two dishes. The first dish contains developer and the second water and fixer alternately. You place the developed print in the second dish, rinse it, discard the water then add the fixer. Rebottle the fixer afterwards.

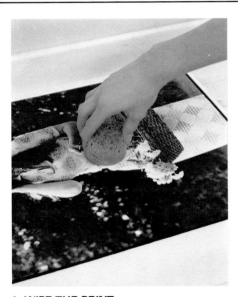

9 WIPE THE PRINT
A large print carries a lot more surface water than a small one, so it helps to remove as much water as you can before you leave it to dry. If you are quick and do not let the emulsion become tacky, you can wipe the print with kitchen paper towel to remove excess moisture. This will also improve surface sheen. Alternatively use a sponge.

10 DRY THE PRINT
The print will probably be too large for you to dry hanging it in a drying cabinet. If so, attach a clip to one of the corners—keeping it away from the image area—and hang it up to dry in a well-ventilated room. An RC paper should take about 30 minutes. When it's dry, trim off any spare paper. Here, we've made a 16x24in (40x60cm) print on 20x24in (50x60cm) paper.

11 EXTRA-LARGE COLOUR PRINTS
The technique for making large colour prints is much the same as for small ones, though prints larger than 16x24in (40x60cm) are expensive and difficult to process. You cannot afford many failures. Here, a 12x16in (30x40cm) drum is being loaded—make sure you fold the paper the right way round to fit the drum. Drums should be loaded in complete darkness.

The permanent darkroom

Which room?

If you decide that you want to become seriously involved with processing and printing your own photographs, then it's well worth your while building a permanent or semi-permanent darkroom. You could use a spare bedroom, a disused coal store or a dry cellar (providing it has good ventilation).

Another possibility is the garage. You can separate off the last 5–6ft (1.5–2m) at one end, or you can fix up movable screens or curtains to mask off the darkroom when you need it. This arrangement gives you an ideal shape darkroom: long and narrow. You can set up a long bench and have all your chemicals and processes arranged along it in sequence from left to right.

The minimum size darkroom you will need is about 5ft by 8ft (1.5m by 2.5m). The author's darkroom, shown in these pictures, measures 6ft by 11ft (2m by 3.5m). It was converted from an old cowshed. Part of it was divided off with a plasterboard wall and all the remaining walls were covered with plasterboard. The existing floor was covered with concrete to create a level surface and later with a vinyl covering. Afterwards the fittings were added.

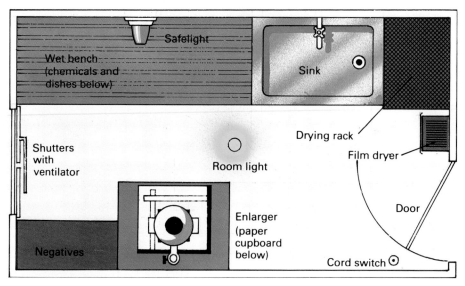

1 PLAN YOUR DARKROOM

Before you start any construction work draw up a plan to decide how you are going to arrange everything. Most people work from left to right, or clockwise, so arrange your processes to conform to this. Also, try to keep wet and dry areas separate, as far as possible, and reduce the amount of moving you have to do by using both sides of the darkroom.

Above is a typical darkroom layout for a small room with plumbing. As you come in through the door, the first thing you see is the enlarger. Moving clockwise around the room, you pass the processing bench, washing facilities and finally the drying rack. The dry area (enlarger, paper and negatives) is on one side of the room and the wet area (processing bench, chemicals and washing area) is on the other side.

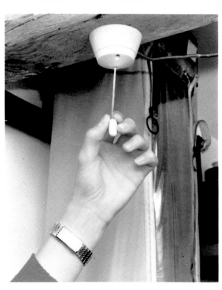

4 LIGHTING AND ELECTRICS

This darkroom has seven double sockets with switches. None of them is near the sink area and all are placed so that the wires never have to trail very far. The light circuit is separate and is operated by a pull-cord switch rather than the usual wall plate. This avoids the risk of receiving an electric shock from touching a switch with wet hands.

5 STORING NEGATIVES

Negatives are best stored next to the enlarger area. Not only is this convenient, but they will also be well away from the wet area. A steel shelf of the type shown here is ideal for storage, and other items such as focus finders, gloves, *etc.* You must *never* put chemicals, wet processing equipment, *etc* on or near it. Only permanently dry items are stored here.

6 STORING PAPER

Don't store photographic paper on shelves; it can be quite heavy and may overbalance. Here the paper is being stored underneath the enlarger, near floor level but well away from the wet area. Down here, stray light from the enlarger won't strike the boxes directly, and the weight of the paper helps to stabilize the enlarger bench and dampen vibrations.

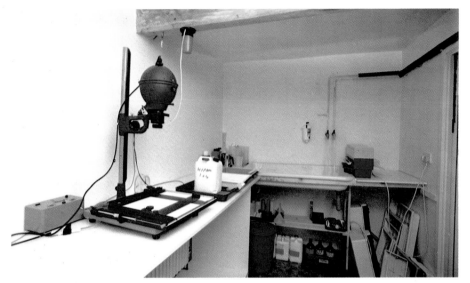

2 A TYPICAL DARKROOM
This is the author's darkroom. The bench on the left is the wet area—the enlarger usually sits where the camera was positioned to take this picture. At the far end of the room a simple wooden framework holds a large darkroom sink with both hot and cold water. Because of the pale paintwork, a single orange safelight with a 15w bulb provides enough light.

There are power points above bench level which is safer, and avoids having wires trailing too far. There is a central heating radiator under the bench to help keep dishes warm in winter, and the cold pipes are lagged to stop condensation forming and dripping on to the prints or negatives. A ventilator has been attached to the outside wall to remove unpleasant fumes when mixing chemicals.

3 BLACKING-OUT THE ROOM
The best blackout comes from a well-fitting door, light-tight ventilator and no windows. If your door lets in light apply heavy, black industrial foam tape around the edges to seal out the light. But make sure you have some kind of ventilation before you do this because this type of tape also seals out the air. You can buy special darkroom fans to overcome this problem.

7 STORING DISHES
Store all dishes, tanks and colour processing baths at floor level under the wet bench. Stand the dishes on edge—they will collect less dust that way than if they were laid flat. They also occupy less space stored upright, and you can find the dish you want without having to hunt through a pile because you can quickly see their sizes.

8 THE DRAINING RACK
Construct a draining rack under the sink as part of its support frame. You can use this rack to dry all your funnels, developing tanks, measures and other items quickly and thoroughly. On the floor beneath this rack you can store your bottles and containers of chemicals. Wash all items thoroughly before leaving them to drain, and wipe down the rack regularly.

9 FLOOR COVERING
If your floor is wooden you must cover it to stop the floor boards from rotting. Similarly, concrete floors must be covered or treated, otherwise you will have problems with dust and it might absorb chemicals to be released later. A good solution is to lay down some vinyl floor covering. It can be wiped clean and provides a good grip for the feet.

CREATIVE DARKROOM TECHNIQUES

Images without a camera, colour from black and white, night from day, and fantasy from slices of real life – all these things can be created in a darkroom or workroom. You may think that once a print is produced, that's the end of it; for others, the print is just the start of a journey through new imagery.

Dyes, chemical toners, special papers, and simple techniques produce pictures that are both graphic and original. Combining various effects can transform 'original' into 'unique'. The flower on the facing page, placed on top of a sheet of photographic paper and exposed to light from an enlarger, forms a unique image; the next attempt would be slightly different because the subject would never be in exactly the same place or form an identical shape.

The following section deals more with broad concepts, methods and ideas than step-by-step processes. As new products and tricks are constantly introduced, you have to look around to see what's available. Every time a manufacturer changes the characteristics of a photographic printing paper, it may turn out to offer a new spin-off effect in creative work.

The only guideline is to experiment freely, taking care to follow safety precautions with chemical processes. Remember that original slides or negatives are valuable and irreplaceable, so if you plan any retouching, toning, or any other after-treatment, always make a copy.

Push processing

The prospect of taking pictures at night makes most photographers reach for their flash guns. But there is another solution to the problem of low light —one that:
● preserves the natural drama of the scene lighting,
● minimizes the amount of extra equipment the photographer needs to carry,
● can be used with any camera that has an f2 or faster lens,
● makes exciting pictures by ordinary artificial light.
The answer is to push your film.
Pushing means exposing the film as if it had a higher speed than the manufacturer says, then changing the development to compensate. It is a common technique with black and white film, but you can also push colour slide and negative films with good results.
Typically, a pushed film will have a grainy appearance and less detail in the shadow areas. If it is a colour film it will probably show changes in colour as well. These qualities can all give extra impact to the right pictures, so you may want to push your film for creative as well as practical reasons.

Limitations of pushing
If pushing was the answer to every photographic problem then there would be no point in exposing film at its normal ISO rating. In practice the strengths of pushing can also be its weaknesses. Less exposure and more development means less detail and more grain, and if you are photographing a scene that needs to be recorded

sharply and with plenty of detail in the shadows then you will be disappointed by the results.
When you push negative films, the constrast will be increased by the longer development—but only until base fog begins to show (see box). So the best subjects for pushing are those that are not too contrasty to begin with.

How far can you go?
In practice you can push the effective speed of your black and white negative films by two or three stops. This means that you can set your light meter to four or eight times the recommended film speed. Colour negative films can also be uprated by two or three stops, but some unusual colour shifts can be expected.
Colour slide films can usually be pushed by only one or two stops. Kodachrome films cannot be pushed because they must be processed by a laboratory, and very few labs are willing to give the film the necessary special treatment.

Pushing black and white
Although you can use an ordinary developer for pushing, simply by extending the development time, it is better to use a specially formulated speed-increasing developer that won't increase the base fog too much.
Developers such as Acuspeed. Emofin and several others are made to give the highest film speeds with short developing times.
Pushing with an ordinary developer can require long developing times. This can soften the film emulsion, so be sure to

◀ Colour negative films can be pushed successfully as long as the subject does not need very accurate colour reproduction or fine grain. This picture is a print from a small section of a 35mm Fujicolor 400 negative that was exposed at 3200 ISO. The dancer was lit by lights, so colour accuracy was not important.

▶ 400 ISO colour slide film pushed two stops to 1600 ISO will give results like this picture by *Michael Boys*. Grain and sharpness are much worse than normal, but the effect has been used to accentuate the soft mood of the picture. A subject like this suits pushing.

◄ Although 35mm cameras are usually chosen for low light photography, modern roll-film cameras can also be used, despite their slower lenses. Here Kodak Royal-X Pan film, which has a normal rating of 1250 ISO, was exposed at 6400 ISO and developed in DK50. The large film size, requiring less enlargement, minimized the increased grain of the pushed film.

▶ Working with tungsten-balanced slide film uprated to 800 ISO accentuated the blue of the sky and the atmosphere of the fair at dusk, at the same time rendering the light bulbs in their natural colours.

▼ Kodacolor 400 negative film was rated at 1000 ISO and processed for $5\frac{1}{4}$ mins. in Paterson Acucolor 2.

How base fog affects your pictures

When you develop your film it isn't only the *exposed* silver halides that are turned into black metallic silver. If you develop your film long enough, *unexposed* silver halides will start to be developed as well. This unexposed silver creates 'fog' which can spoil your pictures if you aren't careful.

The bars in this diagram represent the different densities of silver created in a normally exposed and developed film. The shaded area represents the fog level. The shortest bars correspond to the shadow details of the image.

This diagram represents an over-developed film: the base fog level has risen to swamp details in the shadows. The image has lost information. A print made from a negative like this will have muddy grey looking shadows and will have to be printed on harder paper to give an acceptable print.

use a stop bath and a hardening fixer if you push your film by extending the development time.

Pushing black and white films is now so common that film manufacturers have begun to design their products in such a way as to give better results with pushing.

For example, Ilford's HP5 can safely be pushed to an equivalent of 1600 ISO, or even higher if the contrast or the subject lighting is low enough.

Pushing colour slides

To push slide film, the processing is altered by increasing the time the film spends in the first developer. Kodak publish data for pushing E-6 Ektachrome films. By following their instructions Ektachrome 400 can be exposed as 1600 ISO. Ektachrome P800/1600 is specially designed for pushing to 800, 1600 or 3200 ISO using 'P1', 'P2' and 'P3' E6 processing. Agfachrome XRP 1000 pushes to 2000 ISO and Fujichrome RD1600 is push-processed automatically. Other makes of film can be push-processed using home kits by extending the first development time (see table) but leaving other process steps unchanged.

Pushing colour negatives

When colour negatives are push processed they give considerably increased graininess and soft colours. For this

reason most commercial laboratories will not push colour negatives, and processing has to be done at home. Any of the 400 ISO colour negative films available can be push processed fairly well. All are compatible with the Kodak C-41 process, but the kits made by such firms as Photo Technology, Paterson or Tetenal can also be used. Strange colour casts may be noticeable due to the phenomenon known as 'crossed curves', but this will not necessarily spoil your pictures. If your pictures need accurate colour, then you shouldn't push your film.

UPRATING YOUR FILM

This table gives developing times in minutes for uprating 400 ISO films to higher speeds.

Equivalent ISO rating	Black and white Times for Tri-X at 20°C		Colour slides first development times at 38°C		Colour negatives first development times at 38°C	
	D-76	Acufine	E-6	Tetenal UK-6	C-41	Photocolor II
800	9	5½	9	8½	4½	3¾
1600	11	7½	12	12	6¾	5
3200	15	11½	20	19½	8	6¼

The development times given are only a guide for further experiments. However, they should give usable slides and negatives for the exposure ratings listed.

Making black and white photograms

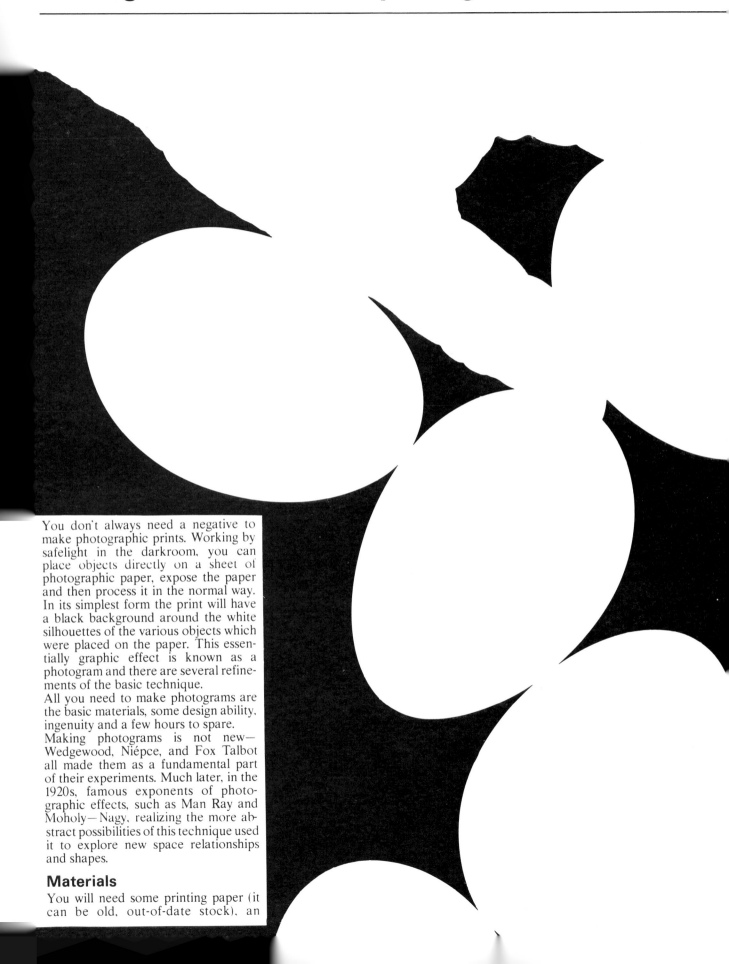

You don't always need a negative to make photographic prints. Working by safelight in the darkroom, you can place objects directly on a sheet of photographic paper, expose the paper and then process it in the normal way. In its simplest form the print will have a black background around the white silhouettes of the various objects which were placed on the paper. This essentially graphic effect is known as a photogram and there are several refinements of the basic technique.

All you need to make photograms are the basic materials, some design ability, ingenuity and a few hours to spare.

Making photograms is not new—Wedgewood, Niépce, and Fox Talbot all made them as a fundamental part of their experiments. Much later, in the 1920s, famous exponents of photographic effects, such as Man Ray and Moholy—Nagy, realizing the more abstract possibilities of this technique used it to explore new space relationships and shapes.

Materials

You will need some printing paper (it can be old, out-of-date stock), an

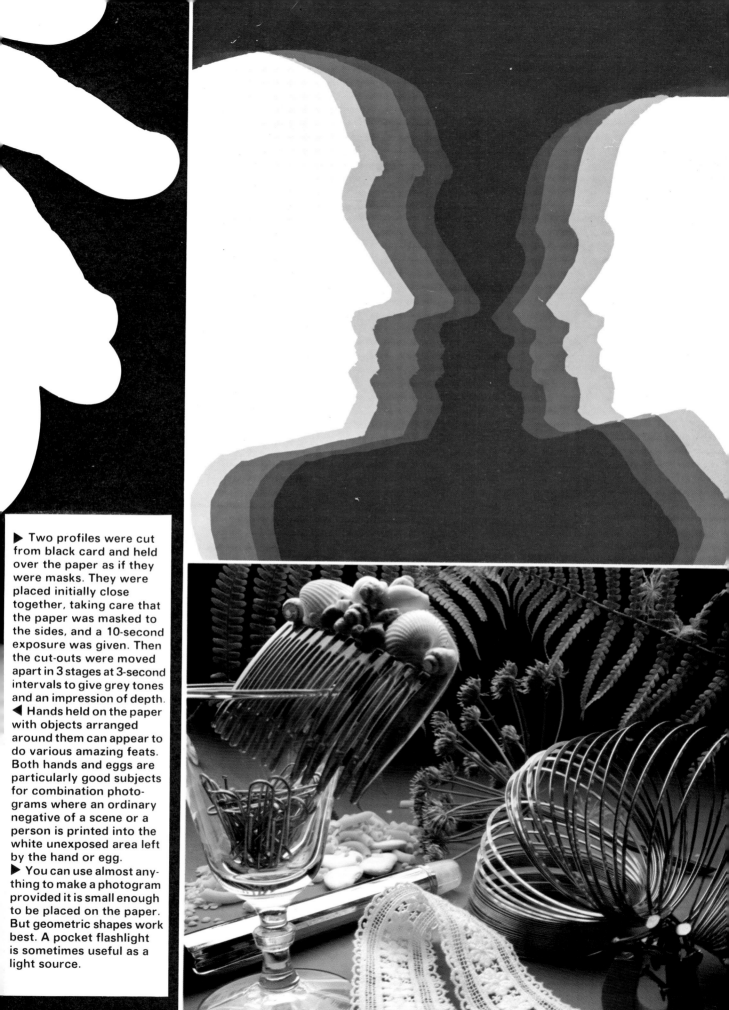

▶ Two profiles were cut from black card and held over the paper as if they were masks. They were placed initially close together, taking care that the paper was masked to the sides, and a 10-second exposure was given. Then the cut-outs were moved apart in 3 stages at 3-second intervals to give grey tones and an impression of depth.

◀ Hands held on the paper with objects arranged around them can appear to do various amazing feats. Both hands and eggs are particularly good subjects for combination photograms where an ordinary negative of a scene or a person is printed into the white unexposed area left by the hand or egg.

▶ You can use almost anything to make a photogram provided it is small enough to be placed on the paper. But geometric shapes work best. A pocket flashlight is sometimes useful as a light source.

enlarger, a safelight, the processing chemicals for making black-and-white prints and a miscellaneous collection of objects and materials—some opaque and others translucent. A supply of black card and an alternative light source such as a pocket flashlight could also be useful.

For most photograms an exposure of several seconds is enough, but you may like to make a test print of a series of exposures which give different grey tones through to black. (You will need to standardize on the height of the enlarger head and the stop used). When you are using the enlarger solely as a light source, and don't need to worry about focusing, it is a good idea to move the enlarger head to the top of the column and stop the lens down. This will give a longer exposure time and allow you to move objects if necessary.

Grey tones

As a relief from the starkness of black-and-white effects you can produce softer grey tones, either by moving the opaque objects slightly and giving another brief exposure to give a grey tone margin at the contour where the paper was previously unexposed, or by using translucent objects. Useful translucent items are glass ashtrays, textured glass, wine glasses, marbles, cling film wrap, cellophane, light bulbs, and net curtains. Place the objects directly on the printing paper on the baseboard. Scrunch the softer materials up to create contours and form.

Displacing some items, or even removing them completely and replacing them with others during exposure, also gives grey tones. For example, you might have a scattered pattern of small cut-out paper shapes which could be slightly displaced during the exposure by blowing them gently from one side. If you choose to remove the objects and replace them with other things, a smaller shape must be put down in place of the shape which has been removed.

Oblique light sources

Instead of using the overhead enlarger light for exposure, try using a flashlight and shine the light obliquely at the objects. This is especially effective if used for translucent objects such as small glass bottles. There is plenty of scope to experiment with angles and times, and if the flashlight beam is too bright it can be masked by taping pieces of card over the glass or cutting down the light by covering part

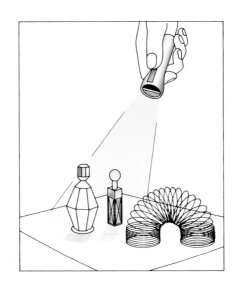

▶ Glass perfume bottles were placed upright on the paper and the exposure made by briefly shining a flashlight, held high, obliquely at the bottles.

▼ Translucent objects such as glasses, bottles, marbles or acrylic boxes give unusual effects when exposed by flashlight. You will need to experiment with the timing, distance and angle of light and tape masks if it is too strong.

of it with red adhesive tape for a fine beam. Light from a small pen-light can also be used to squiggle a freehand sketch on the paper.

Projection photograms

If you have a glass negative carrier, a wide variety of items such as feathers, lace, insects, and leaves can be inserted and enlarged with superb sharpness, after careful focusing, to reveal minute detail. You can also make combined effects. For example, put a lettuce leaf in the carrier and place cut-outs of two frogs, or children's toys, directly on the printing paper.

Thinly sectioned radishes, parings of lemon peel and fragments of orange segments also have hidden wonders. But blot up any excess moisture or leave the section to dehydrate as you don't want vegetable or fruit juices leaking on to the masks around the negative carrier. If you feel more adventurous you can prepare your own glass plates for use in place of the negative carrier. Some unusual abstract effects can be made with crystals—for example, unrefined sugar, set in dishwashing liquid, which is allowed to dry hard. Alternatively, try ink (a few drops) on glue smeared between two glass plates.

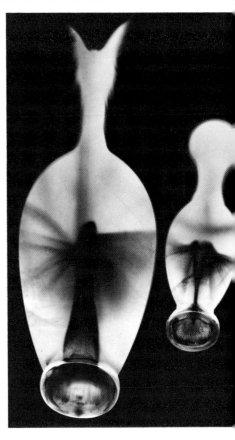

Variations

More variety still can be introduced by achieving soft and hard-edged images on one print. To do this you place some of the objects directly on the paper and other objects on a sheet of glass which you hold above the paper (for the softened effects).

Another variation is to print a combination of photograph and photogram. For example, a negative of a real field with hedges and trees could be placed in the negative carrier and skeleton leaves and dried grasses laid on the paper, after composing and focusing the negative. The combination is then exposed normally.

It can be interesting to introduce some colour. Kentmere and Luminos produce a line of tinted papers which are brightly coloured and are processed just like bromide papers in ordinary developers. Colour may also be added as an after treatment, using vegetable or fabric dyes, or even with felt-tipped pens. You use a tablespoon of vegetable dye to 17 US fl oz (½ litre) water and tone more fully than desired as a certain amount of colour washes out. Cold water fabric dyes are best but they may stain your hands so lift the print out of the dye with tongs.

▲ The image of a lacewing fly, placed directly on the glass of a negative carrier, was projected on to the paper. The photogram obtained was then used as a paper negative to contact print a white-and-black print.

▶ Top right: with a supply of tacks, lentils, rice, pins, paper clips, washers and similar objects, you can make many amusing designs similar to the example shown here. Use translucent objects if you need grey tones.

▶ This looks like an abstract photograph of a potter working at his wheel. It is really a child's toy, a slinky, held so it swings gently halfway between the enlarger lens and paper; exposure 3 sec. at f4.

A photogram can be used as a paper negative; you turn it into a positive simply by laying it face down on another sheet of printing paper (emulsion to emulsion) and exposing through the back just as if it were a negative that you were contact printing. (A print on lightweight paper is best and you will need a sheet of glass to keep the papers flat.)

As you see, there are endless permutations and combinations, so some original thought is required when planning a photogram. Too frequently they suffer from randomness and until you have some experience it is best to keep the design simple, using only two or three objects.

Apart from the satisfaction of producing a pleasing visual effect, photograms may make original book or record cover designs or even Christmas or greeting card themes— use masks with cut-out letters for black wording.

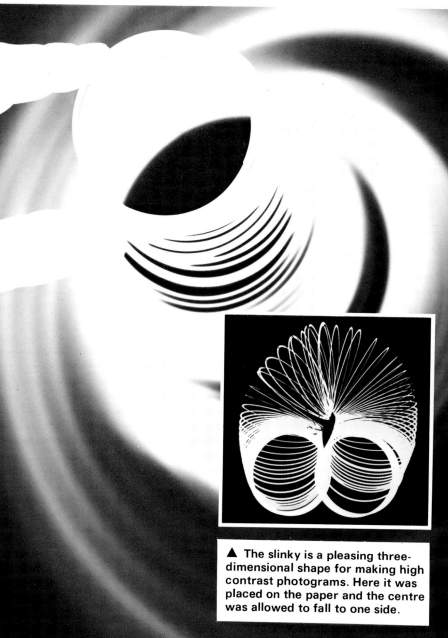

▲ The slinky is a pleasing three-dimensional shape for making high contrast photograms. Here it was placed on the paper and the centre was allowed to fall to one side.

Making colour photograms

Colour photograms are easy and interesting to make. Like any photogram, they are essentially shadowgraphs on photographic paper of objects with decorative shapes or translucent patterns.

With colour reversal papers, such as Ektachrome paper or the Ilford Cibachrome material, you can make a photogram in natural colours. Or, if you wish, you can turn the spectrum upside down to produce photograms of familiar objects in bizarre colours using negative colour paper such as Ektacolor.

As you are not usually concerned about accurate colour balance, this is a good opportunity to use up those packets of old paper or chemicals you were wondering what to do with. The limits will not be your materials or your knowledge of photography; they will be the extent of your imagination. Here is a photographic field where artistic skill counts for more than photographic ability.

Materials and equipment

You will need a darkroom, an enlarger with a set of colour filters or a dial-in colour head, a thick sheet of glass (with smoothed or tape-bound edges to prevent cuts), a supply of colour printing papers and the compatible print processing chemicals.

Colour negative papers such as Kodak Ektacolor give unusual photograms in complementary colours—for example, green in real life becomes magenta in the print.

For photograms in natural colours you use the reversal print materials of the type used to make prints from slides—either the Ilford Cibachrome process or Ektachrome 2203 or 14RC paper with the appropriate Ektaprint chemicals.

Finally, for creating abstract photograms you need a small torch, some thin card for masks, and tricolour filters (obtainable from a photographic dealer), such as No. 25 (red), No. 58 (green), and No. 47 (blue), or you could use coloured acetate film (bought from graphic art shops).

Choosing suitable subjects

Subjects fall into three general groups: natural subjects such as leaves, flowers and foods; created scenes such as landscapes; and abstract patterns.

Whatever subject you choose, remember that you will be producing a shadowgraph in colour. It therefore helps to choose colourful items that are also translucent, such as marbles, acrylics, and leaves, so that they transmit light.

Leaves and small flowers are among the simplest subjects for photograms. They can produce delicate colours which you can change by using different filters.

Many larger flowers will need some surgery to allow them to transmit light.

▲ ▶ You can make beautiful photograms by laying flowers on colour reversal paper. (Thicker flowers need cutting away to make them translucent.) The enlarger lens was set at f8, filtration 30M, time 30 sec.

▼ Protect the paper with a thin sheet of plastic and lay the section of pepper on top. Left: Ektacolor 74 paper, filters 110Y + 70M, time 20 sec—use unexposed, processed colour negative film in carrier. Centre: Ektachrome 14RC paper, filtration 30M + 10C, time 20 sec. Below: filtration 30M + 30C, 15 sec.

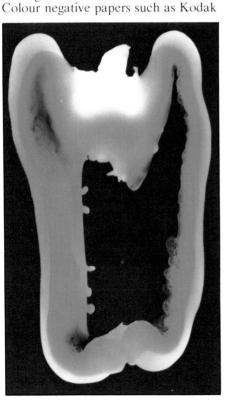

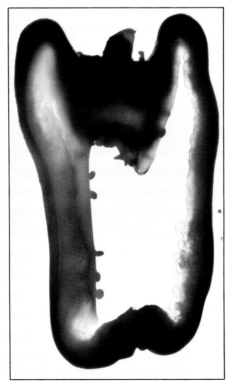

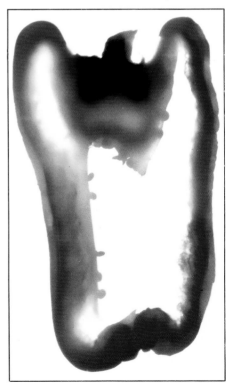

For example, those flowers with lots of petals will not show their true colour unless most of the petals are removed. Roses come into this category. Try cutting flowers like these in two. You may even have to remove most of the inner petals, leaving just the outer ones intact to give the flower its distinctive shape. Not all foods make suitable photograms. Choose those with bold colours such as oranges, red or green peppers, peaches, tomatoes, or brown bread. Light coloured foods don't have so much impact.

However, it is in the world of created scenes and abstract patterns that your artistic ability will have greatest scope. With colour reversal paper and using tricolour filters (or coloured acetate film) and shaped masks, you can create such colourful scenes as a sunset in America's Death Valley or a spectacular burning house. With a blue tricolour filter and a few twigs you can simulate moonlight over the moors or a dark haunted wood. The main thing to remember is to keep your composition simple.

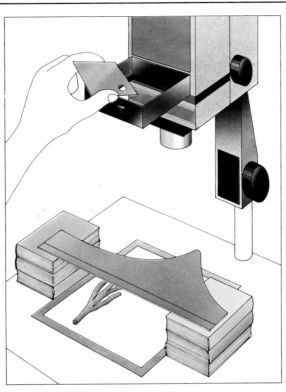

◀ ▼ For a sunset scene on Ektachrome **14RC** paper *David Nicholson,* who did all the photograms for this section, used various materials. For the orange background he used a piece of orange acetate filter with a hole punched in it by a paper punch to represent the sun. The filter was put in the negative carrier. The dark foreground line was a piece of card which rested on books about 8in (20cm) above the paper. The mountain shape, cut from card, was placed on top of the other card. A piece of cactus with a suitable outline was then laid on the paper. The lens aperture was f8, filtration 30M + 30C and the overall exposure was 20 seconds but the mountain shape was removed after 15 seconds to add depth.

Then there are the abstract patterns you can produce with cut glass or prisms. For the light source use a small pen-light covered with a tricolour filter and experiment first to see what lighting patterns you can make by shining the beam from different angles. Then switch out the lights, position your glass object on the photographic paper and repeat your experiments. Two or three separate exposures using a variety of coloured filters and taken from different directions will produce a whole range of colours and shapes you never imagined existed. Exposure depends on size and power of the light and will be around 1 or 2 seconds.

The table of filters for different effects tells you which filters produce which colour. For creating fantasy scenes it is worth noting the following colour associations to help you choose suitable colours for the subjects you have in mind: red—sunsets, fire; green—spring, fields, woods; blue—snow; dark blue—moonlight; cyan—sea; yellow—harvest fields, beach, desert.

Exposure and filtration

With negative colour paper all the tones are reversed. The areas that receive the greatest exposure go black while colour objects produce colours that are complementary to their natural colours. This gives a dramatic effect but you may prefer the more natural colours, obtained with colour reversal paper.

Treat colour reversal paper as though you were printing slides in the usual way (see section on printing slides). Colours can be reproduced close to the originals, providing filtration and exposure are adjusted appropriately. With natural colours, accurate reproduction is desirable but not always essential. For created scenes and abstract patterns, accurate reproduction is not too important.

Set up the enlarger and give the same range of exposures as suggested for negative colour paper (see step-by-step illustrations). However, filter values should be 30 magenta plus 30 cyan.

Judge density and colour balance just as you would for a print from a transparency and modify if necessary. For guidelines on how to do this see section on 'Colour Printing from Slides'.

Working in the dark

Working in the dark or near darkness need not be a problem. It is largely a question of practice and preparation. With flat subjects, simply compose your

Filters for different effects		
Filter colour	Print colour	
	Negative colour paper	Reversal colour paper
red green blue	cyan magenta yellow	red green blue
cyan magenta yellow	red green blue	cyan magenta yellow

▼ For abstract designs on colour reversal paper use a colour filter over a pen light. Give one-second exposures for each colour and change the position of the light each time.

design on a suitable glass sheet, then switch out the lights. In the dark, position your photographic paper, emulsion side down, over the objects and cover the paper with another glass sheet. Turn this sandwich over, place it under the enlarger and expose.

With large or bulky objects you have no option but to use the correct colour safelighting—even for colour reversal paper—to enable you to position the objects properly. However, you can keep safelight exposure to a minimum in two ways. First, decide what your composition is going to be and practise positioning the pieces until you can do it quickly. Second, before you remove the photographic paper from its packet, allow yourself 5 to 10 minutes for your eyes to become accustomed to the low lighting level.

After about 30 seconds exposure to a safelight with a Kodak No. 13 safelight filter set 4ft (1.2m) away from the paper, the maximum density of Kodak Ektachrome paper begins to be affected. (In normal colour reversal printing, however, you should *never* use a safelight.) However, for the less critical photograms, safelight exposures of up to 1 minute can be tolerated. But if you can manage to work in complete darkness it is always best. Working with moist objects brings its own problems, the main one being how to protect the sensitized paper. One way is to use a thin, clear polythene bag which is large enough to hold the photographic paper. Place the object— say, a slice of fruit— on top of the polythene and arrange the composition. Then, switch off the white light and insert the paper, emulsion-side-up, into the polythene envelope. Pull the polythene tight to remove most of the creases. For most applications, slight creases won't show in a photogram.

▲ An unusual composition on Ektacolor 74 paper. The roses were cut in half and the centre removed, leaving the outer petals. Roses and glass vase were laid on the paper along a glass sheet for the 'table'. Filters 80Y + 50M, exposure 20 sec.

Adding texture

Having spent many satisfying hours in the darkroom producing prints, you will probably want to progress to more creative ways of presenting the image. Perhaps one of the simplest and, if applied imaginatively, a most effective device is the use of textured screens.

The effects obtained range from simple lines to a coarse, grainy appearance, and the patterns can be so subtle as to be almost invisible, or they can be boldly graphic. Generally, less obtrusive patterns complement the subject better. In fact, part of the fun of this technique is that you can find so many different patterns to use—all on the same image if you wish

In the early stages of trying to match texture to image you will find that some effects do not work, but keep experimenting and you will soon be creating interesting prints. Though you can buy texture screens from photographic suppliers, it is easy to make your own.

Texture screens can be used in two ways: by sandwiching within a glass negative carrier or by contact with the printing paper. By the second method you have the choice of a negative transparency, a paper negative or even a piece of thin fabric or paper.

Choosing a subject

As with any graphic effect, the simpler the theme the better the result. And screens are especially good for breaking up large areas of rather flat tone. But if you have an image which has natural texture, an old stone building, for example, a superimposed pattern can clash with the inherent texture. Similarly, a subject which has a lot of detail, such as a varied landscape, looks too busy if given a pattern.

The actual size of the details in any screen is important and the smaller they are—grains of sand, perhaps—the more even is the effect of the pattern. Provided the texture is chosen with care, screens can add a new dimension to your printing.

Making your own screens

When you take your next roll of black-and-white film it may be worth setting aside about six frames for taking examples of different textures. (You use black-and-white screens for colour printing.) Or you may decide to use the entire film for this exercise. But remember, so that the screen is not obtrusive you will need a thin negative, so under-expose by at least two stops. Then develop the film normally. Some photographers prefer to over-expose the film and under-develop it (time cut by a third) to keep the shadow detail. Lighting should be fairly flat and you should be no closer to the subject than around 3ft (1 metre). If in doubt about the texture looking too big when enlarged, try taking several exposures of a subject from different distances.

Where will you find texture? You certainly won't have to search far—it is all around you: concrete, paving, brick walls, sand, sandpaper, textured ceramic tiles, crazed ceramic surfaces, linen-look fabrics, textured wallpapers, spun metal, sawn wood, leather, polyurethane foam, textured glass, fur, lentils, are just some ideas. In time you will be able to build up a collection of favourite patterns. For contact screens you will need a supply of various translucent materials, each piece large enough to cover the printing paper. Fine silk, tulle, chiffon, muslin, net curtain material, tissue paper, a single layer of a paper table napkin and similar materials are all suitable for this method. Letraset, stuck down on clear acetate film, is another source of ideas for contact screens.

You could also make up your own patterns by drawing a series of fine lines with black ink on thin tracing paper. Yet another way is to 'ink up' a piece of textured paper by rolling printer's ink across it; then press it firmly on to a piece of tracing paper so the texture pattern is transferred. Both negative and positive single weight paper prints of a particular pattern can be used as contact screens. As you can see there are endless ways to achieve a textured effect and you will have a rewarding time thinking of new ideas and applying them.

Sandwiching screens

This is the most controllable way to introduce texture to a subject. After cleaning carefully, the screen and negative are simply placed emulsion to emulsion in the negative carrier (it should be a glass one to keep the sandwich firmly together) and projected on to the printing paper in the usual way — that is, by adjusting the height of the enlarger head to cover the image area and focusing sharply. Occasionally, a more diffuse effect is sought and in this case the negatives of the subject and the screen are put back to back. First the subject negative is placed in the negative carrier and focused sharply, and then the screen negative is introduced also, emulsion side up.

▲ Matching the screen to the mood of the picture is important. Here the Paterson Rough Etch screen emphasizes the historic setting.

▲ A very bold effect. The aggressive shape of the building is carefully matched to the geometric lines of the Paterson Concentric screen.

▶ Take care your home-made screens are not too dense. After the film was briefly exposed while in contact with a piece of dry mounting tissue it was deliberately under-developed.

▲ Far left: the texture of a white ceiling tile obliquely lit overlays a slightly over-exposed portrait to give an impressionistic effect.

◀ Monochromatic colour and simple outlines make a good foil for this Paterson Rough Linen screen.

▼ A shot of backlit dress fabric adds interest to the broad area of subdued colour in this sunset.

Before you make your print, however, you should make the usual test strip for exposure and with colour you should also make tests to balance the colour filtration. The use of a screen will marginally increase exposure times (about one stop for film and about three stops for paper) so you might like to take this into account for your initial exposure step. Finally, don't forget to observe all the normal precautions when handling light sensitive materials. Colour printing with a texture screen is perhaps a little more difficult than black-and-white material, but equally rewarding in the outcome. Rule one is not to try combining a colour negative of the subject—the double mask will defeat you!

If you want to add texture successfully to a colour negative sandwich, use one of your black-and-white negative screens or a colour slide screen. In the latter case, if there is much colour present be prepared for some unusual colour change effects in the print.

If you intend to make a colour print from a slide you can sandwich the subject slide with a black-and-white *positive* film screen or use a colour slide screen. Whichever system you adopt, always make colour filtration tests on the sandwich itself and not just on the main image.

The contact way

As mentioned earlier, to be successful the contact screen and the printing paper must be in firm contact—weighted by a clean sheet of heavy glass or held together in a contact frame (one without masks). Contact screening is not so satisfactory for colour work because of the need to work in complete darkness. Also the effects can be too coarse. However, it may be worth experimenting with say very fine tissue paper or gauze.

Home-made texture screens

Grained leather

Enlarged magazine illustration

Weathered plywood

Dress fabric

Rough wood

Side of brick

Rough wall rendering

Paper

Enlarged magazine illustration

Wallpaper

Underside of linoleum

Silk blouse

Combination printing

Combining different images to form an unusual composition is not a new technique. Several Victorian photographers experimented with putting two or more negatives together to produce a different picture. This technique is known as combination or double printing and often involves the use of masks or dodging tools to eliminate unwanted material in the final print. But the images were not necessarily designed to be unusual—a favourite trick among early photographers was to use a separate negative of clouds which was then superimposed on to a cloudless sky to add visual interest.

In England, during the thirties, photographers such as Angus McBean and Winifred Casson used combination photography to produce fantasy images. Sometimes very beautiful and unusual effects can be created by the imaginative combination of widely different subjects.

There are various ways of combining images—some may be contrived deliberately by careful double exposure in the camera, but many can be achieved with the enlarger. The basic methods are simultaneous printing (known as sandwiching), and successive printing, both of which are covered here.

Equipment

Apart from the usual darkroom equipment it is useful to have a wide selection of negatives. If you have a negative file and contact sheets, it is comparatively easy to sort through them to decide which negatives would fit together to make a fantasy image. The simple images give better visual impact and make it easier to merge the images. If the negatives are not suitable for superimposition, you could take photographs with the idea of using them for creative imagery. You will also need a sharp, pointed pair of scissors, some thin card, a yellow pencil and a set of dodging masks.

Successive printing

Successive printing allows more scope for the imagination than sandwiching which is limited in its results. With this technique two or more negatives are printed in succession on to the same sheet of printing paper. For complicated combinations, specially cut masks and dodgers are needed. The basic procedure is shown in the step-by-step illustrations. But don't expect immediate success. First results are often disappointing so don't be disheartened as the techniques require practice and patience. If your first print is not entirely satisfactory, keep it for reference to check what adjustments are necessary when you make the next one. You might like to practise by adding clouds to another photograph to make it more interesting. When adding backgrounds such as clouds or foregrounds such as branches or leaves, it is usually best to print the main image first and the clouds or branches second.

▶ Keep it simple at the start. Here the cat negative was printed first shading the figures, then their negative was printed shading the cat and grass.

▲ The sky portion of the second negative printed to show cloud detail.

▼ The main image in its original form.

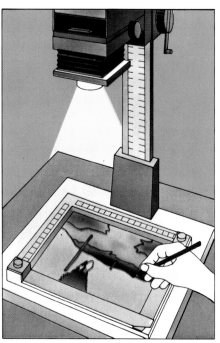

CREATING THE PICTURE
Select 2 suitable negatives with light, featureless backgrounds. Place the main negative in the carrier and focus on to a piece of white paper. Arrange the image as you like and draw the main outlines on the paper. Remove the first negative and insert the second. Arrange it in the frame and draw the main lines on the same paper.

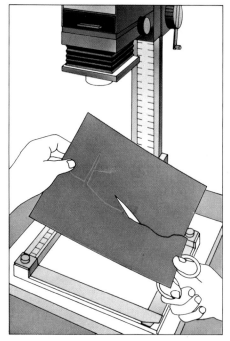

MAKING THE MASK
When you are satisfied with your layout remove the paper and substitute a piece of thin card the same size. Projecting the main negative, outline the boundary on card between the 2 images. Cut along line carefully. This gives you 2 masks. Make test strips to check exposure, ensuring both negatives are enlarged to layout size.

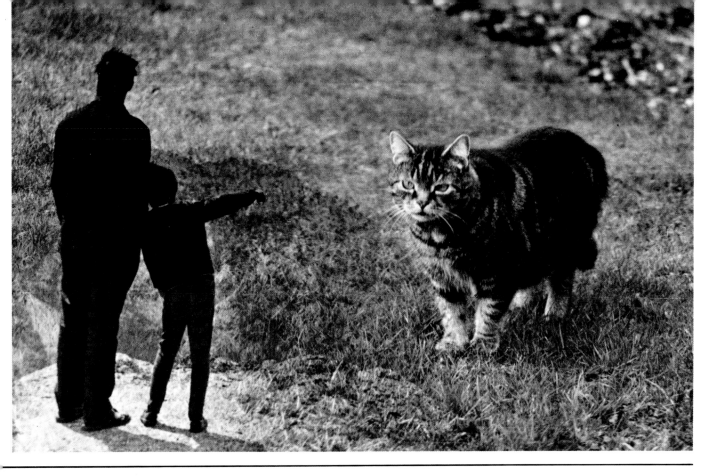

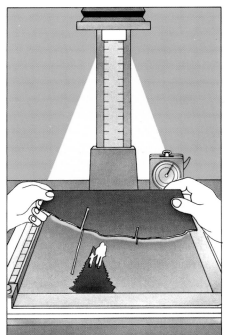

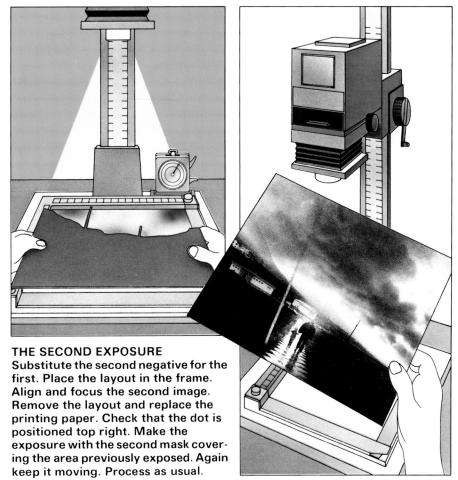

THE FIRST EXPOSURE
Place a sheet of printing paper in the frame. Check it is firmly located. Make your exposure covering the area for the second image with the appropriate mask. Keep it moving slightly to avoid a sharp line on the print. Remove the paper. Mark a china crayon dot in the top right corner of the border area. Place in a light-tight box.

THE SECOND EXPOSURE
Substitute the second negative for the first. Place the layout in the frame. Align and focus the second image. Remove the layout and replace the printing paper. Check that the dot is positioned top right. Make the exposure with the second mask covering the area previously exposed. Again keep it moving. Process as usual.

If a thin line shows around a combined image then the mask was probably not cut accurately enough, or it was not correctly positioned, or perhaps it was poorly manipulated during printing. No doubt many ideas will occur to you after you have begun to experiment.

You will also find it easier to work with negatives which you have photographed with a specific idea in mind. For example, to put an object into a glass or a bottle you would photograph an empty bottle against a white background (avoid highlights on the bottle). You then photograph the object against a light background. The resulting negatives can then be manipulated through the enlarger.

Ghost pictures

The easiest way to produce these is by making a double exposure in the camera. Alternatively, take a negative of a landscape, or an interior, and another of a figure against a white background such as a wall, a sheet or the sky. Then expose the negatives in turn using the combination printing technique. Colour transparencies may also be used; when printed they become negative prints. For example, a positive transparency of a white cat with white eyes, which might be useful for some fantasy images.

Negatives with photograms

For a more graphic look you can combine a negative with a photogram. You will need a sheet of glass that fits over the printing paper. The glass should completely cover the paper otherwise the edges will print as a rectangle on to the picture.

Place the negative in the carrier and focus it sharply. Broken glass, leaves, torn paper, netting, seeds, or beads are arranged on the glass which is then placed carefully on top of the printing paper in the frame. Expose the negative on to the paper through the objects on the glass sheet.

You can also draw or trace directly on to tracing paper with opaque black drawing ink. This drawing can then be combined with a projected negative by contact printing.

◀ This is the sort of work that is possible after a lot of practice. Commissioned by Peter and Tressillian Garner as a portrait, *Hag* assembled it from 5 negatives—the house and grass —2 separate portraits—the interior with the sofa—the sky. Prints this complicated need more than 1 enlarger.

Other combinations

A negative may be used repeatedly (multiple printing) in the same print to form a pattern or create some other effect. For example, a photograph of gulls, taken against a clear sky could be printed several times to give the effect of a sky full of gulls. Each time the exposed paper is re-exposed to light the print becomes darker, so you must allow for this when you plan your imagery. Multiple printing methods and their effects are dealt with in greater detail in the next section.

Print finishing

Sometimes a little retouching is needed on the final print. Perhaps the change from a light area to a dark one is too sudden, or a light patch on grass requires blending in. This can be done by spotting (see previous chapter). Take a fine sable brush and stipple the area with the correct tones of grey.

Colour

Combination printing in colour entails the problems of correct filtration. It is not impossible but, whether you use colour negatives or slides, it is very time-consuming.

The easiest way to get fantasy images in colour, apart from sandwiching transparencies, is to superimpose two or more images on to a screen with projectors (one for each transparency) and then to rephotograph the projected image. The transparencies could, of course, be projected on to something else—an object such as an egg, for example, or even a nude. These are just a few ideas for creating surrealist images.

It is now up to you to experiment, for the number of negatives that can be used together is limited only by your own skill and imagination.

▼ Simple changes of scale can produce quite strange effects. The main image is the man standing on the stone mole with the foreshore around him. By combining it with the clouds, which appear much closer, and shading the sky in to the sea, the finished picture becomes very ambiguous.

Images can be combined by printing different negatives successively, as has been seen, but sometimes they can be printed as one. In simultaneous printing you take separate (usually two) negatives and superimpose them; this sandwich is then placed in the negative carrier and projected to give an image of the combination. A test strip is made and the print is exposed and processed in the normal way.

Selecting the negative

When you are making a selection of negatives suitable for black-and-white sandwiching, it is best to choose those that have some clear areas on the negative so that the negative sandwiched with it can print through these clear regions. (The clear area would, of course, print as solid black if this negative was not sandwiched but printed as normal.) By sandwiching, the clear area becomes filled with a texture, another subject or some spatial illustration such as a room or a street.

Check that the negatives slot into place by holding them up to the light and trying all sorts of combinations. (You may find it difficult to assess the effect on a small format such as 35mm—especially in negative form. If so put the sandwich into the enlarger and look at it in projection.)

When negatives are sandwiched there is a build-up of density where tones overlap, so longer exposure times are necessary and some prints will need a lot of burning-in in these areas to bring out the detail. With experience you will begin to judge how far to go with this, and exactly what works and what doesn't work. For example, you will quickly find that opening up the enlarger lens by one or two stops doesn't necessarily solve the problem of long exposure because one negative will print through sharper than the other. This is because the two images are separated by one thickness of film base (unless sandwiched emulsion to emulsion with no separation of the images and here you can open up the lens), and are therefore at slightly different distances from both the lens and the printing paper. So focus somewhere between the sharpness of the two images and stop down three stops. (You will often find that, in order to marry properly, two images have to be sandwiched base to emulsion.)

Increase the interval of your test strips from the usual 5 seconds to 10 seconds. In the case of very dense film sand-

▲ To make this print a silhouette of a girl in profile was taken while she was sitting behind a black picture frame. This was combined with a negative of some foliage which appears in the final image only in those places where the first negative was clear.

wiches it could be as much as a 20-second interval or more. Try opening up one stop just for the burning-in, but do this on a test before attempting it on the final print.

Black backgrounds

When purposely shooting material for sandwiching it is useful to have a large piece of black velvet or felt as a portable backdrop which can be pinned up wherever you need it. You can then photograph objects or people against it to obtain a negative which is clear apart from the tonal part that is the image of the figure or object. Slightly underdeveloping the negative also helps to suppress any details of this backdrop.

You could then take a close-up negative of leaves or other shapes and patterns and sandwich the two. The final print would show the foliage instead of a black background and the leaves would also print faintly through the figure. (They print faintly because light would have been blocked from this region to a certain extent.) The final print as a whole, being in one plane, has a rather

flat effect. You could get a three-dimensional effect by sandwiching the object or figure with a street scene or strongly dimensional setting.

Some texture screens are available commercially or you can make your own. (See earlier). Sandwiched (emulsion to emulsion) with the main subject negative they produce a print that may have an overall speckled, etched, canvas or crazed appearance.

Silhouettes

A deliberately photographed silhouette sandwiched with a texture screen gives a deceptively simple effect. You can photograph a silhouette by directing the lights at the white background paper or wall, and by placing the subject well forward of the lights. Take the reading for the exposure from the

SELECTING NEGATIVES FOR A SANDWICH PRINT

The selection of the right negatives to sandwich together is very important. One of them should have a large clear area through which the details of the second will print. Here *Ian Hargreaves* has chosen a landscape with dark rocks, which are almost clear on the negative, as a background for this portrait. The printing through of the textures of the rocks in the skin areas adds interest.

To print well sandwiched negatives should have a similar contrast range.

lit wall. Overdeveloping the negative also helps to darken the silhouette.

With natural light a silhouette photo can be made by placing the model in front of direct sun and exposing for the sky, or by placing an object on a window sill and exposing for the bright background: to obtain a light sky avoid under-exposure. Because the background prints white in the positive — that is, it appears dense on the negative—the texture sandwiched with the silhouette only prints through in the silhouette area.

Accidentally thin or under-exposed negatives can sometimes make fortuitous sandwich material. However if you use a larger size negative than 35mm—for example, 6 x 6cm or larger — you may be able to remove the parts of the image you don't want with Farmer's reducer with a very fine brush. It is too tricky to apply Farmer's reducer locally to a 35mm negative, even if you use the finest paint brush.

Sandwiching colour

Because of the built-in orange mask you can't sandwich colour negatives successfully but you can combine a colour negative and a colour transparency or two colour transparencies (slides). And even if you don't intend to make a print from the combination yourself, you could take it to a processing and printing laboratory to have one made. In any case it might be amusing to slip several of the more surrealistic examples into a show of a family holiday, for example.

As with black-and-white sandwiches you should look for simple images where there are pale or almost colourless areas so that the images marry well and without producing unnatural colour effects or too great a contrast. In many instances you will need to take photographs specifically for this technique.

And don't discard thin, over-exposed slides that look disappointing when projected because they may be useful for this type of project where a perfect exposure is not essential.

When putting a sandwich together make sure that each slide is clean and dust-free. Then bind them firmly together with adhesive tape or put them in the same mount. To make a print from the colour slide sandwich follow the guidelines for making prints from slides given earlier but remember, because of the increased emulsion thickness, the exposure time will need to be increased. However, if you find that your exposure times are running to several minutes be careful that you don't burn out your filters.

You can have endless fun with this technique, creating unusual effects, or you may simply use it to add interest such as a sunset, to an otherwise dull and lifeless image.

▲ Special effects such as this need a little care. By combining this photograph of locomotive controls with blue rays, a futuristic image is achieved.

▲ A good example of the effect you can get by combining a colour negative and a transparency. The negative of the boy is sandwiched with a transparency of a hand spread over a pane of glass with condensation and water droplets at the bottom of the picture.

◀ Such a precise alignment between two images is particularly effective. The radiating lines of the dandelion emphasize the spreading beams of the sun while contrasting with the solid line of the hills.

▶ One of the easiest ways to make a sandwich is to combine two slides. You don't even need to make a print. You can put them together in one mount and project them in the same way as your other slides.

Multiple printing and movement

During printing you can move the paper to create different effects such as several distinct impressions of the same image (that is, multiple effects), or a single image with streaks so that it appears to be moving very fast, or an image with fainter ghostly after-images. Of these three effects the most unusual treatment, and one that is worth mastering, is multiple printing. It has a strong element of design about it which is visually very pleasing.

Choosing a negative

When considering a subject for any of these techniques there are certain requirements that must be met. As with most of the creative darkroom effects, rule one is to look for simple imagery. Rule two is that the backgrounds around the subject must be white or extremely pale. (On the negative they will, of course, be dense black.) This acts as a built-in mask and allows you to move the paper and again print the image, or part of it, in a previously unexposed area.

Alternatively, you could take a negative and mask the background around the image by painting a special opaque fluid on the film base. This is, however, extremely difficult to do with a 35mm negative, even with a fine brush. 2¼ x 2¼in (6 x 6cm) negatives can be masked successfully if care is taken.

Subjects which suit multiple effects are often those where the action has been frozen—for example, a hurdler going over a hurdle, a sprinter taken from the side of the track as he dashes for the finishing line, a tennis player serving, a dancer performing some graceful routine, a high diver executing a mid-air turn and so on. You could also use less obvious action such as a close-up of hands playing the piano. Static imagery of people can also be effective provided that the form is interesting enough in itself to be presented in a repetitive pattern.

If you prefer to choose an inanimate object then go for something which is simple and has good symmetry and form.

And there is no reason why the subject couldn't be as large as a car, for example, or as small as a shiny brass hexagonal bolt. It is worth spending time to think the concept through from beginning to end and foresee any possible hitches. Sometimes it helps to make repeated tracings of the outline of your enlarged image to get an idea of how it might look.

Making multiple images

If you expose several times but move the paper after each, so the image prints in a different spot, you end up with a series of separate images.

The images can be quite separate or they can be made to overlap slightly;

they can be of equal tonal density or become progressively paler; they can be arranged horizontally, vertically, diagonally, circularly or even randomly to suit the effect you desire. So you see why you should think about the composition before you start to make your prints.

Making a tracing: the first stage in creating multiple images is to make a tracing of the multiple effect. Place the negative in the carrier and project and focus it on to the back of an old print on the baseboard. Then replace this with a piece of tracing paper and draw in the first image, move the paper along until you feel the spacing looks right and trace a second image. Continue until you have at least five or six tracings. Use this diagram to work out the appropriate spacing for your print.

The test series: now make a test strip to find the right exposure. Having determined this, take half a sheet of printing paper for a test series which will help you to work out any final adjustments to the spacing and enable you to check that you are not getting a build-up of density in the white background area (there will be unavoidable increase of density where images overlap). If this occurs, choose a harder grade of paper — say, grade 3 or 4 if you have been using grade 2 paper.

Having established from your tracing that 1½in (3cm), for example, appears to be the right spacing, you will need to move the paper along by this amount after each exposure.

Reverse images: to reverse images laterally on either side of a central point, mark with china crayon dots the end of the image just exposed; turn off the enlarger and put the print in a light-tight box. Now flip over the negative in the carrier and check the focus after you have done this. Finally, reposition the printing paper with the safety filter across the lens. When you are ready, make the next exposure.

◀ A white background is essential when making multiple prints from negatives. It also helps to have a simple but elegant subject. *Amanda Currey* has created a chorus line from one dancer by moving the paper a regular distance between exposures.

▶ If you don't already have a suitable subject on a white background, an everyday object can be used to create one. Here a decanter has been shot from above and the paper turned in printing frame between exposures.

Circular patterns

Printing the image in a circular pattern is slightly more complicated but aesthetically well worth the effort. You need to turn the printing paper round a central point. This is done by securing it in the centre (measure this accurately) to the baseboard with a drawing pin. This does leave a small hole but enables you to turn the paper freely. Alternatively, stick a drawing pin into the centre of a piece of corrugated cardboard, turn it over and you have an improvised turntable to which the printing paper can be taped. In this way you can make your print as before but without a pinhole in it.

To get some idea of the final effect you will need to make a tracing. Place the negative in the carrier and focus the

▲ This flower-like pattern was created by pinning the paper to the baseboard and turning it a measured amount between exposures.

image. Take a piece of tracing paper the same size as your final print will be and secure it in the centre to the baseboard with a drawing pin. Trace the first image, then turn the tracing paper round until you are satisfied with the spacing and trace the second image. Measure the distance between the identical point on each image — turn the paper and check that this distance exists between the third and second images. Continue in this way until the circular pattern is completed. You can then see what spacing adjustments may be necessary.

Making a print: first do a test strip to find the correct exposure. When exposing the full-sized sheet of paper swing the red filter across after the first exposure and mark (with a black china crayon) a tiny cross just over the top of the first image but never where any tone will be. (It marks the starting point of the circle.) Then use this point to measure the correct distance between images and turn the paper the measured amount. Make the exposure, shading where necessary. Continue in this way until the circle is complete. The china crayon washes off in the developer.

Multiple effects may sound intricate but once you have tried several different examples and assimilated the methods you can expect to produce first class prints.

Making streaks

During printing you can move the paper so that you get streaking, or multiple ghost after-images, depending on the effect you wish to achieve.

To introduce streaks (they give the image a feeling of fast movement) all you do is expose the paper normally for three-quarters of the exposure and draw it smoothly and slowly in one direction for the remainder of the exposure. If you want the streaks to taper off, increase the speed as you pull the paper across. The print should show a sharp image with streaks flowing from it. To make sure that the streaks are straight, tape a ruler to the baseboard and slide the printing frame along it.

So if you have taken a shot which, in retrospect, you wish had been panned you may be able to achieve a similar effect in the darkroom. Streaking effects don't necessarily need to go in straight horizontal (or even vertical) lines, sometimes you might need a whirling effect and for this you must move the paper circularly.

Ghostly after-images: for this effect allow the paper to remain stationary for a few seconds between movements.

Moving the enlarger head

Instead of moving the paper during printing you can move the enlarger head to create multiple or blurred images. You will need to choose a simple image such as a face or a single object like a flower which is against a white or pale background.

◀ Streaks are made by moving the paper during the exposure. Once the main image has been correctly exposed, the paper is drawn smoothly along a straight edge, speeding up towards the end so that the streak tails off.

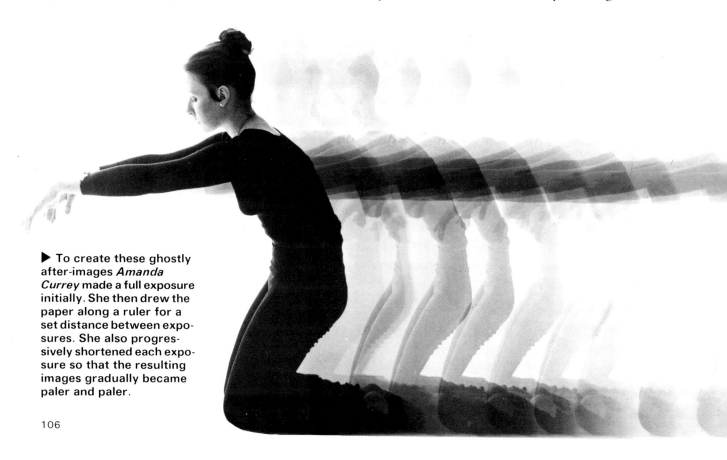

▶ To create these ghostly after-images *Amanda Currey* made a full exposure initially. She then drew the paper along a ruler for a set distance between exposures. She also progressively shortened each exposure so that the resulting images gradually became paler and paler.

For a blurred effect, focus the negative with the enlarger head fairly low on the column and stop the lens down four stops to increase overall sharpness when you make the print. Make a test strip to find the correct exposure. When you make the print, expose the paper normally for half the exposure then wind the enlarger head to the top of the column during the remainder of the exposure. This will produce a slightly blurred three-dimensional effect.

For a less continuous effect, expose the paper normally for three-quarters of the time then move the enlarger head up the column in four separate stages (swing the red filter across or switch off the enlarger while you move the head), giving the paper a quarter of the remaining exposure at each stage.

▶ If you want to try making a multiple print from a transparency choose a simple image on a black background. One colour or variations on one colour are more effective than a mass of conflicting colours.

▼ Working in colour rather than black-and-white is more difficult as you have to do so in near or total darkness. Instead of making china crayon marks on the print surface, a series of pieces of card need to be taped to the printing frame or baseboard that you can feel in the dark. In this example by *Amanda Currey* a circular pattern of card stops was made. The transparency was enlarged on to an intermediate negative masking out the floor and was then enlarged on to colour paper as normal.

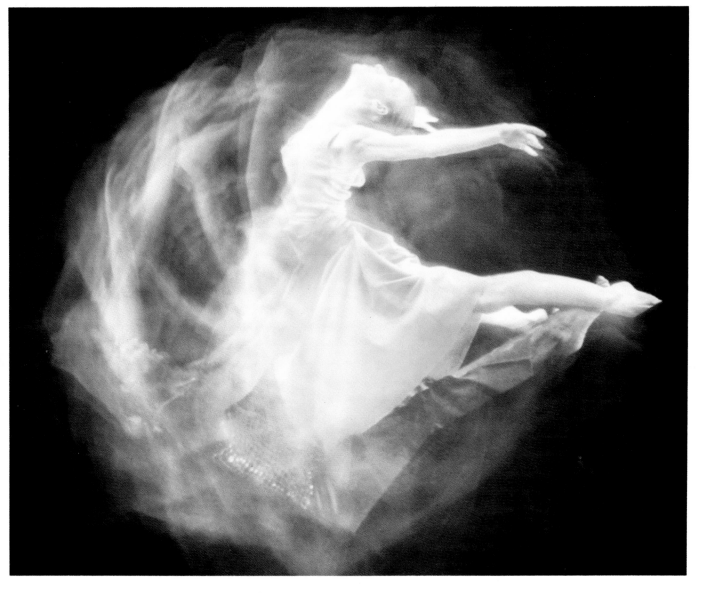

Printing on coloured-base papers

A black-and-white photograph does not have to be printed on white paper. It is just as easy to print a black image on a coloured base using ordinary photographic methods.

Coloured-base papers, either produced by manufacturers or made at home, can put extra variety into decorative or exhibition prints. A good black-and-white image printed on a strong background colour can have more impact than an ordinary colour print. The colours available as base tints are often very pure and bright, and can even be fluorescent or have a metallic sheen.

In general, the most suitable pictures for printing on coloured base papers are shots with simple strong lines, and bold tones. For the coloured base to show through the picture must have plenty of lighter areas: very dark, low-key shots, or pictures with strong greys and subtle gradations, are rarely suitable.

Posterized black-and-white prints (see page 218) work very well. These pictures are made using lith or line film intermediate negatives. The techniques for printing on coloured-base papers are the same as those for making line prints on normal white-based paper.

Types available

The most readily available coloured-base papers are Luminos Pastel, Kentint and Autone. These are available either in sheet form or rolls, and in fibre-based or resin-coated (RC) types.

The fibre-based papers are very light in weight, difficult to handle, and are being superseded by more versatile RC papers. Resin-coated coloured-base paper handles and processes just like any other RC paper. Standard colours include blue, red, green and yellow. There are also metallic gold and silver papers and fluorescent green, pink, yellow and orange papers. The fluorescent papers will glow vividly under 'black' ultra-violet light.

Coloured-base paper is available in sizes ranging from 8 x 10in (20 x 25cm) sheets up to long rolls. Trial packs containing an assortment of different colours in 8 x 10in (20 x 25cm) sheets are made by some manufacturers and give an introduction to the possibilities of these papers. Coloured-base papers generally cost about 50% more than ordinary printing papers.

Using the papers

Because coloured-base papers have a particularly striking appearance, the subjects that are printed on them should also have a strongly graphic content.

Photographs of subjects on uncluttered backgrounds, with bold patterns, textures or shapes are ideal.

One subject which is ideal for coloured-base paper work is lettering. By photographing dry transfer lettering or artwork for signs or notices it is possible to make very effective display panels on these papers.

With matt surface fibre-based papers, it can be difficult to tell which is the emulsion side of the sheet before putting it under the enlarger to make a print. An easy method is to bite a corner of the paper. The emulsion side will feel softer and slightly tacky.

Using the colours

Red, orange and yellow: These three warm colours stand out well. It is less necessary to have a strongly graphic subject with these colours, and they are also easy to handle under safelighting because the base looks light in colour. Red and orange go well with dramatic, action shots, while yellow gives a sunny effect to the final print.

Blue and green: These colours have less impact, and simple compositions or line reductions are advisable. Keep the print light rather than dark. Under the safelight the base of these papers appears very dark—blue looks almost the same

as black—so you will find judging development difficult. Test strips for exposure are essential.

Fluorescent colours: All these have great brilliance when viewed by daylight, and you can print a normal full-tone picture without losing impact. Choice of subject on these vivid papers can be wider than with most coloured papers—as no particular subject is normally associated with fluorescent pink, any subject may be chosen!

Metallic papers: Being essentially light in tone, metallic papers also allow more leeway in choice of subject. Nevertheless, line prints look highly effective on a gold or silver base. Seascapes look excellent on metallic silver or blue, while portraits are a suitable subject for gold. Care must be taken when displaying these prints to ensure that the light by which they are viewed reflects the metal grain of the base colour brightly.

Commercial coloured-base papers and print dyes open up new fields for photographic experimentation. Used selectively, they can add new vividness to your pictures.

Ordinary RC papers can easily be dyed to give a coloured base after the print has been made. Special dyes to do this are sold in kits. If unable to obtain these kits, dyes used for food, clothing, or retouching colour prints can be used and give fairly good results.

COLOURED-BASE EFFECTS

Deciding which coloured-base paper to use for a negative is largely a matter of personal choice. Here, a subject that might not normally be chosen for coloured-base paper work has been printed on different coloured papers to show how their characteristics can change the effect of the picture. The colder colours, green and blue, seem slightly out of harmony with this subject. If the bird was one that hunted by night, such as an owl, then the dark tones of the blue paper might be more appropriate. Note how the edge of the bird's head is lost in the black background on the green paper—not all coloured base papers have the same speed and contrast. Of the warmer colours, yellow, orange and red, the orange gives perhaps the strongest impression of the bird's bright alertness. The choice is unnatural, but effective.

Make your own coloured papers

To dye an RC photograph, make a fresh print, fix thoroughly, and wash. Do not use a hardening fixer, and be very careful not to scratch the emulsion. Immerse the print face up in a clean tray containing a solution of dye and water, and agitate the print gently but continuously. Do not hold the edges of the print with your fingers, as this can stop the dye being absorbed evenly.

Lift the print quickly out of the dye from time to time to check its progress, and remove it when it has become a little darker than you finally intend. Then wash out the surplus dye in a tray of still water. Dry the print in the usual way after wiping off excess water with a soft sponge or a paper towel.

If the final colour is too weak, repeat the process. If it is too strong, a rinse in warm water can reduce the colour. By carefully lowering the print into the dye bath a little at a time you can make prints with a graduated base colour tone that cannot be obtained by any other means.

▲ Immersing a print on glossy resin-coated Ilfospeed paper in a strong solution of bright pink dye gave this unearthly purple hue.

▼ An ordinary black-and-white print on resin-coated paper takes on a deeply sombre atmosphere when dyed a pastel green.

Etch-bleach on coloured backgrounds

Etch-bleach is a simple way of using coloured-base papers to make white images on a coloured background. A special bleach softens the emulsion of the print wherever there is a black silver image, allowing it to be rubbed away to expose the white paper underneath. The original print has to have a contrasty negative image, and can be made from a slide or a positive duplicate on lith film. The print should be well exposed to ensure that there is enough silver for the bleach to work on. After the image has been bleached out, the print is rubbed with cotton balls under running water until all the gelatin is wiped away, then rewashed and dried.

The bleach has two parts: (A) 2oz (50g) cupric chloride mixed with $8\frac{1}{2}$ US fl oz (22cl) acetic acid and made up to 38 US fl oz (1 litre) with water: (B) 20 vols hydrogen peroxide. Mix equal parts of A and B, making up quantity needed only. Wear rubber gloves and handle with care.

▲ ▲ **Internationally famous rock musicians Bob Geldof and Johnny Fingers of The Boomtown Rats make a lively subject for this portrait by** *Lawrence Lawry*. **A high-contrast negative print on green coloured-base paper, left, was etch-bleached, right.**

▼ **Blue coloured-base paper etch-bleached and dyed yellow gave a green image in the dark areas of this variation**.

Colour from black and white: special effects

It's easy to make vivid, multi-coloured prints from your black-and-white negatives—the techniques are simply extensions of those you have already learned from the two previous sections on making colour prints from black-and-white negatives. Those sections discussed techniques of applying a single colour to each print; here we look at ways of combining colours.

How multiple toning works

Special toner kits are available that work by turning the silver of an ordinary black-and-white print into a silver compound, and then treating this compound with metal salts or special dyes that give a brightly coloured image. This is just like the toning described previously, and can be carried out in normal room lighting and at normal temperatures. The difference is that the toners used form part of a compatible system that works gradually. What this means in practice is that you can watch the colour build up in a print you are toning, and stop the process whenever you wish simply by removing the print from the toning bath. You can then apply a completely different colour to the parts of the print that haven't yet been toned by putting the print in a second toning bath.

The **metal salt toners** in the kits give colours similar to those produced by ordinary blue, green or yellow toners. The **dyes** have a very different effect, and give more subtle results. Often the dye solution looks almost clear until it meets the bleached silver of the print—only then does the colour appear on the print image. The colours given by other dyes in the kits appear rapidly in the image area, but are also capable of staining the white paper base if allowed to work for too long. Some dyes have a different effect depending on whether or not they are used on an image already coloured by a metallic toner.

These special kits also give ordinary toning effects in sepia, red or blue, and can be used to dye the paper base different colours. They will produce all the effects mentioned in previous sections and a range of multi-colour effects besides.

Two typical kits

Two currently available special effect toning kits are the Berg Color Tone kit from America and the Colorvir system invented by French photographer Pierre Jaffeux (not yet available in US).

The Berg system is the simpler of the two. Compared to the Colorvir it requires less elaborate making-up of baths, and is more suitable for treating batches of prints together. The Colorvir kit gives the widest range of effects and is far more versatile, but requires more individual attention for each print and is less suited to repeated effects on several prints. Both kits use a final fixing or clearing bath—a special chemical

▼ **SPECIAL EFFECT TONING KITS**
The Colorvir kit (left) contains: bottle F, grey freezing; G, sepia toner, L, yellow polychromie dye; C, toner additive; B, yellow toner; A2 and A1, blue toner. Other bottles (not shown) are D for solarization; H, I and J, violet, green and red dye; and K and M, red and blue polychromie dyes. The kit also includes salt for fixing (in the bag) and a graduated test tube. The Berg kit (right) contains small bottles of dye, two large bottles of activator, and a clearing agent in the small jar in front of the bottles.

▲ *David Kilpatrick* achieved this vivid effect by using the yellow solarization concentrate from the Colorvir Kit to colour the darker details. Subsequent treatment in blue dye only affected the lighter tones.

with the Berg kit, common salt with the Colorvir.

Using the kits

Both the Berg and Colorvir kits work best on resin-coated (RC) papers. The Berg kit is tolerant, and can be used on almost any make of paper. The Colorvir kit can also be used with any RC paper, but results change dramatically from type to type and can even vary with the surface. Glossy gives best results.

With both kits you should use extra care when making the print:

● Always use fresh developer and develop fully.

● Always use fresh fixer without a hardener.

● Don't use tongs or even let two wet prints rub together in the wash. Any surface abrasion, even so slight that it would be undetectable in a normal print, can be emphasized in full colour by the Colorvir process. Veribrom (not available in US) and Agfa Brovira RC papers are particularly sensitive to this. Ilford's Ilfospeed paper seems less so, but is also less sensitive to certain Colorvir special treatments.

● Avoid allowing the chemicals used to

VERIBROM **AGFA** **ILFOSPEED** **MULTIGRADE**

▲ How strongly special effect toners work depends on which paper is used. The procedure used in the picture at the top was applied to four different RC papers.

Results were unsatisfactory with Veribrom (not available in US). Agfa gave stronger yellows. Normal Ilfospeed was not very good, the more complex Multigrade was best.

come into contact with your skin—
wear rubber gloves.

● Use clean trays, graduates and
bottles, preferably ones that have not
been used before.

The Berg Color Tone kit

The Berg kit contains five colour dyes,
a tin of powder to make up a special
clearing solution used after toning is
completed, and a concentrated activator.
Each of the chemicals make up to 1 US
qt (1 litre), and they are best stored
in dark glass bottles with tight stoppers.
The quantities of dye supplied are
enough to treat up to 100 prints, but
the activator supplied is only sufficient
for 50. More activator is available
separately so that the full capacity of
the dyes can be exploited.

In use, the black-and-white print is
treated with the activator for one to five
minutes, until the image looks a weak,
brownish-grey colour. Then the print is
immersed in dye solution until the colour
change is complete. Excess colour in
the highlights is removed by bathing the
print in the clearing solution.

The Colorvir process

The Colorvir kit shown earlier is
more complex than the Berg. Rather
than making up bottles of each solution
to keep, you dilute small quantities of
concentrated dyes to make 17 US fl oz
(500ml) of working solution at a time.
A typical Colorvir treatment bath can
contain as little as two drops of con-
centrate, but is powerful enough to
tone several prints. The solutions will
keep for up to five days, depending on
which concentrates have been used.
In combination, toners A1, A2, B and
D will give a range of colours from
yellow to green and blue, with D-toner
also useful for solarization effects in
combination with other dyes. Solution F
makes the light grey tones of the original
print immune to treatment by the other
solutions, so that toners only affect the
dark areas of the image. Solution G can
be used for sepia toning or to change
the colours of already-toned prints. Dyes
H, I and J colour the toned image and
leave the white print base unaffected.
Dyes K, L and M have the opposite
effect, toning only the lighter areas.
With Colorvir it is possible to imitate
the effects of colour solarization and
such complex processes as contour film
derivations, in which the density of the
original image determines the final
colours of the print. Startling gradations
of colours combined with black or white
can be produced.

◀ Mixed red and blue Berg dyes gave this mauve image with blue highlights. Below: a negative print made direct from a slide was solarized, dyed in Colorvir polychromie red, then in a mixture of all three polychromie dyes.

▶ Colorvir solarization followed by red polychromie dye gave this effect.

▼ Left: Berg and Colorvir kits—a print was solarized with Colorvir, then Colorvir blue toned, immersed in Berg activator and finally dyed with Berg Red-1. The Berg activator lightens the Colorvir blues.
Right: A three stage colour separation with Colorvir. Yellow toning and solarization were followed by treatment in red dye J, producing the russet midtones. Finally, blue and yellow polychromie dyes were mixed to make a green dye which was used for the final treatment.

Black and white solarization

Of all darkroom techniques, solarization and Sabattier effect are among the most spectacular. However, because of their similarity of appearance, they are often mistaken for one another.

Solarization is the complete reversal of the image due to over-exposure—about 1,000 times. Owing to the exposure latitude of modern materials this is extremely difficult to achieve. Sabattier effect (or pseudo-solarization) occurs when a partially developed material (film or paper) is re-exposed to light and the development is continued, resulting in an image with both positive and negative parts. Where the two meet there is a clear undeveloped line dividing them called the Mackie line (after the man who discovered it).

Having established the textbook differences, the effect will be referred to as solarization from now on for the sake of simplicity.

▼ **With the right subject and the right lighting a very fine result can be achieved with film solarization. This portrait for Robert Palmer's record album *Secrets,* photographed by *Graham Hughes,* uses the Mackie line to emphasize the outline of the profile.**

Choosing the subject

Solarization is an effect many people have tried but few have used successfully, so that no subject, or group of subjects, has been established as particularly suitable for the effect.

Detailed, well-defined, hard-edged subjects, such as profiles or buildings, are best. For these it is important to have strongly modelled lighting with well-defined shadow and highlight areas. In other words, dramatic but not too contrasty lighting. Avoid subjects such as nudes, or rolling landscapes, since big, even, flat areas result in objectionable tone quality.

Suitable materials

All sizes and type of film and paper are usable but, as a rule, the slower and finer grain materials give better results than the faster ones.
● Kodak Plus X and Ilford FP4 are preferable to Tri-X and HP5.
● In the case of papers, the greater the contrast the better; use grades 4 or 5 or Agfa grade 6 if available.

Exposing the film

Producing a normal top-quality negative takes experience and care; subject brightness range, exposure and develop-

ment all have to be taken into account and need to be in harmony with one another. In the case of film solarization two more factors are introduced: re-exposure and second development. As a consequence, success at the first attempt is difficult. The third or fourth attempt is usually more rewarding.

When working on 35mm format it is not necessary to use the whole 20 or 36 frames for each trial. It is far too expensive. The film can be cut to lengths of six to 10 frames, or you can expose a suitable number of frames and cut off the exposed bit.

To do this, go into the darkroom, switch off the light, open the camera back and press the rewind catch. With the other hand lift the film up from the film gate, about a couple of centimetres, slide scissors under the film near the cassette end and cut off the exposed bit. Next press the rewind release again and pull the exposed length off the take-up spool. Put it into a light-tight container and put the light back on.

There are various methods of solarizing the exposed film, two of which are discussed here.

The safelight method

You need a timer, a thermometer, a reel from a developing tank, four containers the same size as a developing tank and a safelight with a red filter and 15W bulb. Any good print developer at its dilution recommended for printing is suitable. The stop bath and fixer can be those normally used.
● Arrange the containers on a working surface in the following order: developer, stop bath, water and fixer. The working temperature is 68°F (20°C). The level of the chemicals in the containers should be enough to cover the reel. The safelight should also be nearby, not more than a yard (metre) away. A ceiling safelight is not suitable at all. Once you have laid everything out you can turn out all the lights and begin.
● Transfer the film on to the reel and place it in the developer, starting the timer at the same instant. Agitate continuously, up and down, for 2 to 2½ minutes in the case of 125 ASA films or 3 to 3½ minutes for 400 ASA.
● Once development is complete place the reel in the stop bath and agitate continuously for 1 minute.
● The safelight can now be switched on. Pull the film off the reel and expose it to the safelight for 20-30 seconds at a distance of about 30in (75cm).
● Switch off the safelight and see-saw

Step-by-step to a solarized negative *(A blue background indicates total darkness)*

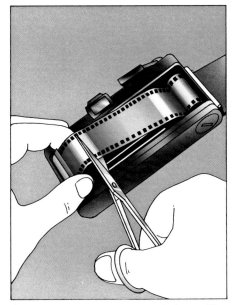

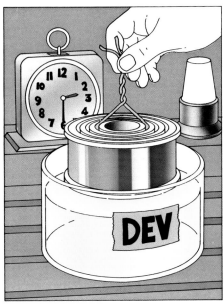

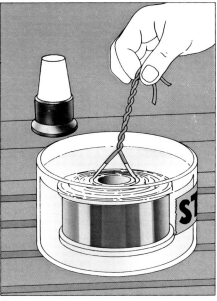

▲ After you have exposed six to 10 frames, open the camera back in the dark. Press the rewind button and lift the film up from the film gate a few centimetres. Slide scissors between the film and the camera, cut off the exposed length and put it in a light-tight container. You will now have a convenient length of film.

▲ Arrange the processing solutions in the order in which they will be used and check that they are at the working temperature of 68°F (20°C). Turn out the light and load the film on to a reel. Once development has begun agitation should be a continuous up and down movement.

▲ When development has been completed, transfer the reel to the stop bath and agitate continuously for 1 minute. (A useful tip is to attach a string halter to the reel: this facilitates agitation and at the same time minimizes the risk of contaminating your fingers with the developing chemicals.)

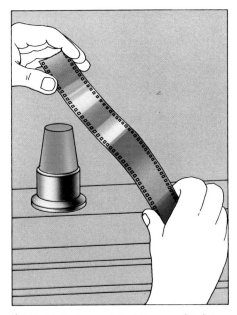

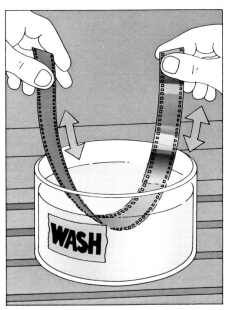

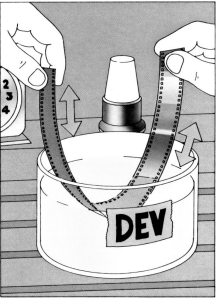

▲ Switch the safelight on and take the film off the reel. Expose the film to the safelight for 20 to 30 seconds at a distance of about 30 in (75 cm), emulsion side towards the light source. Do not let the film drip on to any electrical connections.

▲ Once the second exposure has been completed, switch off the safelight. Hold the film at each end and see-saw it through the wash water, making sure that both ends are immersed. This is to remove the remaining stop bath solution.

▲ The second development lasts for 2 minutes. It is followed by the normal sequence of stop bath, fixer and wash.
The solarized image that is produced will be very dense when compared to your usual negatives.

◀ Plenty of fine detail thrown into sharp relief by the sunlight makes this subject a good one to solarize. Having decided to do so *Richard Brook* enlarged the negative on to high contrast film which he solarized. He contact printed this on to more high contrast film and then enlarged on to paper. Notice how some areas have changed greatly while others have stayed roughly the same.

the film in a loop, emulsion inwards through the wash water for at least a minute, making sure that both ends are rinsed. This removes the stop bath before second development begins. As wet film can be rather tricky to handle it is probably easier to continue with this see-sawing technique during the rest of the process.
● Develop the film for a further 2 minutes. Then follow the normal sequence of stop bath, fix and washing. The film should now be solarized and if your results are successful the film can now be printed.

The white light method

This is the Kodak recommended method for Plus X film and was probably originally intended for sheet film as it involves using small developing trays. However it can be adapted for use with 35mm or 6 x 6cm. Allow about 2½ in (6cm) extra when you cut

the film up and clip each end to the lip of the tray, making sure that the film bows down into the centre. The developer is Kodak HC-110 diluted 1 part to 16 of water and used at 68°F (20°C). You need to work in complete darkness. First development lasts for 1½ minutes.
● Pour the developer into the tray and agitate continuously by rocking from side to side for 1 minute 20 seconds.
● Leave it still for 10 seconds and then expose to white light, that is an ordinary bulb or an enlarger, while the film is still immersed. The exposure time is likely to be in the region of 2 to 5 seconds with a 15W bulb about one yard (metre) away. With an enlarger it is possible to give stepped exposures like a test strip as long as the film is protected from stray light being reflected from the base of the tray.
● As soon as the exposure is finished agitate again until the film has been in the developer for 3 minutes in total.

● Proceed with the stop bath and fixer, and wash as usual. This completes the process and successful results can be printed.

Assessing the results

All solarized negatives are very dense compared to normal ones so don't panic. The negative image from the camera exposure and first development is usually neutral grey in colour. The positive image from the second exposure and development is very much warmer and tends to be creamish in colour. In between the two ought to be a clear line, the Mackie line, though you may need a magnifying glass to see it. With luck both images will have adequate detail and contrast and the lines between them will be clear.
Normally, on the first attempt, the problem is to decide what went wrong. Remember that the density of the negative is due to exposure and the

contrast results from development. As the first exposure was made quite normally in the camera, it is not likely that there will be a lack of detail in the neutral tone negative image. It might be too flat or too contrasty. If that is the case, first development should be increased or decreased accordingly by between half a minute and a minute.

It is much more likely that the positive image will be faulty. To make a correction the same rule is applied but this time to the second exposure and development. Density is increased by a longer second exposure while it is decreased by a shorter one. Too much or too little contrast is altered by varying second development.

Sometimes the Mackie lines are not very clear. This may be because the original scene did not contain well defined boundaries between the light and dark areas. If this is the case then you are wasting your time and another subject should be chosen. If the subject is suitable then the definition of the Mackie lines can be improved by cutting agitation in both developments. Agitate for the first half then allow the film to remain still for the second. To compensate, increase the total development time by 20%. As a further refinement vigorous negative developers, such as Agfa Rodinal at dilutions 1:10 to 1:25 or Kodak HC-110, can be used.

Solarizing prints

The results of this technique can easily end up as very dark images lacking contrast and detail unless great care is taken with the selection of an image and the intensity and duration of the solarizing exposure. As with negative solarization plenty of vivid variation in tones is needed in the image. Otherwise too much fine detail will get lost.

● Expose a print in the normal way.
● Half-way through development, that is when the image is clearly visible, re-expose to white light. An enlarger is useful here as the aperture allows a fine control of the amount of light.
● The moment you see a change in the image switch off.

As the paper is still in the developer, the image will now change rapidly so you will need to transfer it quickly to the stop bath once you have achieved a satisfactory result.

Over-exposure is the commonest cause of failure when working with prints. A judicious use of reducer can rescue marginal failures but it will probably be quicker to go back and do it again using a shorter second exposure.

▲ Solarized film is very dense and quite unlike a normal negative.

▶ This still life by *Heino Juhanson* was illuminated from below. When the film was solarized a Mackie line was created between the light and dark areas creating an outline that gives coherence to the shape of the entire group. Solarization also radically changed the tones of the vegetables.

▼ The flat, metallic look of a solarized print needs the right subject for a successful image.

Successful colour solarization

Solarized black-and-white photographs are composed of positive and negative tones. Although it was possible in the past to create such effects by gross over-exposure, modern materials have such exposure latitude that an alternative method has to be used.

Pseudo-solarization, or Sabattier effect, occurs when development is interrupted, the film or paper is re-exposed and processing is completed. The result is similar to true solarization for black-and-white film or paper.

With colour materials a set of colours complementary to the original are created, that is, yellow replaces blue, magenta replaces green and cyan replaces red, so long as white light is used to make the second exposure.

As the colours that are produced are bizarre and unnatural, it doesn't matter whether you start with a slide or a negative when making either a solarized transparency or print. In view of this the image that is your starting point, whether it is a slide or negative, is usually called the colour source.

Solarizing slides

One of the most useful materials on which to make solarized slides is print film. This is a print emulsion, coated on a translucent film base. It is normally used to make colour transparencies from negatives. The Kodak version, Vericolor Print Film, is processed in the same way as colour negative film, that is in the C41 process. The Agfa Print Film (not available in US) is processed in their colour print chemicals at present. Both types are only available in sheets but 8 x 10in (10.2 x 12.7cm) boxes can be ordered through a good photographic store.

Making an exposure grid

As two exposures are necessary and the relationship between them is important a special type of test strip is needed.

Working in total darkness, take a sheet of print film from its box and place it emulsion side up on the baseboard under the enlarger head. (Remember, the emulsion side is stickier than the base when placed in contact with a moistened lip.) Place the colour sources emulsion side down on the film and cover them with a piece of plate glass that will hold them flat. If you are working from 35mm originals, six will fit comfortably on an 8 x 10in (10.2 x 12.7cm) sheet. Make a test strip as a colour contact sheet, keeping the covering card parallel to one edge.

Processing is carried out in small processing trays standing in a larger one, which acts as a water bath to maintain the temperature of the solutions. For Kodak materials this is 100°F (38°C) and for Agfa 75°F (24°C). Use a reasonable depth of processing solution to ensure that the sheet of film is completely covered. There is no way of checking this visually once you begin. As tongs are impractical when working in complete darkness, you will need plastic or rubber gloves to handle the materials. Colour developers are extremely irritating to the skin and such protection is always necessary.

After the first series of exposures slide the sheet of film into the developer. Be sure to handle the film without delay as the development time is short. Half way through development extract the sheet and, supporting it on a piece of glass to keep it flat, make a second series of exposures, each twice the length of its equivalent in the first series, at right angles to the first set.

The light source for the second series should be a 30W bulb approximately 5ft (1.5m) from the film. Filters can be used to colour the light source — any strongly coloured filters will do. As the

▲ Even a simple composition can form the basis of a striking solarization.

▼ Here a pale red filter was used to make a selective solarization.

The original image, or colour source, (above) need not be boldly coloured. But the picture should be composed in an interesting manner with clearly defined patterns.
The simplest form of solarization (above right) involves a second exposure to an ordinary light bulb. Print film is the best material for this. Using the enlarger to make this exposure gives greater control over the level of illumination, but the colours will still be rather crude.
Greater subtlety and variety (right) can be achieved by placing filters in the negative carrier of the enlarger so that the light only affects parts of the emulsion. Here, a pale red filter has been used with a neutral density filter, which prolongs the exposure slightly.
The process is taken one stage further (below) by printing the solarized print film directly on to another sheet of print film without any further solarization. This reverses the colours so that blue becomes yellow, and vice versa.

FOGGING EXPOSURE (secs)

FIRST EXPOSURE (secs)

▲ In the past solarization has been a trial and error technique. The grid allows the effect of the second exposure to be accurately assessed.

intention is to create an unusual and artificial image, such modifications will often enhance the effect.

Return the film to the developer and complete the process as normal. Once the film is dry, the grid that you have produced will indicate the variations in colours that are possible and you can select the combination that you prefer. Once you have established the exposures that you prefer, the film need not be re-exposed on glass but may be left in the developer. The results obtained will feature strong colours but their range will be limited. The highlights will be coloured.

Solarizing prints

The most straightforward way of solarizing colour prints is similar to its black-and-white counterpart. A slightly curtailed first exposure is given and the paper is placed in the developer. The second exposure, to a white or coloured light source, is made one third of the way through development, while the print is in the tray. The length of each exposure is calculated by making a test grid.

Although simple, this method has the disadvantage of being difficult to control. The results, relative to other methods, are rather crude.

Using tricolour filters

An alternative method of making solarized prints, that gives much more control over the final result, involves the use of special filters.

Tricolour filters were originally developed for the printing industry. Each one is a very pure primary colour. They are available in the Kodak Wratten range and the red, blue and green filters are numbered 25, 47 and 58 respectively. When they are used over the light source during the second exposure only one layer of the emulsion is solarized.

The first step is to make a colour print in the normal way, creating the density and colour balance that you want. Process the paper in trays. Once you have a satisfactory print, place a piece of glass on the printing frame and refocus, using a sheet of white paper. The glass protects the frame from chemicals during the second exposure. When you have refocused, stop the lens down to the aperture used for the standard print and make the first exposure, reducing the time given by about 10-15% when compared to the standard print.

Half way through development, extract

Step-by-step to solarization

▲ An exposure grid can be used with any of the solarizing techniques. The first step is to make a test strip, giving shorter exposures than usual. Try to keep the card parallel to the edge of the paper or print film, creating steps of equal width. *A blue background indicates total darkness.*

▲ Processing is always done in a tray. Make sure the tray is at least one size larger than the material being processed and that the developer fills it to a depth of at least ½in (1.5cm). Check the temperature of the developer before you begin. Agitate continuously by gently rocking the tray.

▲ For the second exposure the film or paper should be handled without delay. Take the material from the developer, support it on a piece of glass and make the second series of exposures at right angles to the first series.

▲ Immediately the second series of exposures is finished the material is returned to the developer. The process then continues through its normal sequence, which depends on the type of material and the manufacturer.

the sheet of paper and place it on the glass, having first removed the colour source from the carrier and taped one of the tricolour filters in place under the lens. Give a second exposure approximately the same length as the first, return the paper to the developer and complete the processing sequence.

If you do encounter difficulties with this method, make a test grid to determine the exposure more accurately. Take great care not to drip any developer on electrical connections or switches that are close to the enlarger.

Filtering with a source

This is a variation on the previous method. The first exposure is made as before and development begun. A filter is taped in position but the source is retained in the carrier. Half way through development the paper is removed from the processing tray and then placed, emulsion side up, on the glass.

A cotton ball is soaked in developer and used to swab the print flat. The enlarger is turned on and the half developed image is quickly aligned with the projected image. It is swabbed continuously with developer until the print appears to have changed in the way that you want. Such an assessment can only be based on experience gained through trial and error. Switch off the enlarger, remove the print from the glass and place it quickly in the bleach-fix and complete the processing.

Using a lith mask

This is a third variation involving tricolour filters that gives white highlights. The negative is contact printed on to lith film so that the black image does not form more than 25% of the entire image area.

The first exposure is given as before and development begun. The filter is taped in place and the source replaced with the lith mask. Half way through development the print is removed from the processing tray and swabbed flat on to the glass with a cotton ball as before. The enlarger is turned on and the image of the mask aligned with the image on the print. The second exposure should be approximately half of the first one. Complete processing as before.

As can be seen, there are many variations in technique that can be employed when making colour solarizations. From them it is very easy to develop your own style. All you need is the inclination to experiment.

▲ The strong patterns made by photographing the twin towers of the World Trade Center in New York from below combine with the unrealistic colours of the solarization to create a bold abstract image.

◄ Even in a simple print solarization, the combination of positive tones and solarized colour creates a disturbing effect.

Glossary

Words in *italics* appear as separate entries.

A

Accelerator The chemical in a *developer* which speeds up development, usually an alkaline salt, such as sodium carbonate or borax.

Acetic acid An acid commonly used in diluted form (2%) for *stop baths*—the processing step that follows the developer. It is also used in acid fixers.

Acid A substance with a pH less than 7. An acid neutralizes an alkali (a substance with a pH greater than 7). Stop baths are acidic to neutralize traces of developer, which is alkaline. Acids typically feel 'coarse' and the stronger ones, such as sulphuric or nitric acid, can cause serious burns.

Acid fixer A *fixer* which includes an acid, usually acetic acid.

Acid hardening fixer An acid fixer that contains an ingredient, usually alum, to harden the film or paper emulsion. The film or paper is then less susceptible to scratching.

Actinic light Any kind of light that causes a chemical or physical change in a substance. When photographic materials are struck by actinic light of sufficient quantity they produce an invisible, often referred to as a *latent*, image which is made visible by the developer.

Acutance A measurement of image sharpness which is dependent on the film emulsion and the developer. A laboratory test determines acutance from how rapidly image tones change between light and dark on going across a 'knife-edge'. Images of high acutance show high contrast across edges and appear sharper than images containing the same subject detail but with low acutance. Special high acutance developers make images appear sharper but, unfortunately, images produced this way also appear grainier.

Agitation The technique of moving or stirring a solution to ensure even and consistent processing. The amount of development or other processing, (for example, fixing) that occurs depends partly on the degree of agitation. (However, time, temperature and chemical formulation are also important.)

Air bells Small bubbles of air which stick to the surface of the emulsion on films and printing papers, and stop the developer acting on the emulsion.

Alkali A substance with a pH greater than 7. Alkalis are used in most developers and give the solution its 'slippery' feel. The stronger alkalis, such as sodium hydroxide (caustic soda), should be treated with care as they can cause serious burns.

Alum A type of chemical often used as a *hardener* in fixers. The most common ones are potassium alum and chrome alum.

Anti-halation backing A thin coating of dye, pigment, or carbon on the back of the film which helps to prevent light from reflecting back to the light-sensitive emulsion. Without the backing, all bright lights in a scene would have a strong 'halo' of light around them.

ASA American Standards Association (former name of American National Standards Institute). The sensitivity (speed with which it reacts to light) of a film can be measured by the ASA standard or by other standards systems, such as DIN. The ASA film speed scale is arithmetical—a film of 200 ASA is twice as fast as a 100 ASA film and half the speed of a 400 ASA film.

B

Bleach A chemical bath that reacts with the black silver formed by the developer in one of two ways; either by converting it back to its original silver salts, or by dissolving the silver completely. Most colour processes use the type of bleach which regenerates the original silver salts. Some black-and-white processes also use bleach, for example, sepia toning.

Blocking out The technique of painting parts of the negative with an opaquing solution to block out the image in the treated areas. It is used to remove unwanted backgrounds which will then appear white on the final print. This operation requires considerable skill.

Brightness range The brightness difference between the darkest and the lightest parts of a scene (or image). This range depends on the reflectance of the various objects in the scene and on the nature of the illumination. On a sunny day with few clouds this range may exceed 1:100, but the same scene on a dull day may have a brightness range of less than 1:20. With careful exposure and film development, both of these conditions can be accommodated by the film.

Bromide paper A popular type of black and white printing paper which gives a neutral or blue-black image colour. It gets its name because the emulsion used is silver bromide. The other main type of black and white paper is *chlorobromide* (for example, Bromesko, Ilfomar) which gives a warmer (browner) image colour.

Buffer Chemicals which help to maintain the pH (acidity or alkalinity) or chemical constitution of a solution, and so keep the solution activity constant. They are normally used in developer solutions to help give consistent processing. Examples are borax/boracic acid and sodium carbonate/sodium hydroxide.

Burning-in A printing technique where extra exposure is selectively given to parts of the image. In black-and-white printing burning-in darkens tones and modifies contrast (when using multicontrast papers); it is particularly useful for bringing out highlights. In colour printing, burning-in can modify both tone (density) and colour.

C

Cartridge A light-tight container in which lengths of film are sold. Normally these are made of plastic and come in two sizes—a 126 size and a 110 size.

Cassette A metal or plastic light-tight container which holds various lengths of 35mm film. They are smaller and simpler than cartridges, and some types may be used more than once.

CC filters 'Colour compensating' filters which are used in enlarging colour film to modify the final overall colour balance of the print. Their various strengths are indicated by numbers usually ranging from 05 to 50. For example, the weakest yellow filter is 05Y and the strongest magenta filter is 50M. These filters may be combined to give a complete range of colour correction.

China crayon (also known as a china-graph pencil or china marker) can be used to write on film without damaging the surface and is easily cleaned off when required.

Chlorobromide paper A photographic printing paper which consists of a mixture of silver chloride and silver bromide emulsions. When developed these papers give a warm-toned image, as compared with most bromide papers which produce a neutral or blue-black image tone.

Clearing bath The general name given to any processing step which is designed to remove or chemically neutralize any potentially harmful chemicals which are carried over by the film or paper.

Clearing time The time required in the fixer for the film to go from its initial milky appearance to a clear film. To ensure that fixing is complete it is normal to leave the film in the fixing bath for twice the clearing time. The clearing and fixing times depend on the formulation of the fixer, temperature, agitation, and the amount of use the solution has already had.

Cold cathode A type of fluorescent tube which runs at a low temperature and is a suitable light source for diffuser enlargers. Compared with condenser enlargers, there is some loss of definition and contrast. Cold cathode light sources are mainly used for large format enlargers.

Colour balance The overall colour cast of the film or print. Normally a film or print is balanced to give grey neutrals (such as a road or pavement) and pleasing skin tones. The colour balance preferred by the viewer is a subjective choice, and this is the reason why there is a variety of colour films available; each one having its own colour characteristics.

Colour head An enlarger head which includes built-in movable coloured filters to alter the colour of its light. The correct filtration for the colour negative or transparency being printed is dialled in. Most colour heads produce a softer light than a conventional black and-white enlarger. A conventional enlarger, however, can be used for colour printing by placing coloured filters in a simple filter drawer positioned above the condenser.

Colour negative A type of film which is used primarily to give colour prints; although colour transparencies and black-and-white prints may also be produced. The colours of a colour negative are complementary in colour and hue to the original subject colours. For example, a light blue appears as a dark yellow and a dark green appears as a light magenta. The characteristic orange appearance of all colour negatives comes from the built-in corrector which improves overall colour fidelity.

Colour reversal A colour film or paper which produces a positive image directly from a positive original. Thus a colour reversal film gives a colour transparency directly from the original scene and a colour reversal paper (for example, Cibachrome or Ektachrome paper) gives a positive print directly from a transparency. Most colour reversal materials are identified by the suffix 'chrome'.

Colour sensitivity The response of a photographic emulsion to various colours (wave-lengths of light).

Compensating developer A developer which acts more vigorously on the less exposed areas of the film and less actively on the more exposed areas. The net result is a reduction in negative contrast. At best, this compensating effect is only small, and is most found when very dilute developers are used with a minimum of agitation.

Condenser A simple one-element lens which causes light to converge. These lenses are used in many enlargers to focus the light source on to the back of the enlarger lens. Their position or strength (focal length) may be varied according to the film size being enlarged.

Contact printing In this type of printing the film is held in contact with the printing paper and no lens is needed. Contact printing can be used for making prints from large films—4 x 5in (10.2 x 12.7cm) and larger—or when contacts are required for inspection or records.

Continuous tone Any photographic material which is capable of producing a continuous range of tones from white to a maximum black. A continuous tone material shows subtlety of tone throughout its range, from rich shadows, through mid-greys, to delicate highlights.

Contrast The variation of image tones from the shadows of the scene, through its mid-tones, to the highlights. Contrast depends on the type of subject, scene brightness range, film, development and printing.

Contrast grade The number which indicates the contrast of photographic paper. The scale of numbers usually runs from 0 through to 5, with the most contrasty papers having the highest numbers. Negatives having a low contrast—referred to as soft negatives—are printed on to high-number paper grades such as 3 to 5, normal negatives should print best on grade 2, and high-contrast (hard) negatives on grades 0 and 1.

Contrast index A Kodak system designed to standardize negative printing characteristics. If a photographer develops all his films to the same CI, then he should obtain prints of similar quality on similar paper grades,

provided that other factors, such as lighting and subject matter, are also standardized.

Copper toning A chemical process which changes the image colour of black-and-white prints. Depending on the activity of the toner and the time it is allowed to react, a range of tones from warm brown to red may be obtained.

Cyan A blue-green colour which is complementary to red. It is one of the three subtractive primaries: the other two are yellow and magenta.

D

Darkroom A room which is sufficiently dark to enlarge and process photographic prints; and to handle, without fear of premature exposure (fogging), other photographic materials.

Daylight colour film A colour film which is designed to be used in daylight without or with electronic flash or blue flash-bulbs. This film type can also be used in tungsten or fluorescent lighting if a suitable filter is put in front of the lens or light source.

Density The ability of an area of a paper or film to absorb light. Areas of high density absorb a lot of light and appear black, whereas low-density areas absorb only a small amount of light and appear closer to white (theoretically having a density of zero). A density increase of 0.3 represents a doubling of light-stopping ability so a 1.3 density area absorbs twice as much light as another area of 1.0 density.

Density range The difference between the minimum density (D min) of a print or film and its maximum density (D max). Typical density ranges are 0 – 1.8 for black-and-white and colour papers, 0 – 1.2 for black-and-white and colour negatives, and 0 – 3.0 for colour slides.

Developer A solution which converts the latent image on exposed film or paper to a visible image. A black-and-white developer produces a black silver image, while a colour developer generates both a black silver image (removed in later steps) and a coloured image consisting of three dyes (yellow, magenta and cyan).

Developing by inspection This technique, whereby the paper or film is viewed periodically under a suitable safelight during processing, allows development to be terminated at exactly the desired time. Development by inspection is only practical for papers and some slower films.

Developing tank A container in which film or paper is developed. The film is loaded on a spiral (reel) which is then placed in the tank. Most tanks allow processing in normal lighting, once the photographic material has been loaded into the tank which must be in total darkness.

Dichroic filter A filter, usually made of glass, which transmits certain colours and reflects all others. Its actual colour depends on the material coated on the glass. Dichroic filters are favoured for colour enlargers because they are resistant to both fading and heat.

Dichroic fog A magenta-green stain (colloidal silver) which can form on a developing film if it is transferred directly from the developer to the fixer without first going through a wash or stop bath. In practice dichroic fog is very rarely seen. Once formed, it is impossible to remove.

Diffused image An image which has indistinct edges and appears 'soft'. Overall or partially-diffused images can be produced in the camera by using special lenses and filters, or by shooting through various 'filmy' substances such as Vaseline, transparent adhesive tape and fine stockings. Images may also be diffused during enlarging by placing a diffusing device between the enlarging lens and the paper.

DIN Deutsche Industrie Norm. A film speed system used by Germany and some European countries. An increase/decrease of 3 DIN units indicates a doubling/halving of film speed, that is a film of 21 DIN (100 ASA) is half the speed of a 24 DIN (200 ASA) film, and double the speed of an 18 DIN (50 ASA) film.

Dodging The technique used during enlarging which reduces exposure in certain parts of the image by blocking the light. A dodging tool is moved gently above those areas of the picture which require lightening (or darkening if printing from a transparency) while the remainder of the image receives the full exposure.

Double exposure The process of exposing two separate images on one piece of film or paper. This is a relatively simple procedure when enlarging and when using most medium and large format cameras, but can be quite difficult with most 35mm cameras.

Double weight paper The thickest (heaviest) photographic paper normally obtainable. Many types of photographic paper are available as single and double weight, the latter being preferable when handling large print sizes. Resin-coated (RC) papers are normally only available in a medium weight; this is halfway between single and double weight.

Drying marks Marks sometimes formed while the processed film is drying; these may show up on the final print. Usually drying marks are located on the film base side and are normally removed by careful rewashing or gentle rubbing with methylated spirit or a proprietary film cleaner. To avoid drying marks use a wetting agent in the final rinse and ensure that the water is clean.

Duplicate (Dupe) Any copy of a photographic image (negative or transparency, black-and-white or colour) which is as close a match to the original as possible.

E

Easel Also known as an enlarging easel or a masking frame. It holds the photographic paper flat while an enlarged image is projected on to it. The easel also controls the size and squareness of the print borders.

Emulsion A photographic emulsion is the light-sensitive layer (or layers) which is coated on to the film or paper base. It

consists of silver halide salts suspended in gelatin.

Emulsion speed See *ASA, ISO* and *DIN*.

Enlargement This usually refers to a print (positive) made from a smaller negative (or transparency).

Enlarger A device which projects an image, usually of greater size than the original negative or transparency, on to photographic paper or film. Enlargers consist essentially of a light source, condenser(s) to control the light, a negative (transparency) holder, an enlarging lens, and some method of varying the negative-to-lens and lens-to-paper distances.

Enlarging lens A lens which is specially designed to give excellent results at the relatively short lens-to-paper distances used in enlarging. A good enlarging lens is essential for high quality prints.

Exposure latitude The maximum variation of film or paper exposure from the 'correct' exposure which still yields acceptable results. For example, most colour negative films have an exposure latitude of −1 (one stop under) to +2 (two stops over). Exposure latitude depends on the actual film in use, processing, the subject and its lighting, and what is considered as acceptable to the photographer.

F

Farmer's reducer A solution of sodium thiosulphate (hypo) and potassium ferricyanide that is used to lighten the whole or parts of a black-and-white print or negative. The two chemicals are mixed just prior to use. It is essential to test the effect of Farmer's reducer on a spare print before applying to 'good' prints.

Ferrotype plate See *glaze*.

Film A thin, flexible, transparent material that is coated on one side with a light sensitive silver halide emulsion. It is sold either as rolls or variable widths and lengths, or in sheets.

Film base The material on to which the silver halide emulsion is coated—the two main types being acetate (cellulose triacetate) and polyester (for example, Estar). The polyester type is stronger and dimensionally more stable but is more difficult to work with.

Film speed See *ASA, ISO* and *DIN*.

Filter Any material which, when placed in front of a light source or lens, absorbs some of the light coming through it. Filters are usually made of glass, plastic, or gelatin-coated plastic and in photography are mainly used to modify the light reaching the film, or in colour printing to change the colour of the light reaching the paper.

Finegrain developer Any developer which produces a relatively finegrained negative—usually this is accomplished without the loss of film speed. Most modern developers are of the finegrain type—for example, D-76, ID-11, Acutol.

Fixer Solution which makes a photographic image permanent by dissolving all the remaining light sensitive silver halides. Most fixers

contain a fixing agent (usually sodium or ammonium thiosulphate), an acid, and a hardening agent to toughen the processed emulsion.

Flat image of low contrast, which may occur because of under-exposure, underdevelopment, flare, or very diffuse (soft) lighting.

f numbers The series of internationally agreed numbers which are marked on lenses and indicate the brightness of the image on the film plane—so all lenses set to f8 produce the same image brightness when they are focused on infinity, the f number series is 1.4, 2, 2.8, 4, 5.6, 8, 11, 16, 22, 32 etc—changing to the next largest number (for example, f11 to f16) decreases the image brightness to ½, and moving to the next smallest number doubles the image brightness.

Fogging The act, usually accidental, of all or some parts of the photographic material being developed as a result of something other than exposure to the image. Fogging can be caused by light leaks, chemical contaminants, radiation, static discharges, and mechanical stress.

Fog level The amount of non-image density which occurs when a film is developed, fog level being the photographic equivalent of 'noise' in a hi-fi system. The fog level depends on factors such as the degree and type of development, and the age, keeping conditions and type of film used.

Forced development This occurs when a film (or paper) is developed for longer than the recommended time. Films are force developed when either they have been underexposed, intentionally or otherwise, or when higher than normal film contrast is required, such as when the subject is of low contrast.

G

Gamma A number that indicates the degree of development that a film has received. The more development a film receives the higher is the value of gamma and the higher is the image contrast. Most negative films are developed to a 'normal' gamma of about 0.7—this usually being a suitable degree of development for printing average subjects on to grade 2 (normal) black and white paper. The value of gamma is found from the *Characteristic curve*—see also *Contrast index*.

Gelatin The 'binder' in which silver halide grains are suspended—this light-sensitive emulsion being coated on to the film or paper.

Glaze A glossy surface that results when certain fibre-based printing papers are dried face-down on a glazing plate or ferrotype plate.

Glazer drier For drying glazed (glossy) paper. See *Glaze*.

Glossy drier. See *Glazer drier*.

Glossy paper A photographic paper surface that is ultra smooth and produces the greatest range of tones from white to a deep black—other paper surfaces produce a less dense black. Glossy colour papers produce

not only the largest tonal range of paper surfaces but also the purest (most saturated) colours. A glossy surface is obtained automatically from resin-coated (RC) papers, but 'conventional' papers need to be glazed to obtain a high gloss.

Grain The random pattern within the photographic emulsion that is made up of the final (processed) metallic silver image. The grain pattern depends on the film emulsion, plus the type and degree of development.

Graininess The subjective measurement of the grain pattern. For instance, fast films when greatly enlarged produce images that are very grainy, and slow films give relatively 'grainless' images.

Granularity The objective measurement of grain that is obtained from a microdensitometer (measures density of very small areas) trace across a processed film. Granularity figures for one film can be directly compared to those of another film.

Grey scale A series of grey patches joined together ranging from white through light, mid- and dark greys, to black. Usually the differences between adjoining patches are either visually equal or are of equal density increments (eg. 0, 0·3, 0·6, 0·9 etc). Grey scales are very useful for detecting contrast and colour changes.

H

Halation This is the result of light passing through the light sensitive emulsion, then through the film base, and finally being reflected back from the other side of the film and re-exposing the emulsion, but in a different place from the original exposure. Halation is largely removed in modern films by an antihalation backing which absorbs the light before it can return to re-expose the emulsion. Where very bright lights, such as street lamps, are present in a scene, halation still occurs and produces a bright circle around the central lamp exposure.

Half-tone process The procedure that converts a continuous-tone image, such as a photographic print or slide, into one that contains only black (or coloured) dots. The various tones of the original image are represented by dots of various sizes—small dots in light areas, large dots in shadow areas. Half-tone pictures are used in most printed publications and are easily identified in newspaper photographs by the obvious dot pattern.

Halides A group of compounds that consist of fluorides, chlorides, bromides, and iodides. Silver halides (chloride, bromide, iodide) are the light sensitive salts used in photographic emulsions.

Hardener A chemical that causes a photographic emulsion to dry hard and be therefore less susceptible to damage from scratching. Hardeners are usually incorporated into fixing solutions.

Highlight mask An intermediate negative or positive that is used in some duplicating processes so that highlight contrast is retained in the duplicate.

Hydroquinone A developing agent used in many black-and-white developers.

Hypo The common name given to sodium thiosulphate, a chemical used as a fixing agent in a number of fixer formulations. The fixing agent dissolves any remaining silver halide left in the film or paper after development.

Hypo clearing bath (eliminator) A solution used after fixing and a short wash, to reduce the overall washing time. It reduces the washing time of conventional double-weight photographic papers from 40 minutes to about 10 minutes. A hypo clearing bath has little use for films and resin-coated (RC) papers, which have fairly short washing times anyway.

I

Image An artificial representation of an original scene.

Infectious development A type of development in which an initial, relatively slow reaction is followed by rapid 'infectious' development in these image areas. The chemical by-products of development act as catalysts for further development. Infectious development occurs with very high contrast materials such as 'lith' films.

Integral tripack This refers to the emulsion structure of modern colour films and papers which consist of three basic emulsion layers coated on top of each other. One layer is sensitive to blue light only, another to green light and the third to red light. These three layers are sufficient to analyse and then reproduce the colours of the photographed scene.

Integrating A term used to indicate an averaging or mixing of light. For example, an incident light reading attachment on a light meter receives light from about 180°, mixes the light, then produces an average reading. Most colour printing heads have an integrating sphere which mixes and diffuses the printing light.

Intensification The technique of adding density and/or contrast to an existing black-and-white negative which is too light to produce satisfactory prints. Chemical intensifiers cannot produce detail where none originally existed, but they can 'rescue' an otherwise unprintable negative.

Irradiation The loss of image definition caused by the scattering of light as it goes deeper and deeper into the photographic emulsion. Irradiation is greatest when the emulsion is thick and, to a degree, the silver halide grains are large; therefore faster films show the greatest loss of definition due to irradiation.

ISO International Standards Organization. The ISO number indicates the film speed and aims to replace the dual ASA and DIN systems. For example, a film rating of ASA 100, 21 DIN becomes ISO 100/21°.

K

Kelvin A temperature scale which is used to indicate the colour of a light source. Reddish sources, such as domestic light bulbs, have a low colour temperature (about 2800K); and bluish sources (e.g. daylight at 5500K) have higher colour temperature values. The Kelvin scale equals Celsius temperature plus 273, thus 100 degrees C equals 373K.

L

Lamp housing The unit into which an enlarger light source is fixed. The shape and size of the lamp housing has an effect on the evenness, temperature, and character (whether point or diffuse source) of the enlarging light.

Latensification The amplification of the latent image before it is processed to a visual image. Latensification can be achieved by chemical or light fogging of the film. This technique is difficult to control and is capable of only a x2 (one stop) increase in film speed.

Latent image The invisible image, produced by exposure of photographic film or paper to light, which is made visible by development. The latent image, when kept at low temperature and low humidity, can remain relatively stable for months and even years.

Latitude When used in connection with films, latitude refers to the amount of under- and over-exposure permissible to achieve acceptable images. Exposure latitude depends on type of film, subject, lighting and the visual quality of the final result. Colour materials, especially slide films, generally have less latitude than black-and-white films.

Light-tight Any container, room etc. which is not penetrated by light. In photography it is essential that developing tanks, changing bags, cameras and darkrooms are light-tight.

Light trap Any arrangement which excludes light from a container or room but still allows entry of chemicals and air.

Lith developer A developer solution used to process lith (lithographic) films.

Lith film A film emulsion of very high contrast which is made principally for the printing industry. It is also used in a number of unconventional photographic processes such as bas-relief, solarization, and posterization.

Local control A term used to describe techniques which change print density and/or colour in local selected areas. There are three main types of local control: 1. shading—which locally reduces the printing exposure and gives lighter tones when printing negatives (darker tones when printing slides); 2. burning-in—which gives darker tones (lighter tones from slides) by increasing exposure in the area concerned; and 3. colour dodging—which changes colour locally by shading the area with a colour filter.

M

Magenta One of the three subtractive primary colours on which modern colour photography is based; the other colours being yellow and cyan. Magenta is a purply colour produced by mixing equal quantities of red and blue light.

Magnification A term used to indicate the size of the image either on the film or on the final print. A magnification of x1 means the film image and the subject are the same size.

Mask Any device which obscures or modifies selectively one part of an image. Masks are used to alter the tonal scale, colour or content.

Masking frame See *Easel*.

Matt Any surface which is relatively non-reflective and can be viewed without getting specular reflections ('hot spots') from light sources.

Metol A developing agent used in many developer solutions. Metol is also known by several brand names including Elon (Kodak). See also *MQ*.

Monobath A black-and-white processing solution which both develops and fixes the film. Providing the monobath is between 64.5°F (18°C) and 75°F (24°C) the actual time (within reason) the film is in the solution is not critical; the film is then washed as for conventional processing.

Monochrome A monochrome picture is the one which has only one colour; the term is normally applied to black-and-white prints or slides.

Montage The combining of two or more separate images to produce a new composition. A montage can involve several techniques including multiple camera exposure, collage (paste-up), multiple printing, and sandwiching of film (negatives or slides).

MQ Any developer formulation which contains both metol and hydroquinone as the developing agents.

N

Negative A general term which is often used to describe a negative image on film, whether it be in black-and-white or colour. See also *Negative image*.

Negative carrier The unit which holds the negative (or slide) in the correct position between the enlarger light source and the enlarging lens.

Negative image Any image in which the original subject tones (and/or colours) are reversed.

O

One-shot solution A processing solution, usually a developer, which is used once and then discarded. Its advantage over reusable solutions is more consistent results; its disadvantage is slightly increased cost.

Opacity The ability of a material to 'stop' light going through it. See also *Density*.

Ordinary emulsion An emulsion which is sensitive only to UV and blue light. Most black-and-white enlarging papers have ordinary emulsions and can therefore be used under yellow-orange safelights.

Orthochromatic emulsion An emulsion which is sensitive to UV, blue and green light. It can be handled under a dark red safelight.

Overdevelopment Development which is longer than the recommended time. Overdevelopment causes increase in contrast, graininess and fog level, and

a loss in sharpness. Occasionally over-development can be used to good advantage when lighting is dim (see *Push processing*).

Over-exposure Exposure which is much more than the 'normal' or 'correct' exposure for the film or paper being used. Over-exposure can cause loss of highlight detail and reduction of image quality. See also *Pull processing*.

Oxidation The effect of oxygen (air) on some chemicals. Some processing solutions, especially developers, are oxidized through contact with air and therefore become less active. If such solutions are to be stored for any time they should be kept in air-tight containers.

P
pH A scale used to measure the acidity or alkalinity of solutions. Solutions with a pH above seven are alkaline and below acid.

Phenidone A commonly used black-and-white developing agent. See also *PQ*.

Photogram A picture produced without the aid of a camera. A photogram is made by placing objects of varying opacity on to a sheet of photographic film or paper and exposing with a suitable light source.

Positive image An image which corresponds in colour and/or tone to the original scene.

Posterization A printing technique which produces an image having two or more (but not usually more than five) tones or colours. The posterized image has large areas of the same tone or colour, and resembles a poster.

PQ Any black-and-white developer having phenidone and hydroquinone as its developing agents.

Pressure plate The plate, usually made of metal, which holds the film both flat and in the correct position for exposure or projection.

Printing frame A frame used in contact printing to hold the negative and photographic paper in contact while the exposure is made.

Pull processing A slang term which means to underdevelop a film or paper intentionally. This technique is used when films are over-exposed.

Push processing The opposite of pull processing—the overdevelopment of films or papers which have been under-exposed.

R
Rapid fixer A fast-acting fixing solution. Most rapid fixers use ammonium thiosulphate as the fixing agent.

RC paper See *Resin-coated paper*.

Reducer A photographic reducer is used to decrease the density of a negative or print. There are a number of formulations, one of the most popular being *Farmer's Reducer*.

Reel See *Spiral* and *Developing tank*.

Rehalogenization The chemical process of converting metallic silver back to silver halide. Rehalogenization takes place in the photographic bleaches used for most colour processes.

Replenisher A solution which is added in small quantities to a processing solution to keep it up to strength.

Resin-coated paper Photographic paper which has a plastic coating on either side of the paper base, the emulsion being coated on top of the plastic layer. RC papers are more convenient to process and dry than conventional papers but have poorer long-term keeping properties.

Restrainer Another name for an antifoggant—a chemical which keeps the level of fogging of a film or paper down to an acceptable level.

Reticulation A 'cracking' of the photographic emulsion which occurs when it receives a temperature shock (for example, hot developer in a very cold rinse).

Retouching The addition to, or removal of, parts of the image. This can simply be the repairing of slight blemishes (dust or hair lines) or complex airbrushing to alter the image completely. It is possible to retouch negatives or positives, in either black-and-white or colour.

Reversal material Any film or paper which gives a positive directly from a positive (for example, slide film or Cibachrome paper), or a negative directly from a negative.

Roll film A film which is loaded on to a spool and protected by backing paper. The most common roll film size is 120.

S
Sabattier effect The result of giving an image-exposed film or paper a short 'fogging' exposure about halfway through development. If the balance between the image and fogging exposure is correct, the final picture will contain areas of both negative and positive image. The Sabattier effect is also known as pseudo solarization.

Safelight A coloured light which does not fog the photographic material being used. For example, a yellow-orange safelight does not emit blue light, and is therefore suitable when working with materials sensitive only to blue light (e.g. most enlarging papers).

Saturation The purity of a colour. The purest colours are spectrum colours (100% saturation) and the least pure are greys (0% saturation).

Sensitometry The precise measurement of film and paper sensitivity.

Separation A separation of the original scene or image into two or more component parts. The term usually refers to tri-colour (blue, green and red) separation of an original colour slide or colour negative. The three colour separation negatives or positives can later be recombined to give the original colours of the transparency or negative.

Shading See *Dodging*.

Sharpness The subjective evaluation of how clearly fine detail is recorded.

Shoulder The upper part of a film or paper's characteristic curve. For negative materials, the shoulder represents the highlights of the scene; for slide and other positive materials it represents the shadows.

Silver halides The group of light-sensitive compounds used in photographic emulsions. Silver chloride and silver bromide are used in papers; silver bromide and silver iodide are used in films. See also *Halides*.

Slide A colour or black-and-white positive image on film designed for projection. Also known as transparency.

Slide copier Device which produces a duplicate slide. Also, it is often possible to crop, alter colour, and combine images on to the same frame. Slide copiers range from simple lens attachments to sophisticated professional units.

Sodium hydroxide Strong alkali (high pH) which is used in some developer formulations—mainly those used for high contrast work. It should be handled with care as it can cause serious chemical burns.

Sodium thiosulphate The chemical 'hypo' which is the fixing agent used in many fixer solutions.

Soft-working developer Any developer which produces lower contrast than a 'normal' developer. It is useful when photographing very contrasty subjects.

Solarization Production of a partial positive image when a negative material (and vice versa) is grossly over-exposed. This phenomenon should not be confused with the *Sabattier effect*.

Spiral See *Developing tank*.

Spotting See *Retouching*.

Stock solution Any solution which can be stored and used as needed in small quantities. Many stock solutions are either diluted or mixed with another solution(s) just prior to use.

Stop Another term for aperture or exposure control. For example, to reduce exposure by two stops means to either reduce the aperture (e.g. from f8 to f16) or increase the shutter speed (from 1/60 to 1/250) by two settings. To 'stop down' a lens is to reduce the size of the aperture.

Stop bath A solution used to terminate the action of a developer. A stop bath is weakly acidic to counteract the alkalinity of the developer.

T
Test strip A series of different exposures on one sheet of paper or film to help determine the correct exposure, and, in the case of colour materials, the correct colour filtration.

Tonal range The comparison between intermediate tones of a print or scene, and the difference between the whitest and blackest extremes.

Toner Any chemical or set of chemicals which alter the colour of a black-and-white image.

Tone separation See *Posterization*.

Translucent Transmitting diffuse rather than image-forming light.

Transparency See *Slide*.

Tungsten halogen lamp A special design of tungsten lamp which burns very brightly and has a stable colour throughout its relatively long life. Its main disadvantage is the extreme heat it generates and its greater cost.

Tungsten light A light source which produces light by passing electricity through a tungsten wire. Most domestic and much studio lighting uses tungsten lamps.

U
Underdevelopment Less-than-normal development for a film or paper. This can be caused by low temperature, short development time, insufficient agitation, or exhausted developer.

Under-exposure An exposure which is less than the film or paper needs to give a 'normal' reproduction of the scene. See *Push Processing*.

Universal developer Any developer formulation which can be used for both film and paper processing, usually employed at different dilutions for each.

Uprating a film See *Push processing*.

V
Variable-contrast paper A black-and-white printing paper which has a range of contrasts depending on the colour of the filter used when enlarging. One box of variable-contrast paper replaces several boxes of different grades.

Vignetting The masking of the edges of an image. This can occur when a lens hood or filter intrudes into the subject area, or when a negative is enlarged through a shaped cut-out.

Visible spectrum The part of electro-magnetic radiation which is visible to the human eye. The visible spectrum stretches from blue, through green, to red.

W
Wetting agent A chemical which is often added to the final processing rinse to promote even drying, thus avoiding drying marks.

Index